Daybreak 2000

Earth's Natural Beauty
Captured at the Dawn of a New Age

Front cover: Uluru Rock, Australia, by Art Wolfe.

Page 7: Great Salt Lake shoreline, Utah, U.S.A., by Scott T. Smith.

Page 8: Freycinet National Park, Tasmania, Australia, by Oriol Alamany.

Back cover: Top row, left to right: Savusavu Bay, Fiji, by Galen Rowell; Kangaroos near Canberra, Australia, by Andrew Henley; Oak tree near Gillingham, England, by Edward Parker; Garden of the Gods, Colorado, U.S.A., by John Shaw. Bottom row, left to right: Saguaro cacti, Arizona, U.S.A., by Jack Dykinga; Tongass National Forest, Alaska, U.S.A., by Jeff Gnass; Bald eagle, Alaska, U.S.A., by Norbert Rosing; Wailau Valley, Hawaii, U.S.A., by Richard A. Cooke III.

Back flap: Lesley D. Young

Book design by Russell S. Kuepper

NorthWord Press
5900 Green Oak Drive
Minnetonka, MN 55343
1-800-328-3895

ISBN 1-55971-740-8

Daybreak 2000 was made possible in part with the assistance of:

 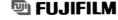

The *Daybreak 2000* experience continues online, at: www.daybreak2000.com

Printed in United States
10 9 8 7 6 5 4 3 2 1

Daybreak 2000

Earth's Natural Beauty
Captured at the Dawn of a New Age

Roger Tefft, Project Director

NorthWord Press
Minnetonka, Minnesota

Dedication

To the leading nature photographers of 2999.
May they inherit a living planet for Daybreak 3000.

Table of Contents

Introduction

This book showcases the work of more than 100 professional photographers, including many of the leading nature specialists of our time, who accepted the invitation to photograph Earth's natural world as it appeared before them on January 1, 2000. The international effort, called *Daybreak 2000*, is far from comprehensive, and the 144 pages presented here barely scratch the surface of the body of images that the photographers obtained. It is, in any case, a diverse representation of what many of the planet's cherished natural areas contained at the start of a new chapter in human history.

The idea for this project came in August 1997. In an age when the numbers of wild areas are dwindling, and human population counts soaring, it seemed appropriate to document, through the eyes of some of the world's best nature photographers, one day in the life of the natural world—natural landscapes, plants, and wildlife. While the project could have been performed on any day, this particular day seems to take on greater meaning, for it was a day on which much of humanity focused its attention on the well-being of the virtual world. Celebrating the arrival of 2000 by capturing images of that which has been "Y2K compliant" since

the dawn of time should be immensely gratifying to the cyber-cynic in us all. Moreover, a time capsule of images of Earth's natural world taken while the sun illuminates the planet for the first time in 2000 may inspire our descendants to care for the world's precious places for the benefit of future generations.

In the more than two years that have passed while nurturing *Daybreak 2000* from an idea to a publication reality, the advice and counsel of photographers, publishing insiders, friends, family, and others was sought. Nearly all embraced the idea enthusiastically and volunteered their insight and expertise, including many of the photographers whose images appear in the pages that follow.

One month before the big day, project kits containing instructions and film, courtesy of Fujifilm, were sent via Federal Express to the photographers in more than 25 countries on six continents. Immediately after the shoot, a deluge of finished images and unprocessed film (developed courtesy of A&I Color) poured into project headquarters in Costa Mesa, California. Ultimately, the process of coordinating more than 100 photographers, sponsors, and other key players, and

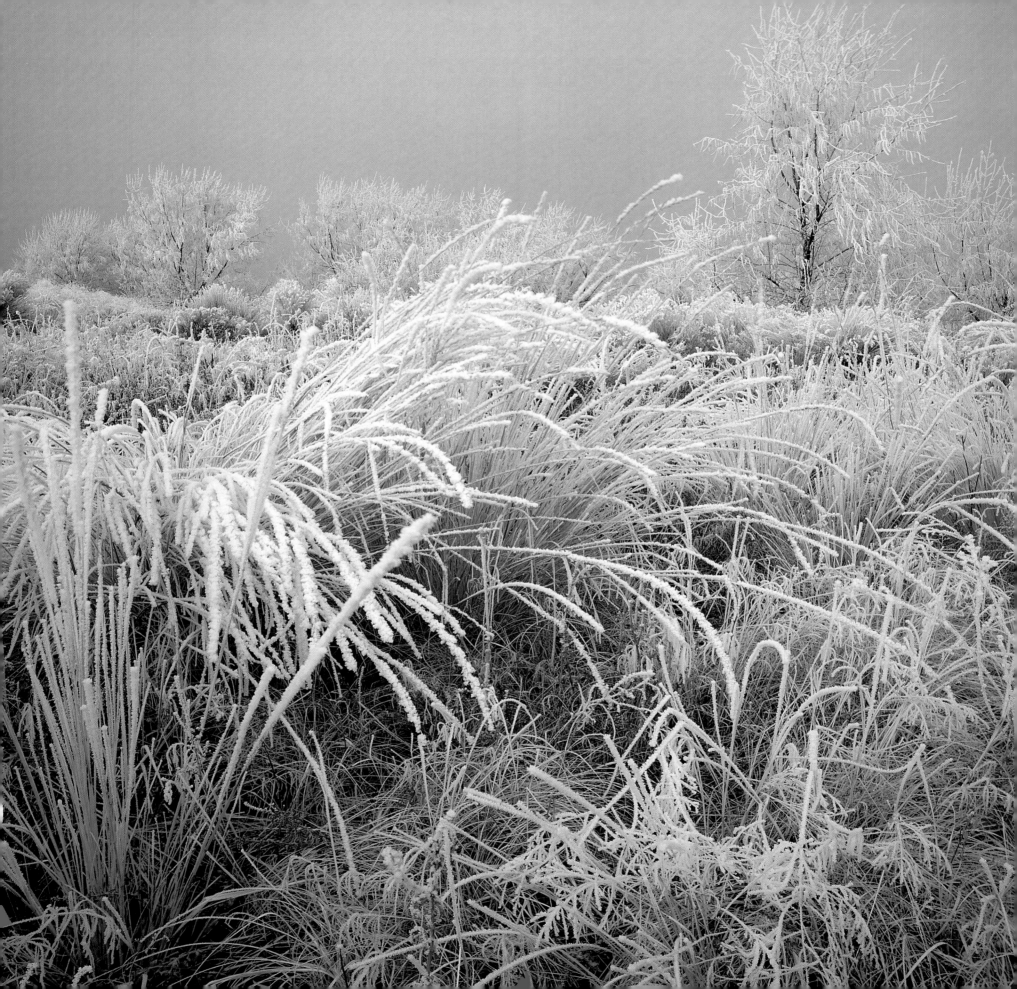

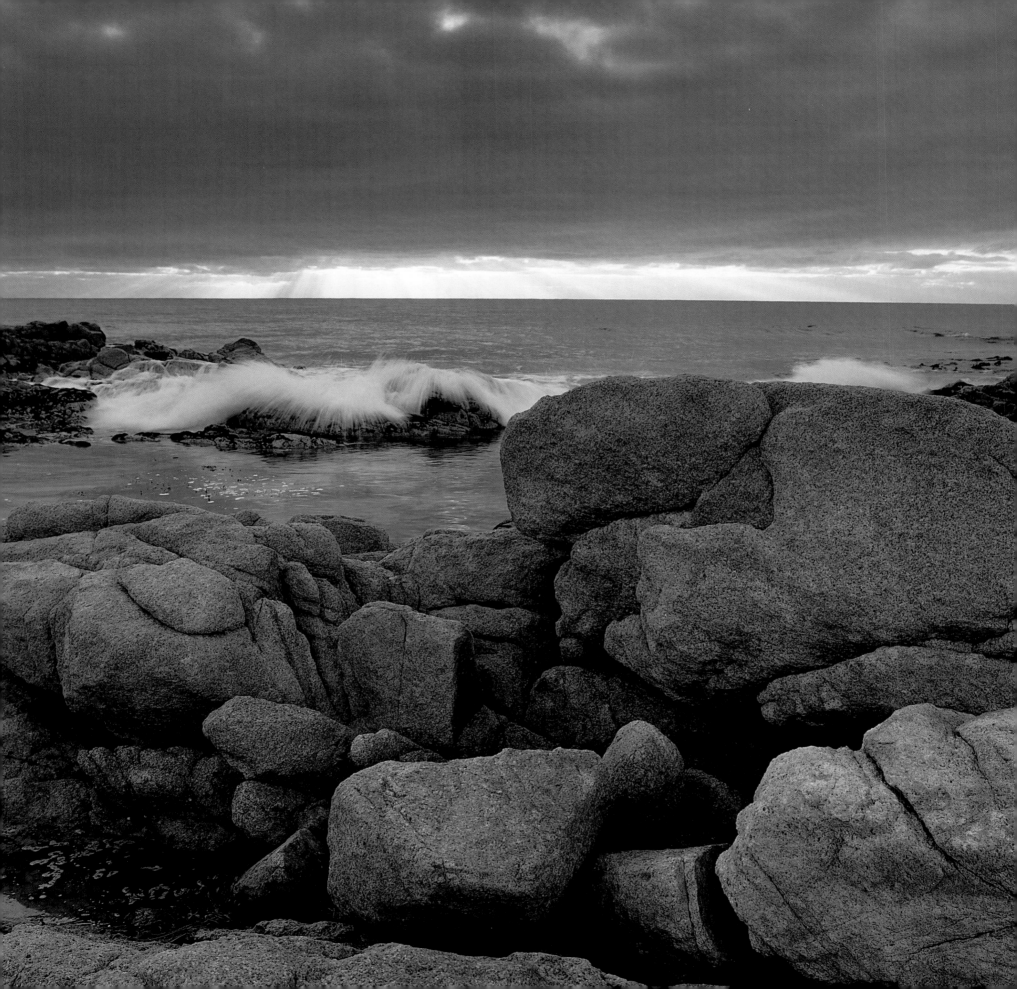

then within two weeks sifting through thousands of images and caption material to select the few shots published here, can only be described as managed chaos.

The photographers chosen for this project were selected for their experience in photographing the natural world. Many were named by their peers. Others were referred by stock photography agents. The willingness of all of them to contribute to a special, cooperative project on what is traditionally a holiday reserved for family speaks volumes. Some nominees were unable to participate, but those who did made the most of the conditions of the day. Each had only the first day of 2000. There may have been many dress rehearsals, but there was only one take.

To hear the photographers speak about it, what made this one-day assignment exciting and at the same time frustrating was the uncertainty of the light or the viability of desired subjects. The vagaries of weather affected many, and it completely obliterated opportunities for some. Photographer Michael Fatali, for example, reported whiteout conditions during a snowstorm that blasted his camp in the slick rock country of Arizona's Paria Wilderness, dashing his hopes for an image on January 1. The glorious New Year's Eve sunrise Kathleen Norris Cook captured while scouting locations around Ouray, Colorado, was far from

repeatable the next day. For all who participated, it certainly was a day they won't soon forget.

The images in this work appear in longitudinal order, beginning at Fiji just west of the International Date Line and, like the sun's continuous sweep of light, proceeding westward.

It is comforting to imagine while turning these pages that for this assignment 2,000 photographers or more could have been dispersed and still only a trace of the world's beloved natural subjects would have been represented. Natural wonders like Oregon's Crater Lake, rare wildlife such as Africa's endangered mountain gorillas, and the vast breadth of biodiversity thriving throughout the world's ecosystems greeted the dawn of 2000 away from the glaring eye of this project.

What has resulted is a work that delivers a glimpse into the splendor of natural Earth. If we do our part, perhaps images like the ones made for *Daybreak 2000* can be made during the first day of 3000 and beyond.

Roger Tefft, Project Director
January 2000

Galen Rowell

NIKON F100, 20MM F4 LENS, AT F/11, SHUTTER SPEED UNRECORDED, GRADUATED NEUTRAL DENSITY FILTER, FUJICHROME VELVIA FILM.

Dawn of a New Age

A new day dawns over placid South Pacific waters at Savusavu Bay, Fiji, just west of the International Dateline—the first day for the next 1,000 years on the Gregorian calendar in which years start with a "2." For hundreds of species of marine creatures beneath the surface, it's just another day where these waters, protected by a coral reef, registered 84 degrees Farenheit at dawn.

Savusavu Bay, Fiji

POSITION: 179°00'E, 17°00'S
TIME: 6:15 A.M.

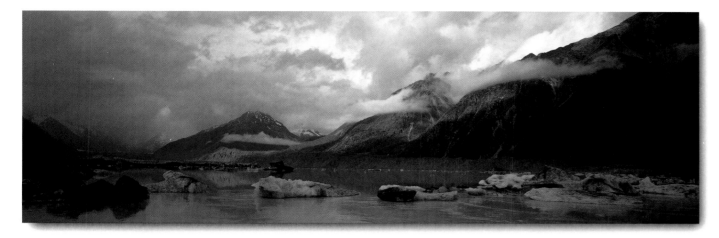

Geoff Mason
LINHOFF TECHNORAMA 6X17 CM,
90MM LENS, EXPOSURE UNRECORDED.

New Zealand

POSITION: 170°00'E, 44°00'S
TIME: 4:30 P.M.

Grand Glacier

Towering Tasman Glacier in Mt. Cook National Park is the source of New Zealand's Tasman River and Lake Pukaki, and represents one end of the geographical extremes in this nation of islands dispersed from the tropics to the antarctic zones. Known as the southern Alps, 12,283-foot Mt. Cook is the standout in this range. "The weather this day was unseasonably cold and wet. We had heavy snowfall to relatively low altitudes for several days."

Andris Apse
FUJICA GX617, 300MM LENS, F/11 AT 1/15 SEC.

New Zealand

POSITION: 170°00'E, 44°10'S
TIME: 10:15 A.M.

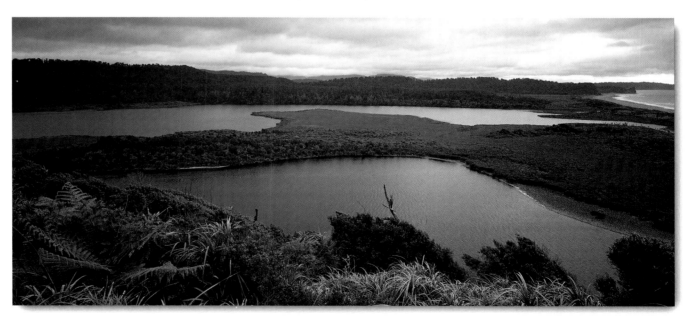

Lush Lagoon

Part of Westland National Park and listed as a World Heritage Area, Okarito Lagoon is a nature reserve that lies nestled along the central west coast of New Zealand's South Island. The area is home to the rare brown kiwi and more than 70 other bird species. Although the light on this day was gloomy, this area is a favorite of Andris. "This part of New Zealand is spectacular and has our very highest mountains, dense rain forests, and this huge lagoon."

11

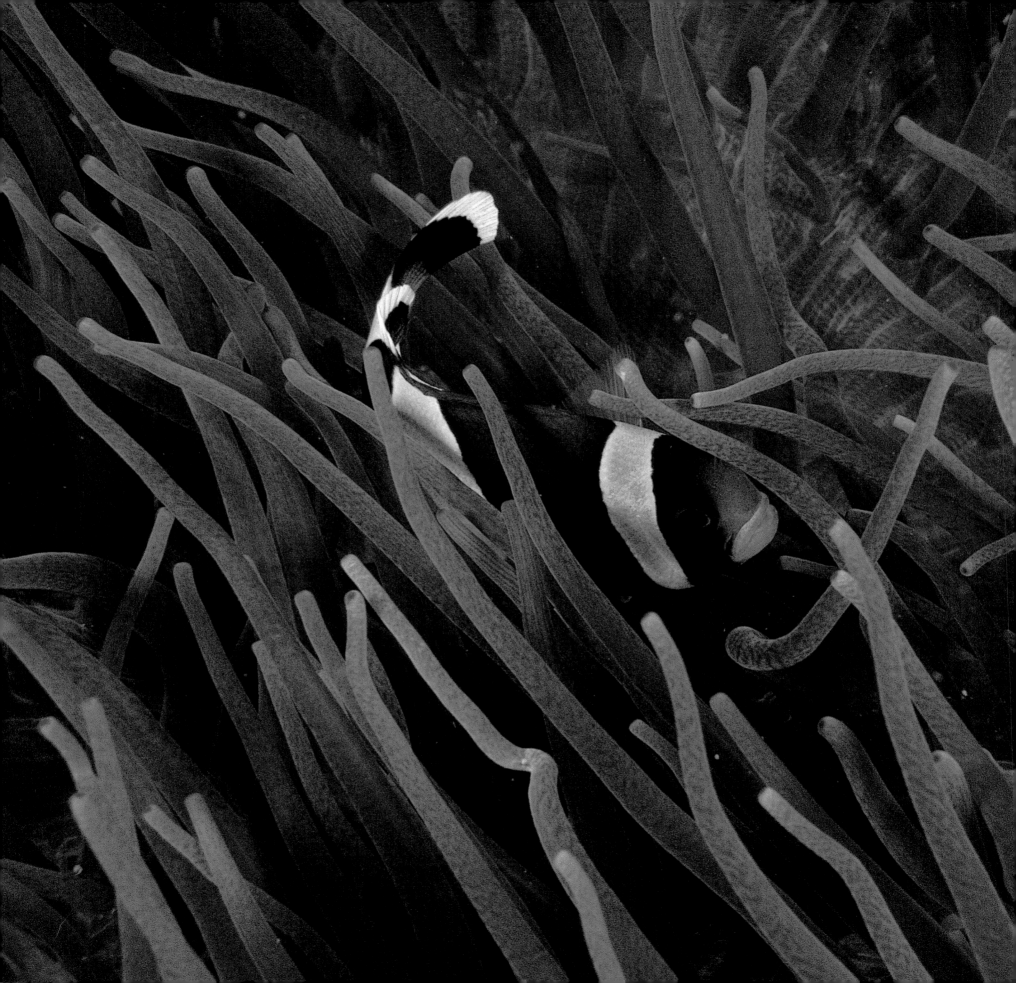

Mark Spencer

NIKON F4, 20MM NIKKOR LENS, F/5.6 AT 1/125 SEC., TWIN IKELITE SUBSTROBE 200 FLASH UNITS, FUJICHROME PROVIA F FILM.

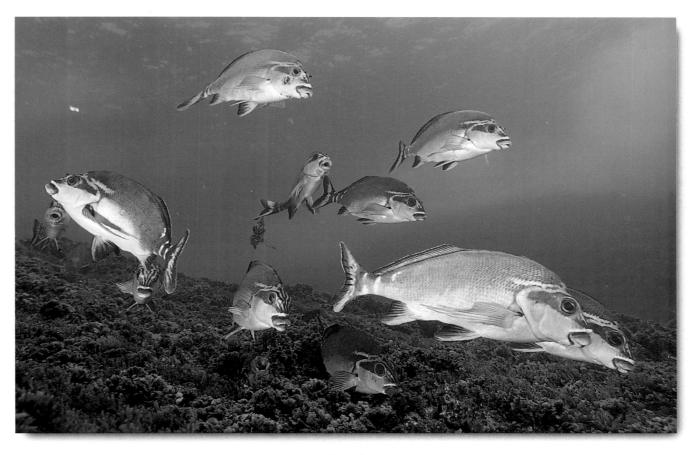

Australia

POSITION: 153°00'E, 30°00'S
TIME: 2:30 P.M.

Fish Refuge

A school of red morwong drift languidly at Australia's Solitary Island Marine Reserve on the northern coast of New South Wales, a spot where temperate and tropical marine animals alike congregate and coexist among a large variety of species. "Underwater photography imposes many restrictions, including the inability to change either lenses or film. Rather than matching the lens to the subject, I must search for subjects to match the lens. I dive with at least two complete camera systems, each sporting different lenses."

◀ Becca Saunders

NIKON F-801, 35-70MM ZOOM LENS, F/16 AT 1/125 SEC., TWIN IKELITE SUBSTROBE 200 FLASH UNITS, FUJICHROME VELVIA FILM PUSHED TO 100 ASA.

Stinging Critter-cism

An anemonefish hides among the protective forest of sea anemone tentacles at Anemone Bay in Australia's Solitary Island Marine Reserve. Becca, accompanied on this project by photographer Mark Spencer, braved rough seas and howling winds to get this shot. "We were the only divers prepared to brave the conditions. We're glad we did. Underwater was great."

Australia

POSITION: 153°00'E, 30°00'S
TIME: 1:00 P.M.

Leo Meier ▼

"LEO MEIER" PANORAMA CAMERA, 38MM F4 ZEISS BIOGON LENS, F/22 AT 2 SEC., FUJICHROME VELVIA FILM.

Australia

POSITION: 152°13'E, 31°35'S
TIME: 7:30 A.M.

A Strangler in Paradise

A strangler fig in Australia's Wilson River Reserve clutches a host plant and consumes it as it grows—in this case, the prey is an ancient brush box tree that had the misfortune of standing within the strangler's reach. "This rainforest is one of the few pockets of lowland rainforest remaining on the east coast of New South Wales." Leo captured this image with his signature design "Leo Meier" panorama camera.

Ken Duncan ▶

LINHOF 617IIIS, 72MM LENS, F/22 AT 15 SEC., FUJICHROME VELVIA FILM.

Australia

POSITION: 152°00'E, 30°00'S
TIME: 8:00 P.M.

A Long Day's End

Opportunities to appreciate nature are sometimes as close as a local beach or park, and may even include a surprise or two. It had already been a long night for Ken, who had organized and attended a New Year's celebration in Sydney, Australia, for an estimated 30,000 youths, but Ken was in the field at North Avoca Beach with his gear good to go by sunrise at 5:20 a.m. By day's end, he and his assistant had been drenched at least twice by waves, and his camera was soaked with saltwater.

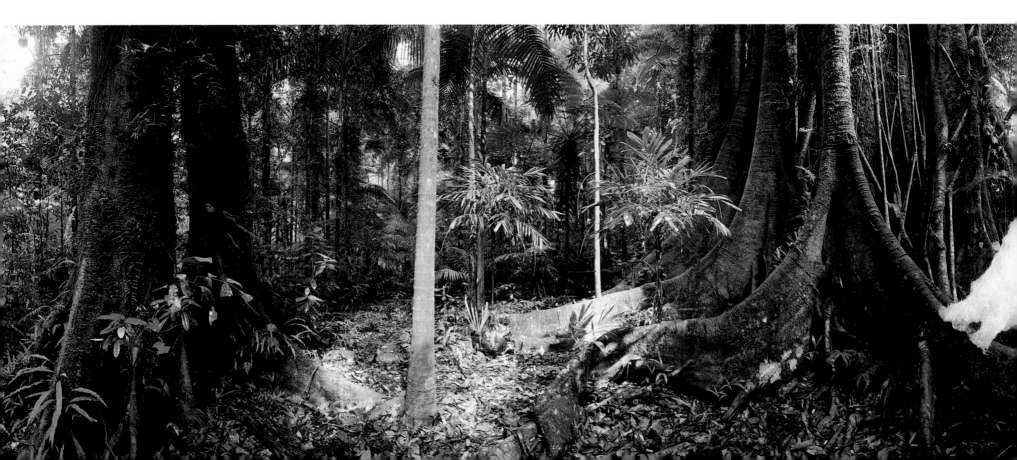

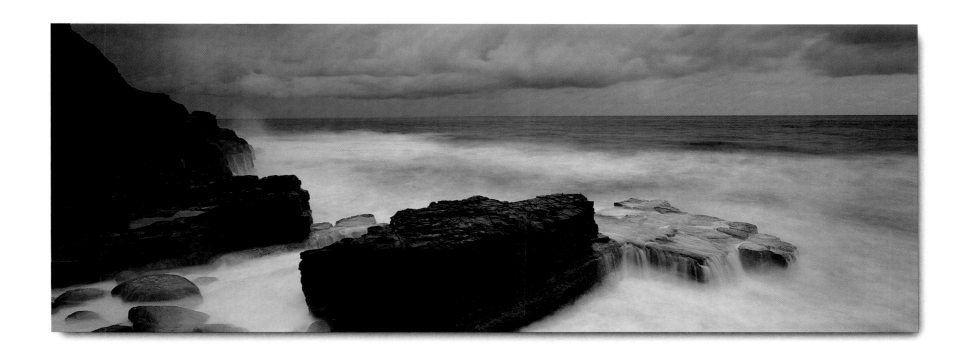

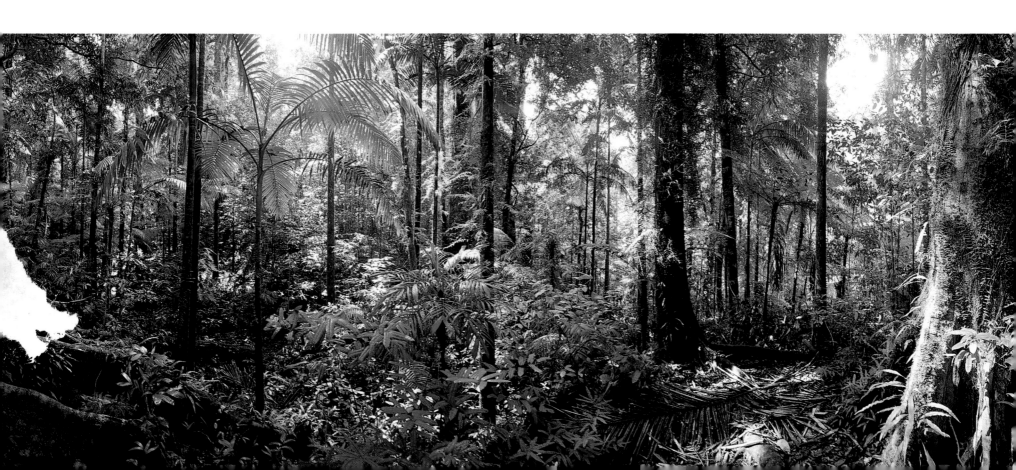

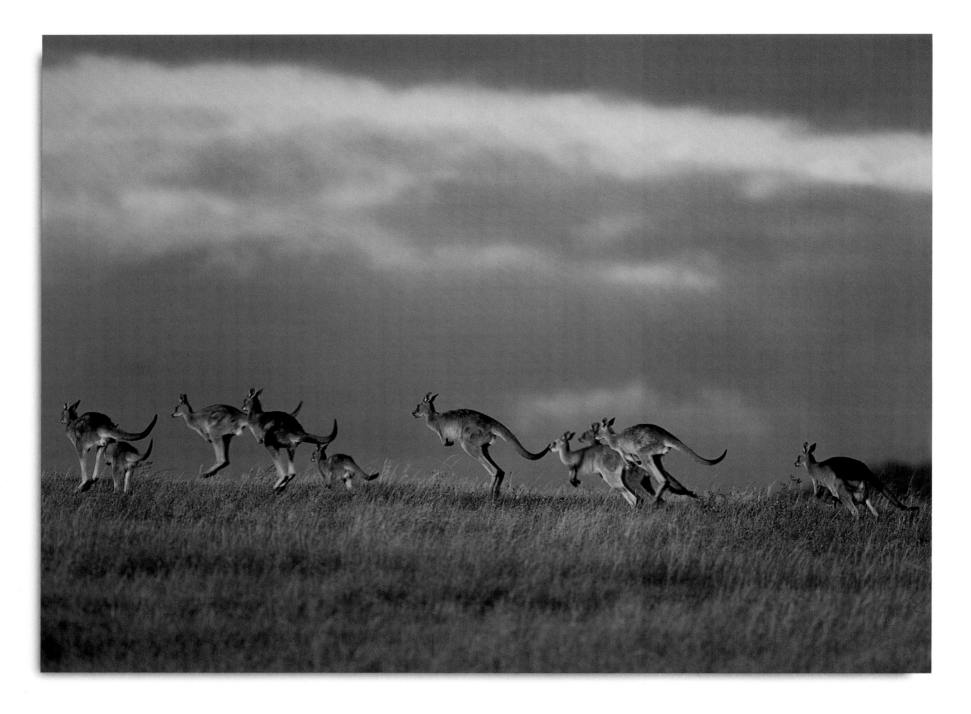

Andrew Henley

NIKON F100, NIKKOR AF-S 500MM F4 LENS WITH TC-14E 1.4X TELECONVERTER, F/8 AT 1/125 SEC.

Kangaroo Cavort

These eastern gray kangaroos, the largest of the kangaroo family, jump start their day on a brisk New Year's morning near Canberra. They spend most of the day resting in shade or shelter of trees and shrubs, moving out to graze and congregate in open country early in the morning or late afternoon. Andrew was shivering in the cool breeze, but he steadied his camera well enough to capture this action shot.

Australia

POSITION: 149°00'E, 35°00'S
TIME: 6:00 A.M.

Theo Allofs

NIKON F5, 600MM F/4 D ED-IF AF-S NIKKOR, FILL FLASH WITH TELE FLASHEXTENDER, EXPOSURE UNRECORDED.

Australia

POSITION: 148°00'E, 28°00'S
TIME: 6:15 A.M.

Hang Out

A group of little red flying foxes clings to a branch in southern Queensland, Australia, following their return at the end of the night from feeding grounds several kilometers away. "Flying foxes are the best known of the fruit bats in Australia, and the largest of all bats. I was very fortunate to encounter favorable light on January 1, which could not be taken for granted, as the rainy season was approaching."

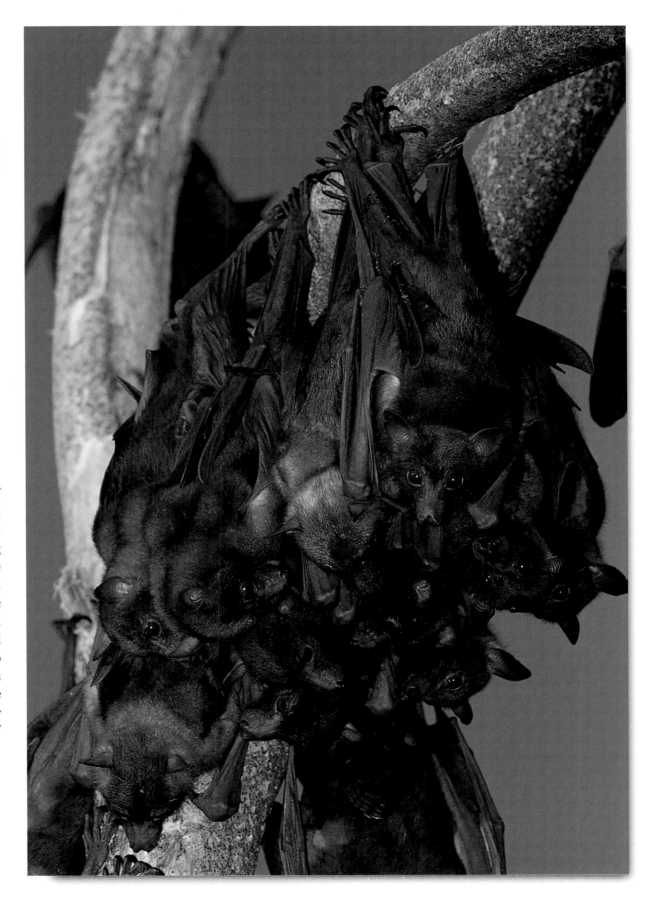

17

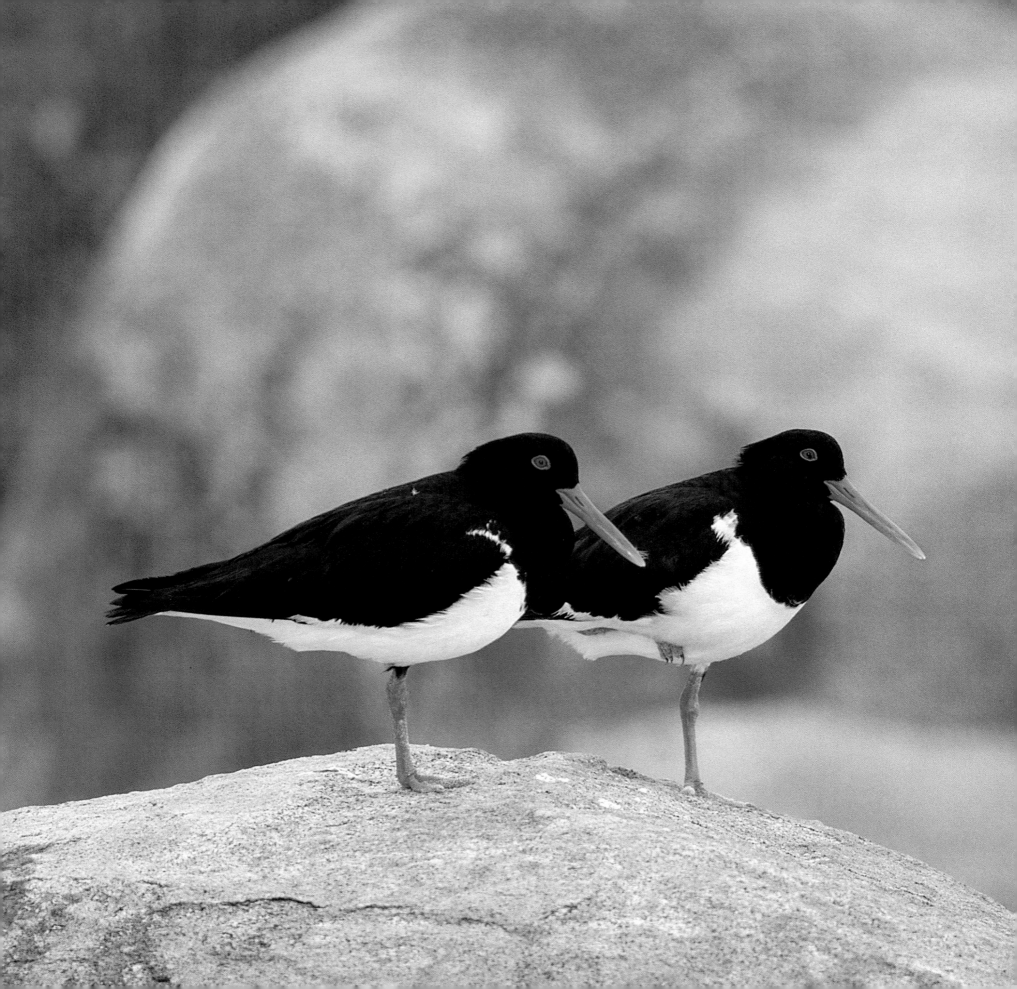

Karen Lee Gowlett-Holmes

CANON EOS5, 28-135MM IS USM LENS (AT ABOUT 50MM), F/4.5 AT 1/125 SEC., FUJICHROME PROVIA 100F FILM.

Australia

POSITION: 147°59'E, 42°58'S
TIME: 11:30 A.M.

Rugged Beauty

Swells crash against The Pyramid, a granite pinnacle in Deep Glen Bay, Forestier Peninsula, Tasmania. With conditions unsuitable for diving, Karen focused instead on this local landmark, maintaining her balance offshore in a 20-foot skiff that pitched heavily with each wave set. "Dawn was a non-event on New Year's Day—the cloud cover was so thick, we did not see the sun until 2:00 p.m. This area of Tasmania has a magic all its own, rugged and untouched—I love it."

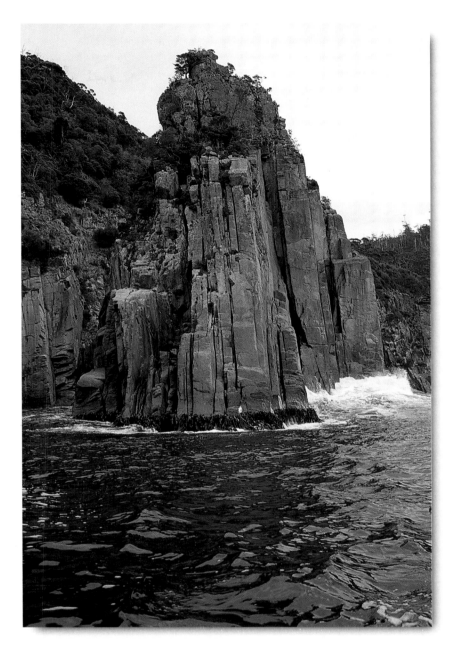

◀ Oriol Alamany

CANON EOS 3, 500MM 4.5 LENS WITH 1.4X TELECONVERTER, F/6.7 AT 1/125 SEC., CANON 550 EX FLASH AND TELEFLASH ATTACHMENT, FUJICHROME SENSIA II 100 FILM.

Standing Watch

A pair of pied oystercatchers stand on a rock overlooking the beach at St. Helens Point State Recreation Area on the northeast coast of Tasmania, Australia. They are keeping an eye on Oriol as he walks along shore photographing them from various angles. The birds inhabit wild coasts around the world, including Spain, Oriol's home.

Australia

POSITION: 148°00'E, 41°00'S
TIME: 1:00 P.M.

19

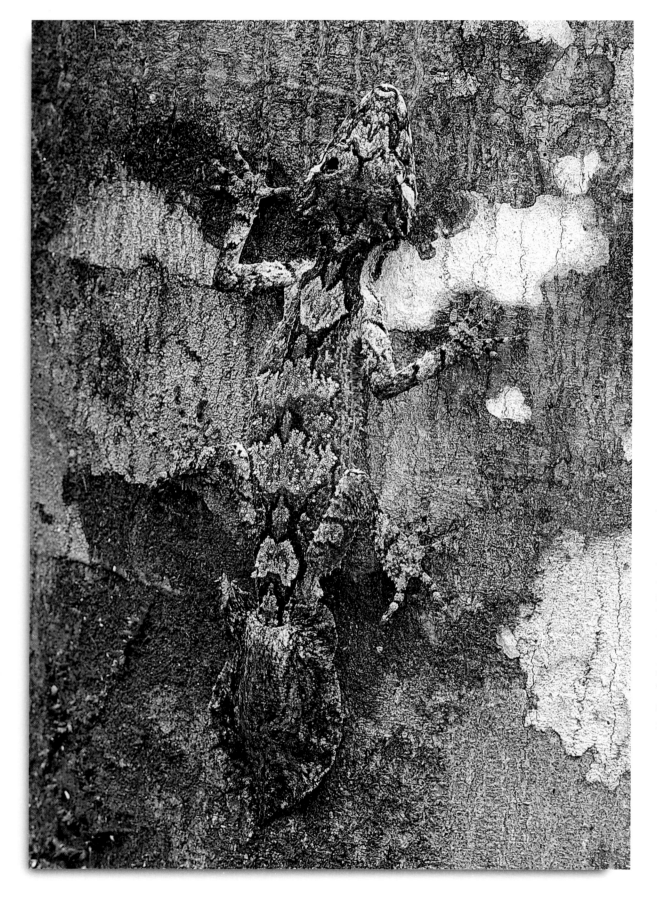

Michael and
Patricia Fogden

NIKON F4, 105MM MACRO LENS, F/22 AT
1 SECOND WITH A SINGLE BURST OF FILL FLASH.

Australia

POSITION: 145°00'E, 20°00'S
TIME: 5:30 P.M.

Good Luck Gecko

A northern leaf-tailed gecko is
nearly invisible with its camouflage
mimicking the texture and
markings of this tree trunk.
Michael and Patricia found this
specimen in Australia's North
World Heritage Tropical Rain
Forest, in Kuranda State Forest.
"We did not have time to scout
locations for scenics—our itinerary
was arranged—however, we had
some luck finding animals,
including this gecko."

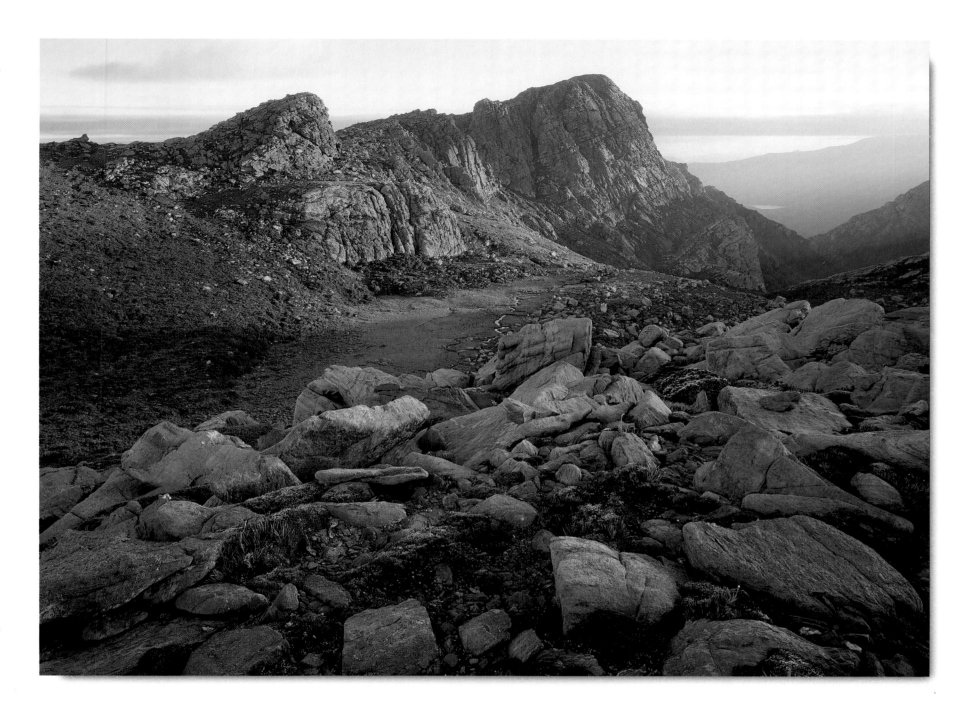

Chris Bell

Australia

POSITION: 146°15'E, 43°10'S
TIME: 6:08 A.M.

LINHOF TECHNIKARDAN 4X5, NIKKOR 65MM WIDE-ANGLE LENS, F/22.5 AT 1 SEC., FUJICHROME PROVIA FILM.

Daybreak in the Back Country

A cloudy sunrise breaks in World Heritage Southwest National Park, the largest wilderness park in Tasmania, Australia. The park features a 10-mile-long quartzite range dotted with dozens of lakes and classic morainal formations popular among hikers. Chris hiked 20 miles to reach this spot.

21

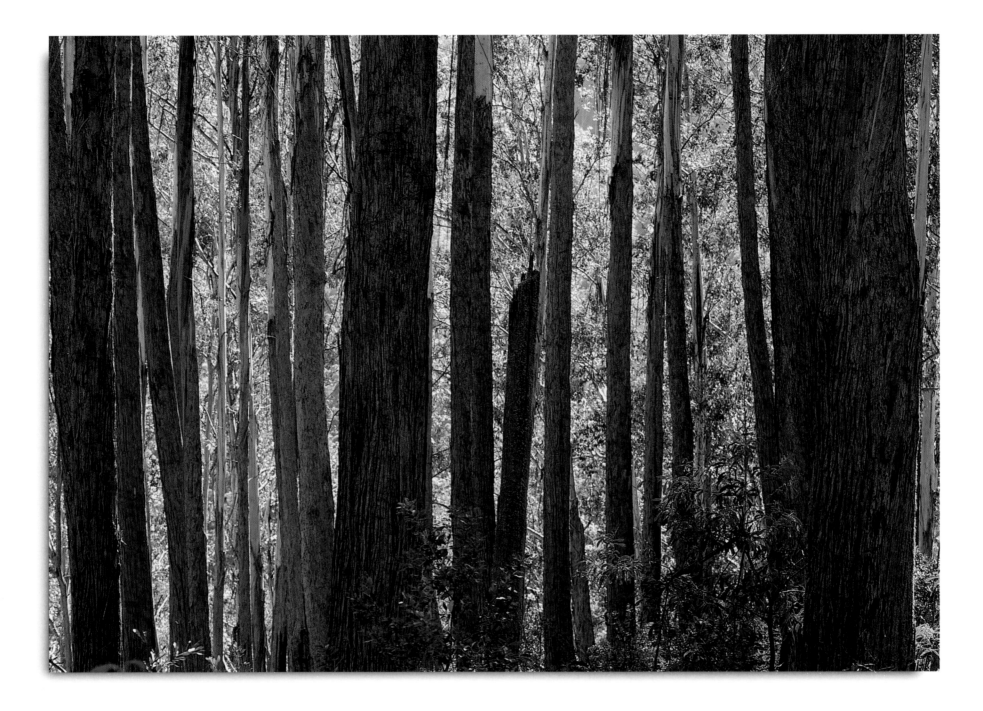

Bill Bachman

BRONICA ETRSI, 150MM LENS WITH 81A FILTER, F/11, FUJICHROME VELVIA FILM.

Placid Place

Sunlight illuminates a grove of mountain ash, flanking the Delatite River—at Mt. Buller, Alpine National Park, in northeast Victoria, Australia. "Very little has changed in the many years I have appreciated this river's banks.

Australia

POSITION: 146°00'E, 36°00'S
TIME: 8:30 A.M.

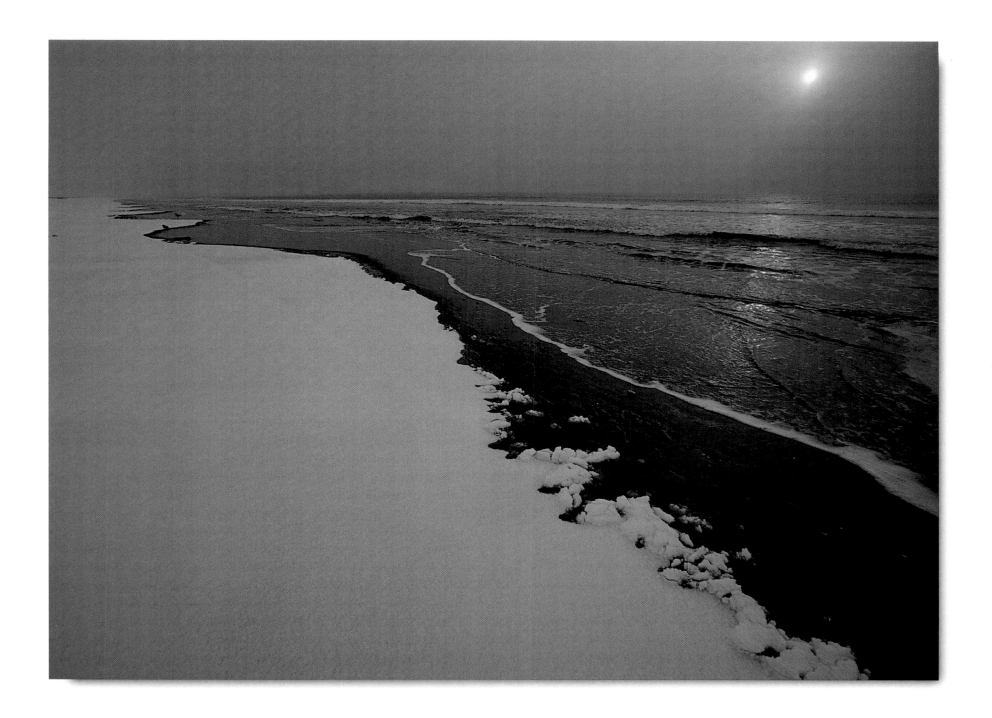

Japan

POSITION: 145°35'E, 43°20'N
TIME: 7:00 A.M.

Toshinobu Takeuchi

MINOLTA, 17-35MM WIDE-ANGLE F2.8 LENS, ONE-THIRD STOP OVER THE IN-CAMERA
METERED APERTURE SETTING AT 1/60 SEC., KODAK E100VS FILM.

Rising Sun

Dense fog along a wintry seashore shrouds the sunrise in Nemuro City, Japan,
the first landfall to receive daylight in Japan.

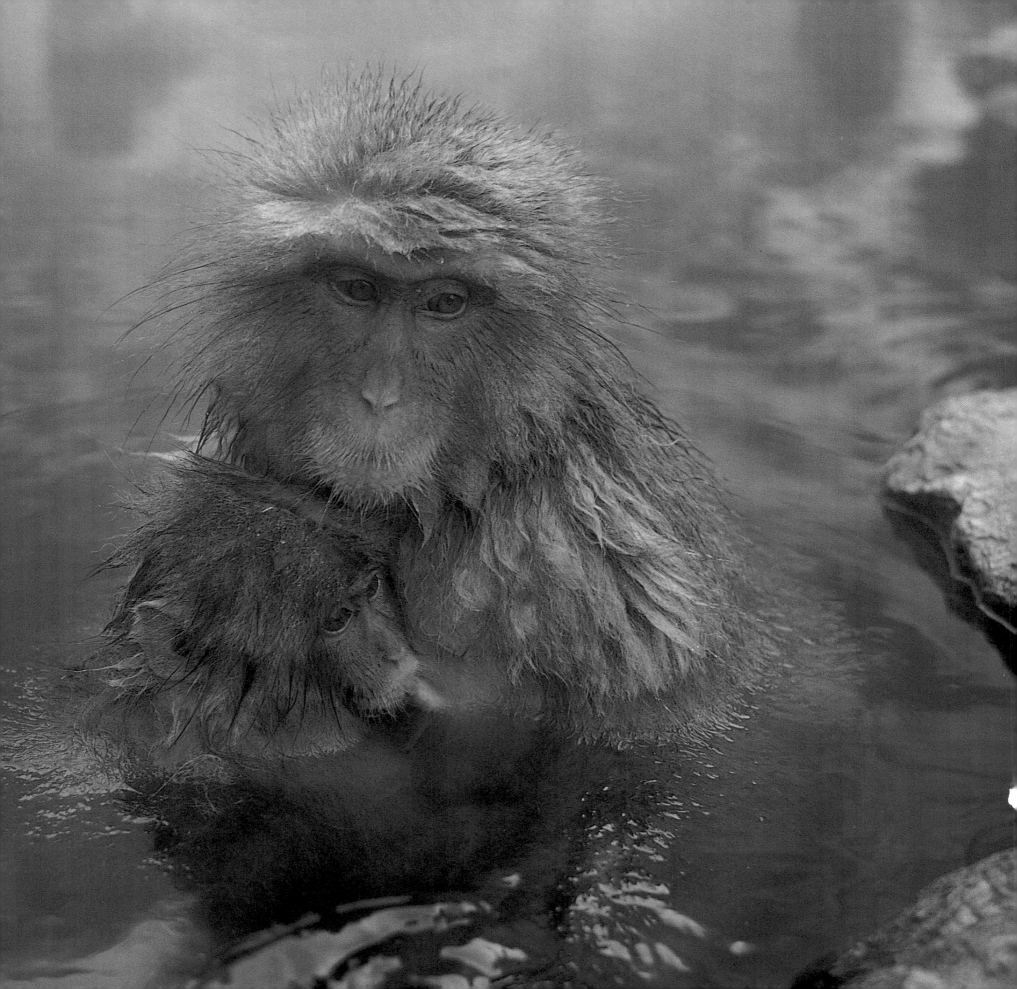

Jean-Paul Ferrero
35MM CAMERA, 24MM 2.8 LENS AT F/16, 1/15 SEC.

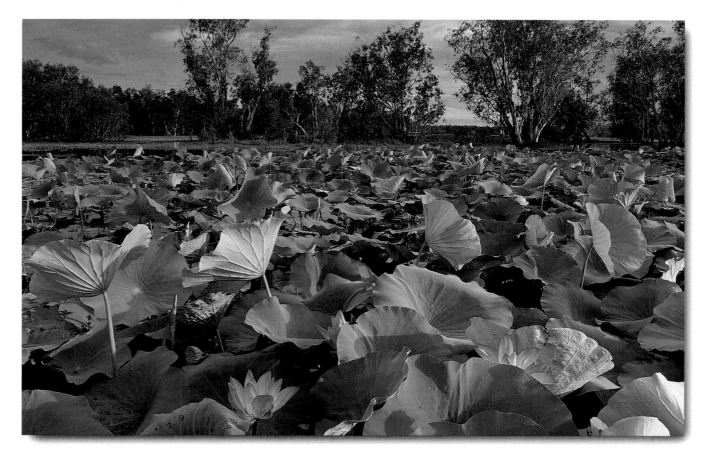

Australia

POSITION: 132°00'E, 3°00'S
TIME: 7:20 A.M.

Wild Wetlands

Red lotus and paperbark trees decorate the South Alligator River at Yellow Water in Australia's Kakadu National Park, Northern Territory, as seen here by Jean-Paul while photographing from a boat—with high gunwales to keep crocodiles at bay. The park encompasses virtually all of the river's drainage basin where it meets the Timor Sea at the country's top end.

◄ Mark Edward Harris
NIKON N90S, 50MM LENS, F/4 AT 1/25 SEC.

Fleeting Light

Japanese macaques, or snow monkeys in Jigokudani ("hell valley") Joshinetsu Plateau National Park, Japan, congregate in baths fed by natural hot springs. After ringing in the New Year in Tokyo, Mark sped to this mountainous park to create this portrait before the light, and his subjects, vanished. "The troop comes down to frolic in the baths until late afternoon when they race back up the slopes, like it's quitting time."

Japan

POSITION: 139°00'E, 36°30'N
TIME: 3:45 P.M.

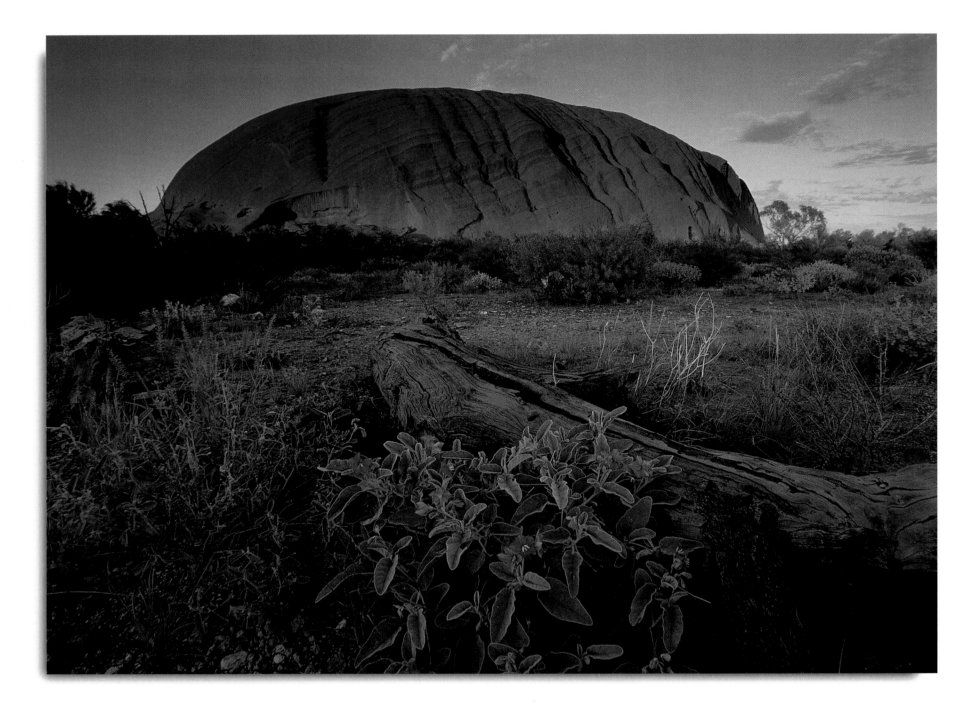

Art Wolfe

CANON EOS 3, 17-35MM WIDE-ANGLE LENS WITH A TWO-STOP GRADUATED NEUTRAL DENSITY FILTER, F/16 AT 1 SEC., FUJICHROME VELVIA FILM.

The Rock

Uluru Rock, formerly known as Ayers Rock, is a giant sandstone monolith that rises more than 1,000 feet above the sand plain of central Australia. Restored to Aboriginal rule in 1985, Uluru is an important natural and cultural icon, a sacred place to the desert people, and the largest monolith on Earth.

Australia

POSITION: 131°02'E, 25°20'S
TIME: 6:10 A.M.

Gavriel Jecan

CANON EOS 3, 17-35MM WIDE-ANGLE LENS,
F/16 AT 1/8 SEC., FUJICHROME VELVIA FILM.

Australia

POSITION: 131°02'E, 25°20'S
TIME: 8:00 A.M.

Life-saving Well

A natural basin that collects rainwater, this pool at the base of Uluru Rock was a life-saving water source for thousands of years for the desert-dwelling Aboriginal people in central Australia.

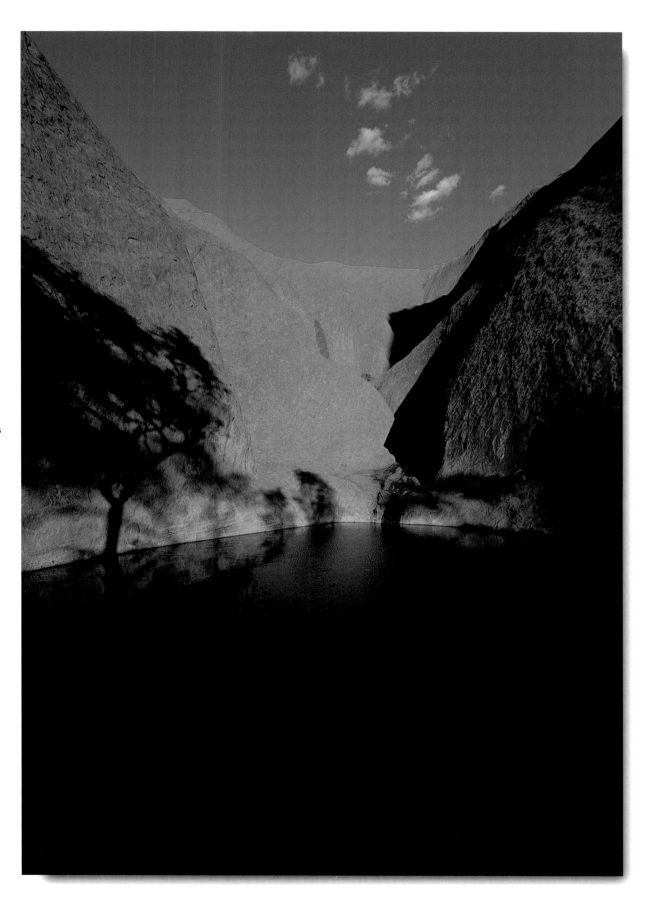

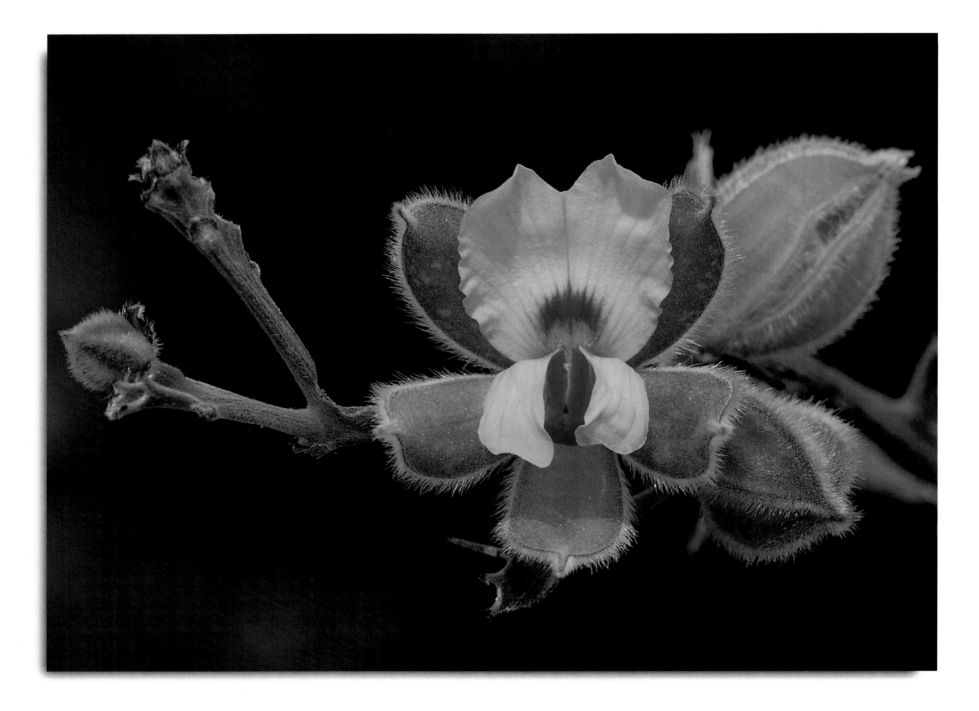

Jiri Lochman

NIKON F-100, 200MM MICRO NIKKOR LENS, EXPOSURE UNRECORDED.

Summer Bloomer

A pea flower endemic to the countryside in Dryandra Forest, east of Perth, is representative of wildflowers that bloom in southwestern Australia. "Although I originally hoped to bring back pictures of a very special, but extremely rare marsupial, I would have needed to spend most of the day trying to find it and would have quite likely ended up without any pictures at all. I was also lucky, as there were some late rains east of Perth, so a lot of wildflowers were still in bloom."

Australia

POSITION: 116°55'E, 32°47'S
TIME: 11:25 A.M.

Michel Gotin

CANON EOS 1N, 70-200MM ZOOM,
F/5.6 AT 1/125 SEC.

China

POSITION: 116°30'E, 31°00'N
TIME: 12:10 P.M.

Chinese Mountain Retreat

The Huangshan Mountains lie in southeast Anhui province, China. Difficult to reach and criss-crossed by narrow, steep paths, their peaks and the pines that grow on them are constantly clouded. In 1990, the United Nations added them to the World Heritage List of the planet's natural treasures.

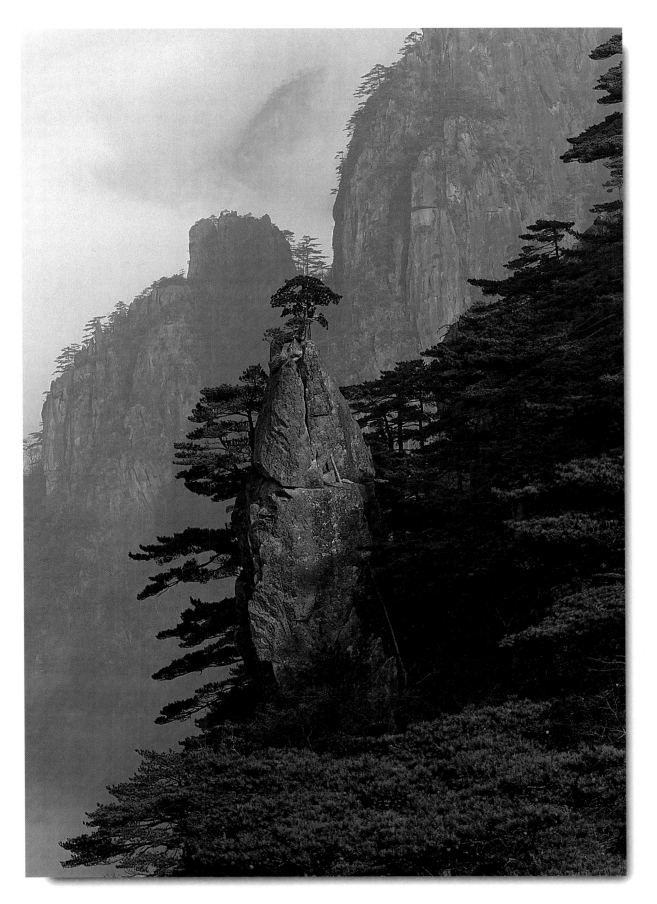

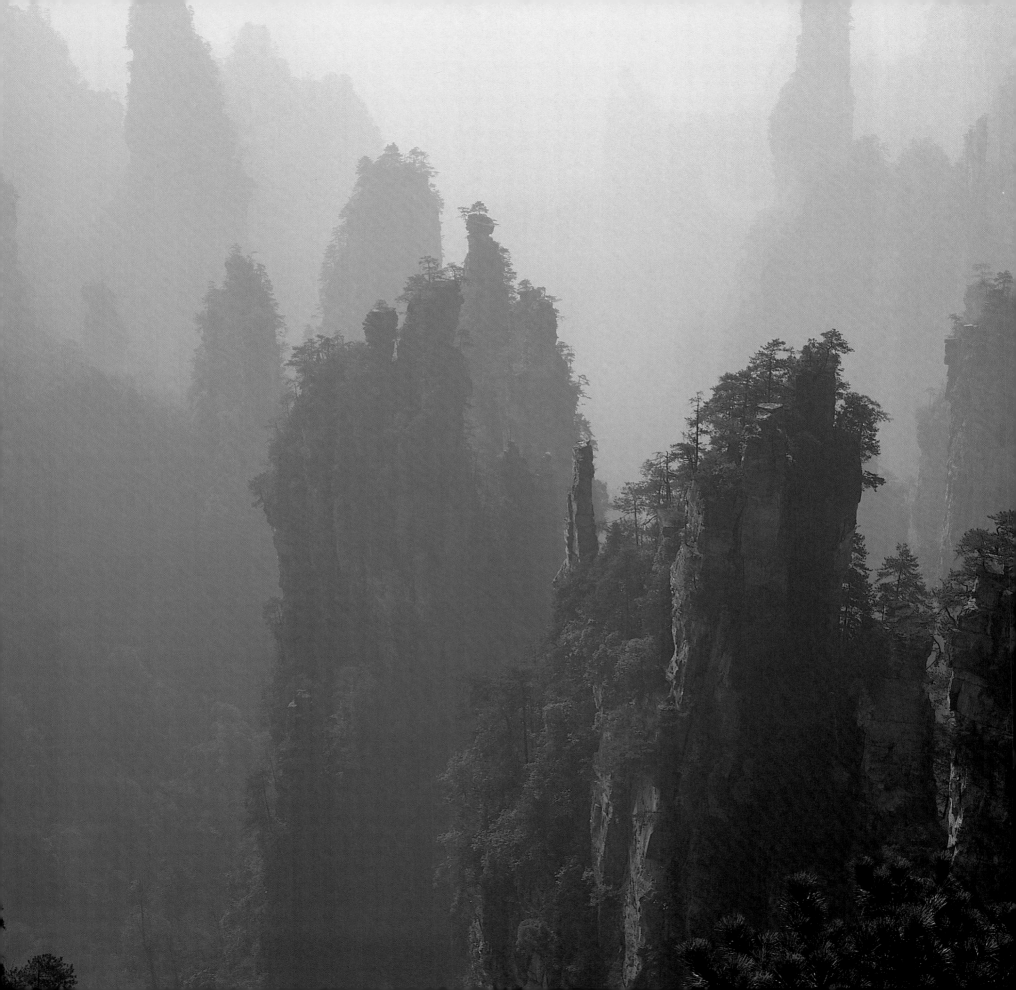

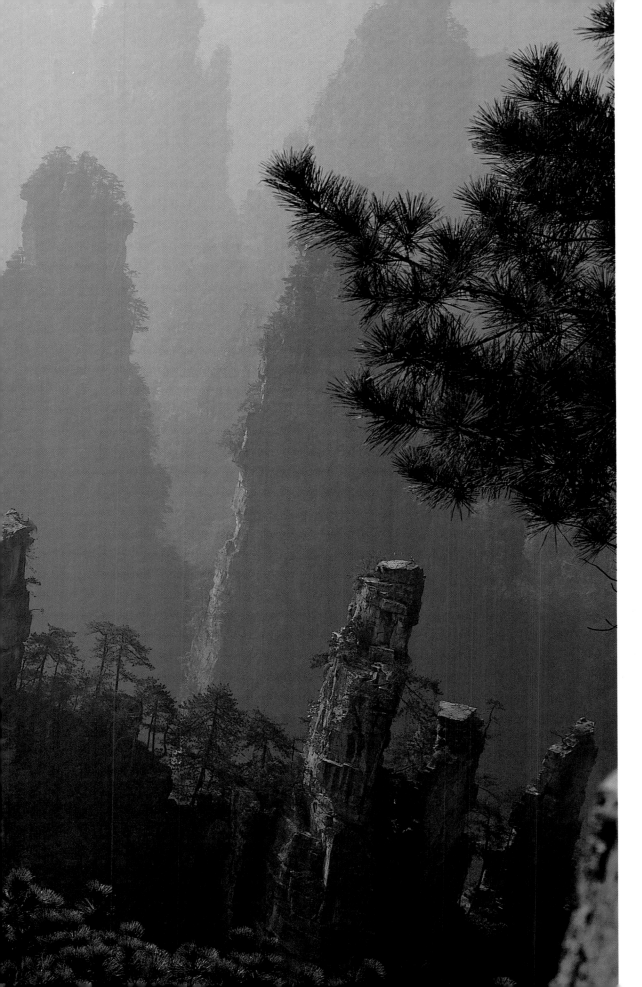

King Wu

FUJICA G690 MEDIUM FORMAT, 65MM LENS,
F/16 AT 1/30 SEC.

China

POSITION: 110°00'E, 30°00'N
TIME: 9:20 A.M.

Mountain Mist

In the northwest of China's Hunan province, Zhangjiajie National Forest Park covers 80 square miles (130 square kilometers), the largest national park of China, created in 1982. "Due to the cloudy morning, there were no sunrise photos captured, but the sun came out at 8:45 and I shot from 9 a.m. until 4:30 p.m."

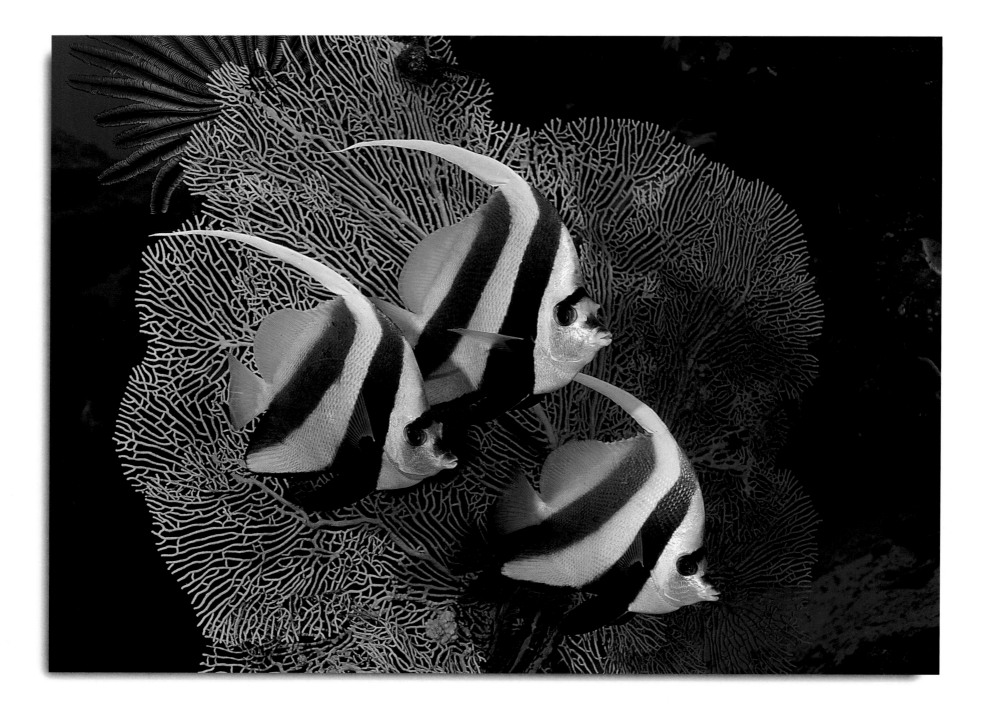

Mark Strickland

NIKON F-4 CAMERA, MICRO NIKKOR 60 LENS IN AN AQUATICA HOUSING WITH TWIN IKELITE
50 SUBSTROBE FLASH UNITS, F/8 AT 1/30 SEC., FUJICHROME VELVIA FILM.

Banner Day

Bannerfish are among the spectacular species of tropical fish found in Similan Islands Marine National Park, in the Andaman Sea off the west coast of Thailand. "Coral reefs worldwide are threatened by pollution, overfishing, development, siltation, and other factors, making marine sanctuaries increasingly important."

Thailand

POSITION: 97°39'E, 8°40'N
TIME: 3:00 P.M.

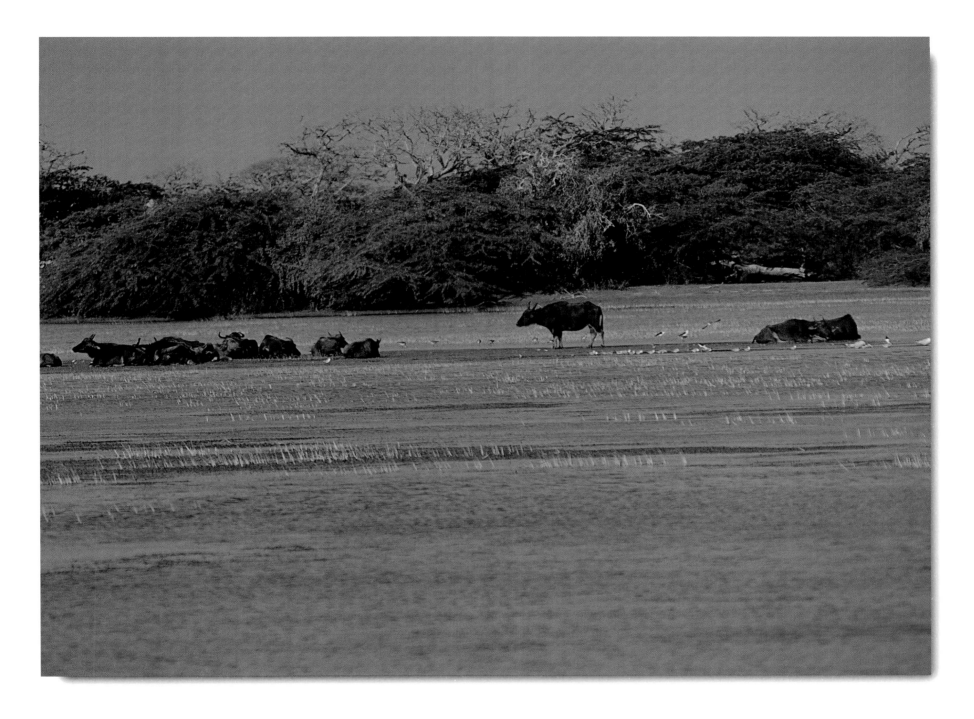

Sri Lanka

POSITION: 81°00'E, 8°00'N
TIME: 9:10 A.M.

Hans Dossenbach
NIKON F5, 400MM NIKKOR LENS, APERTURE AND SHUTTER SPEED UNRECORDED,
KODAK EKTACHROME V100VS FILM.

Lone Standout

A lone water buffalo stands in the mid-morning light in Bundala National Park in southeast Sri Lanka. Hans and his wife Monika both photographed numerous animals during the first few hours of light on January 1, including gray langur monkeys, a Eurasian spoonbill, a yellow bittern, a blue eared kingfisher, a gray heron, a land monitor lizard, a painted stork, and a little green bee-eater.

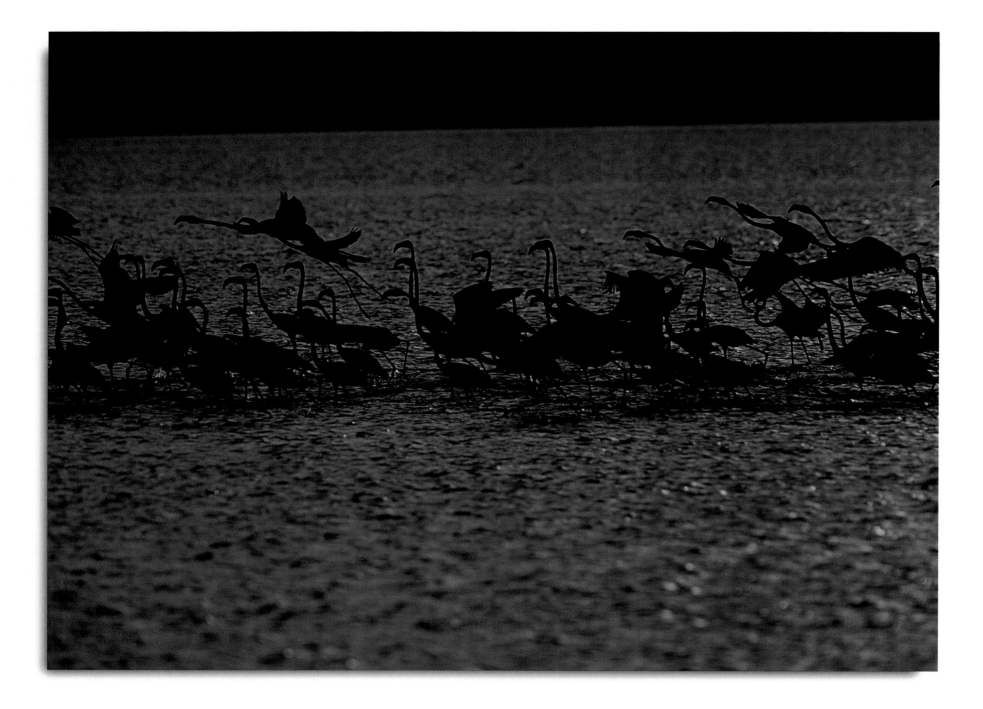

Monika Dossenbach

NIKON F5, 600MM NIKKOR LENS, APERTURE AND SHUTTER SPEED UNRECORDED, KODAK EKTACHROME V100VS FILM.

Flamingoes "Afire"

Sunrise glistens on the water at Bundala National Park, Sri Lanka, creating a silhouette of a flock of greater flamingoes wading and taking wing.

Sri Lanka

POSITION: 81°00'E, 8°00'N
TIME: 6:40 A.M.

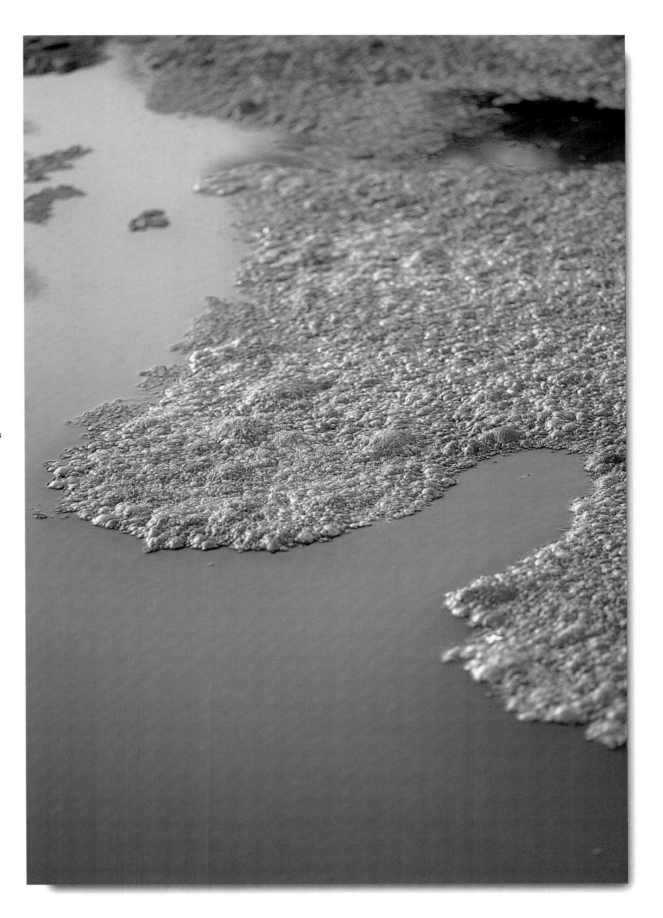

Jagdish Agarwal

MAMIYA RB 67, 250MM 4.5 WITH A POLARIZER,
F/11 AT 1 SEC.

India

POSITION: 73°00'E, 19°00'N
TIME: 5:00 P.M.

Green Sheen

Vibrant algae stands in
Mahim Nature Park,
in Bombay, India, which is
known for its mangroves.

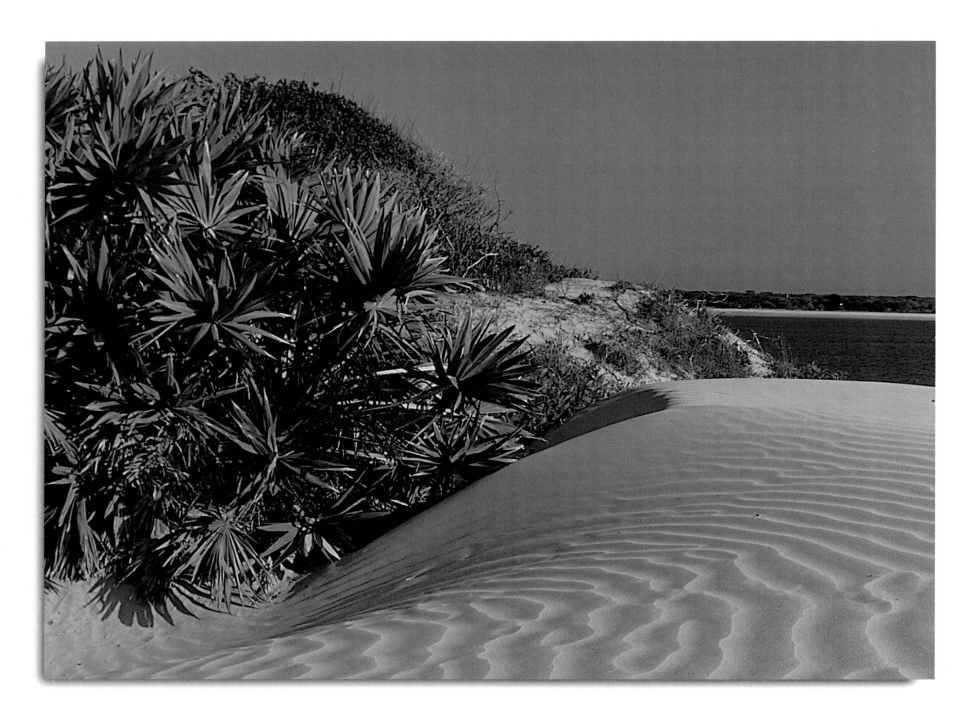

Karl Ammann
NIKON F5, EXPOSURE UNRECORDED, FUJICHROME VELVIA FILM.

Serene Sandscape
Lamu island off the coast of Kenya features picturesque sand dunes.

Kenya

POSITION: 40°00'E, 2°00'S
TIME: 5:00 P.M.

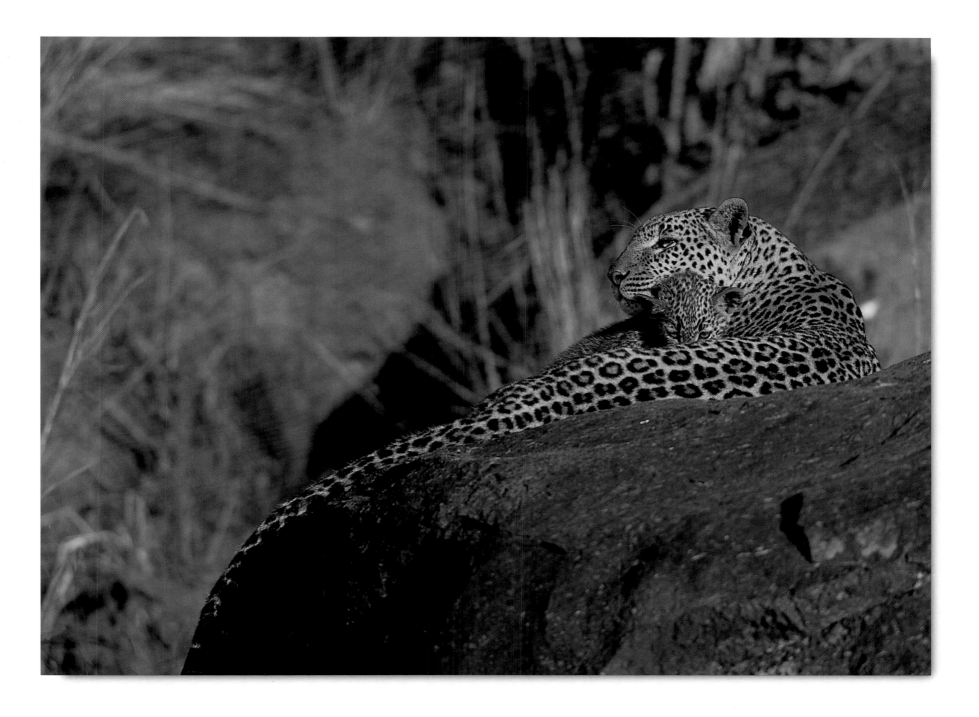

Joe McDonald
CANON EOS 3, 400MM IS LENS WITH A 1.4X TELECONVERTER, F/6.3 AT 1/500 SEC.,
FUJICHROME PROVIA F FILM.

Kenya

POSITION: 37°00'E, 0°00'N
TIME: 7:10 A.M.

Cats Cuddle

A leopard in Kenya's Masaï-Mara Game Reserve suns herself in morning light as one of her four-month-old cubs nuzzles against her fur and the other plays in the bush nearby. "In the predawn darkness we staked out a spot where we hoped the leopard would be. Fortunately, shortly after sunrise the leopard appeared, went to this rock, and her two cubs followed close behind."

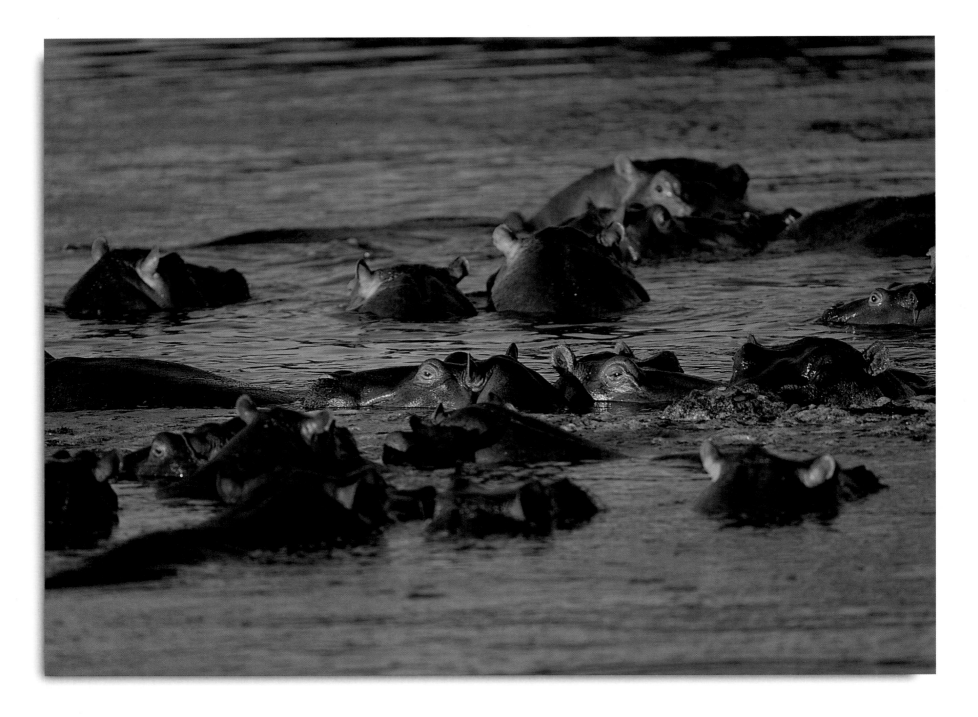

Wayne Lynch
NIKON N90X, NIKKOR 80-200MM 2.8 ZOOM, EXPOSURE UNRECORDED, FUJICHROME VELVIA FILM.

Hippo Heaven

Hippopotamus herds are found in and near the rivers, lakes, and other water holes of Africa, and are adept at remaining below the surface for long periods. Wayne found this group swimming near the center of Serengeti National Park, Tanzania.

Tanzania

POSITION: 34°45'E, 2°30'S
TIME: 7:00 A.M.

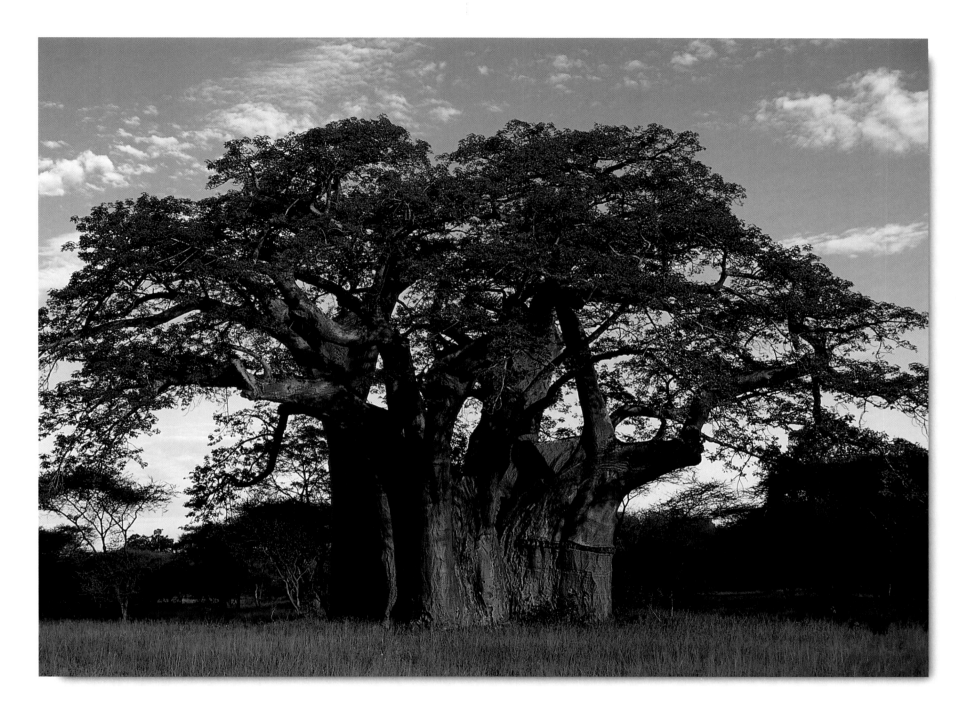

Darrel C. H. Plowes

Zimbabwe

OLYMPUS OM4, OLYMPUS ZUIKO 35-70MM ZOOM LENS (AT 35MM) WITH A POLARIZING FILTER, EXPOSURE UNRECORDED, FUJICHROME VELVIA FILM.

POSITION: 32°17'E, 20°24'S
TIME: 5:15 P.M.

Big Baobab

Baobabs are multipurpose trees, offering nooks for birds to nest and basins to catch rain water if the trunks have hollowed. "This is probably the largest specimen in Zimbabwe, and is about 40 feet [12 meters] across at its greatest diameter. It is possibly in excess of 4,000 years old." After his plans for morning photography were washed away in a heavy downpour, Darrel persevered, creating this image 115 miles (185 kilometers) south of Mutare, Zimbabwe.

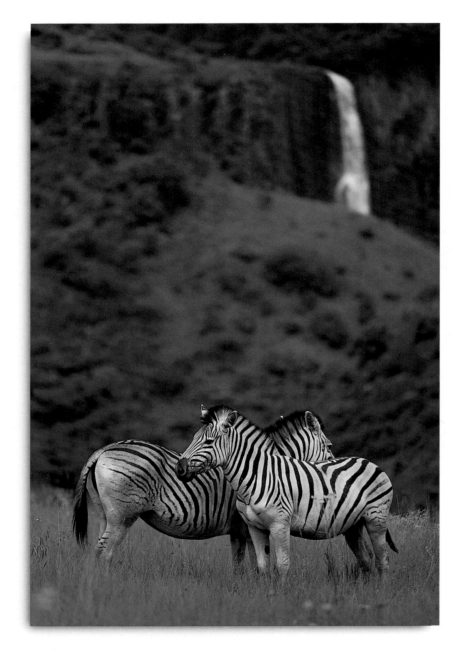

Nigel Dennis

CANON EOS 1N, 70-200MM 2.8L ZOOM,
F/2.8 AT 1/125 SEC.

South Africa

POSITION: 30°00'E, 30°00'S
TIME: 10:00 A.M.

Zooming Out for Zebras

A pair of Burchell's zebras stand in
a pasture in view of Howick Falls,
Umgeni Valley Nature Reserve,
Kwa Zulu Natal, South Africa.

South Africa

POSITION: 28°57'E, 28°42'S
TIME: 10:00 A.M.

Roger de la Harpe ▶

CANON EOS-3, 100-400MM CANON IS ZOOM AT 400MM, F/5.6 AT 1/60 SEC.

Primate Portrait

A baboon gazes about the lush savanna of Royal Natal National Park, South Africa.
Widespread throughout southern Africa, baboons usually live in troops of 30 to 40,
and they become active well after dawn. "They're very entertaining animals.
One can spend many hours watching their antics."

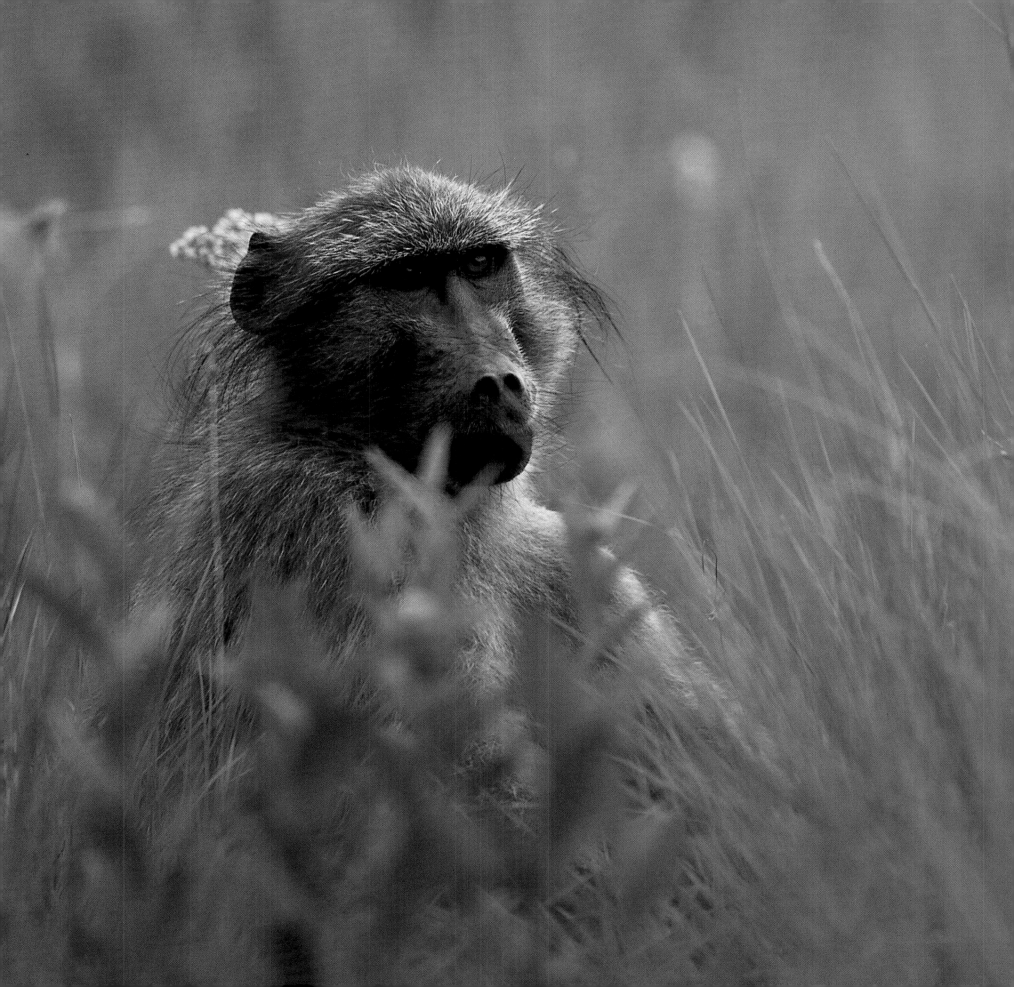

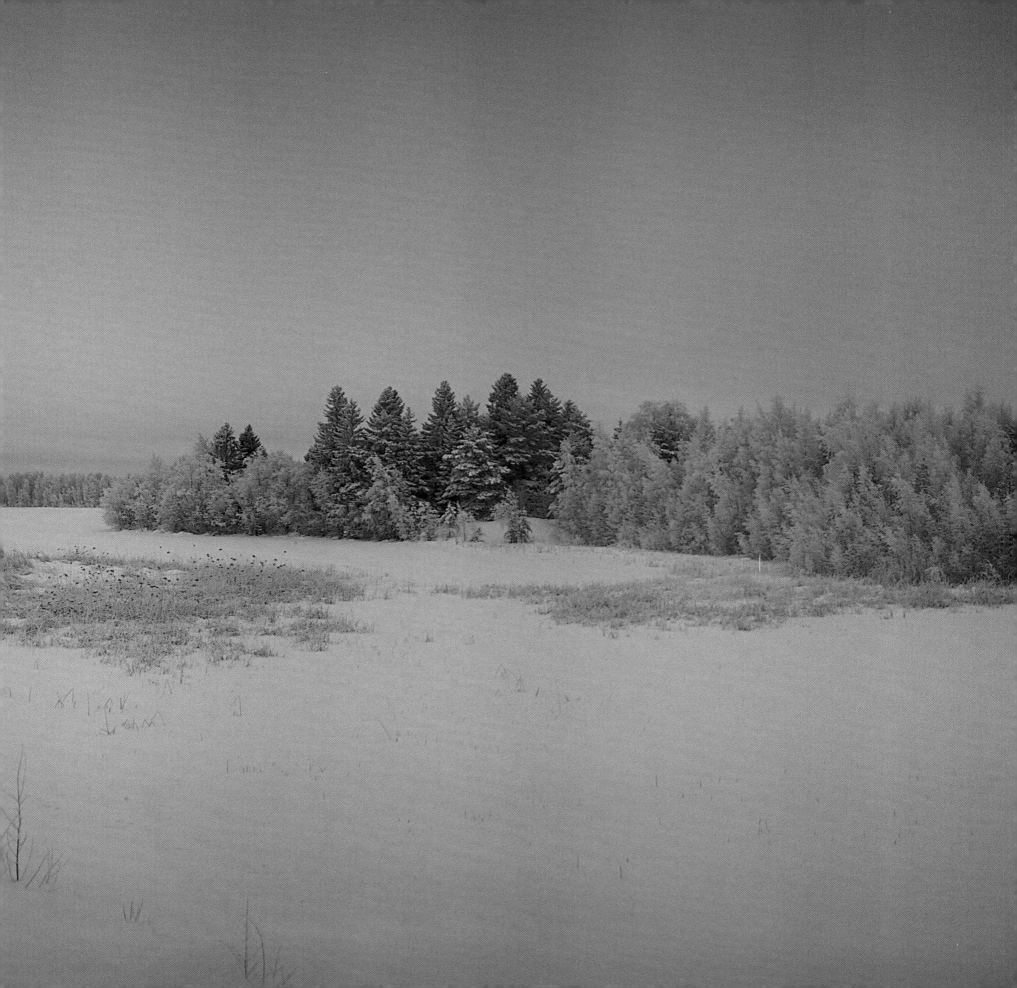

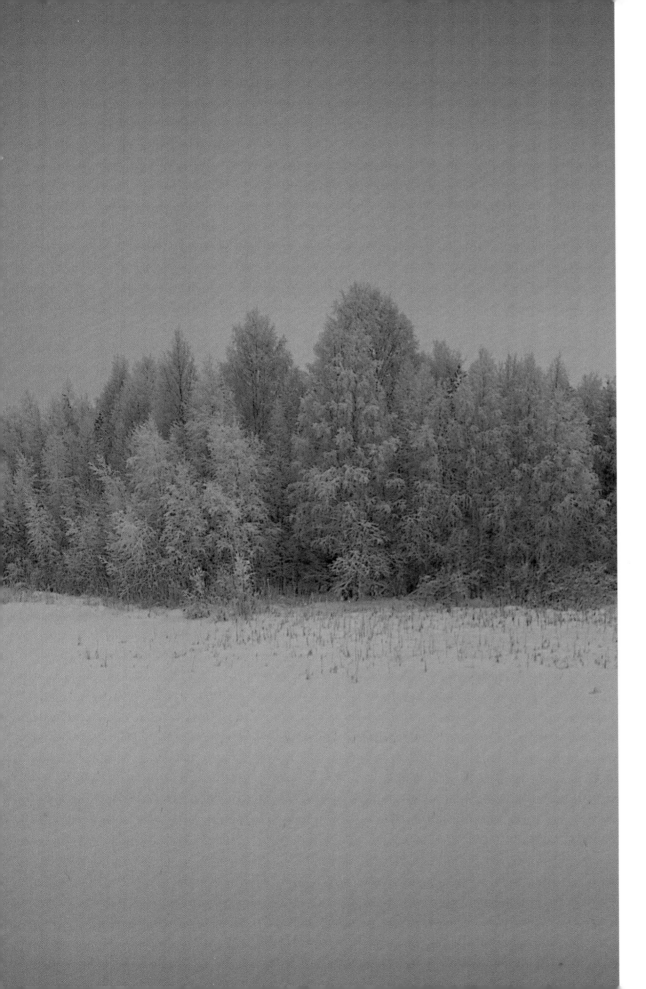

Rainer K. Lampinen

TECHNOPAN CAMERA WITH 28MM HYPERFOCAL
LENS, F/4.5 AT 1/125 SEC., FUJICHROME PROVIA
100F PROCESSED AS E-9 FILM.

Finland

POSITION: 24°00'E, 61°00'N
TIME: 10:57 A.M.

Finland Freeze
The landscape near Vesilahti,
Finland, lies about 40 kilometers
below Tampere and is south far
enough to see the sun on a clear
winter day. By contrast, the sun is
not visible at Utsjoki, in northern
Finland, for about six weeks from
late November to mid-January.
Nearby Lake Arajärvi features
rock formations created by the
pressure of moving ice some
10,000 years ago, about the time
the traditional Finnic calendar was
adopted. "2000 is now the year
10,209 by that system."

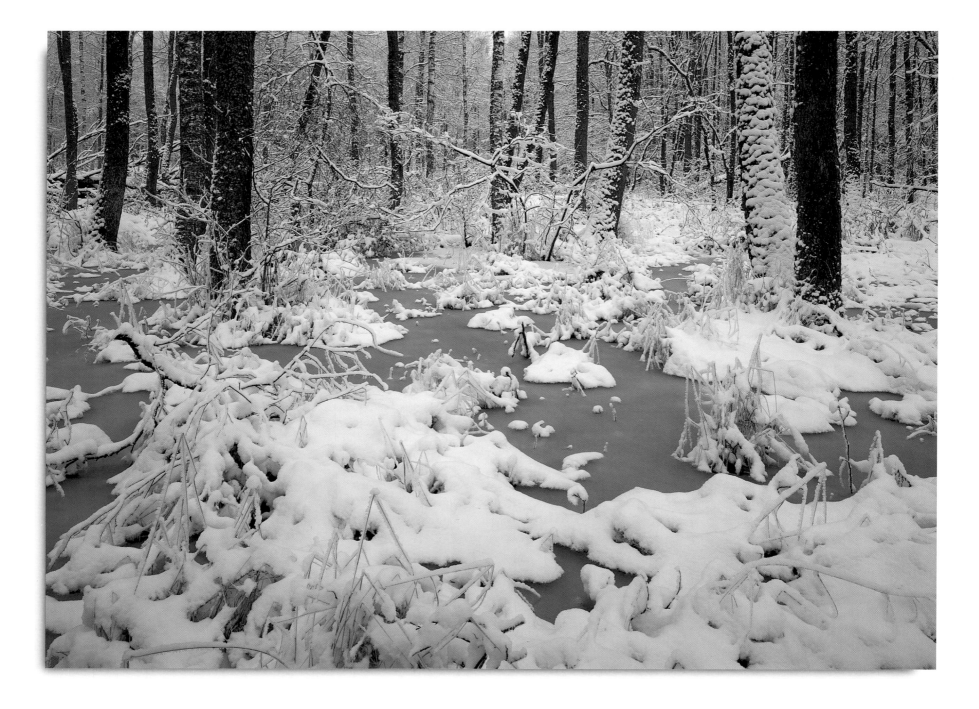

Hans Strand

LINHOF TECHNIKARDAN 4X5, SUPER-ANGULON 90MM 5.6 LENS, F/45 AT 1 SEC.,
FUJICHROME QUICKLOAD VELVIA FILM.

Snowy Swamp

Forested with birch and alder trees, this small swamp lies southwest of Grödinge, Sweden, a small village about 20 miles south of Stockholm. "The more I have been traveling around the world chasing for and photographing icon landscapes in 'hallelujah' light, I have matured to appreciate a more quiet type of nature, which also becomes my own private little part of the planet. That is why I decided to go for intimacy and not drama on this first day of 2000."

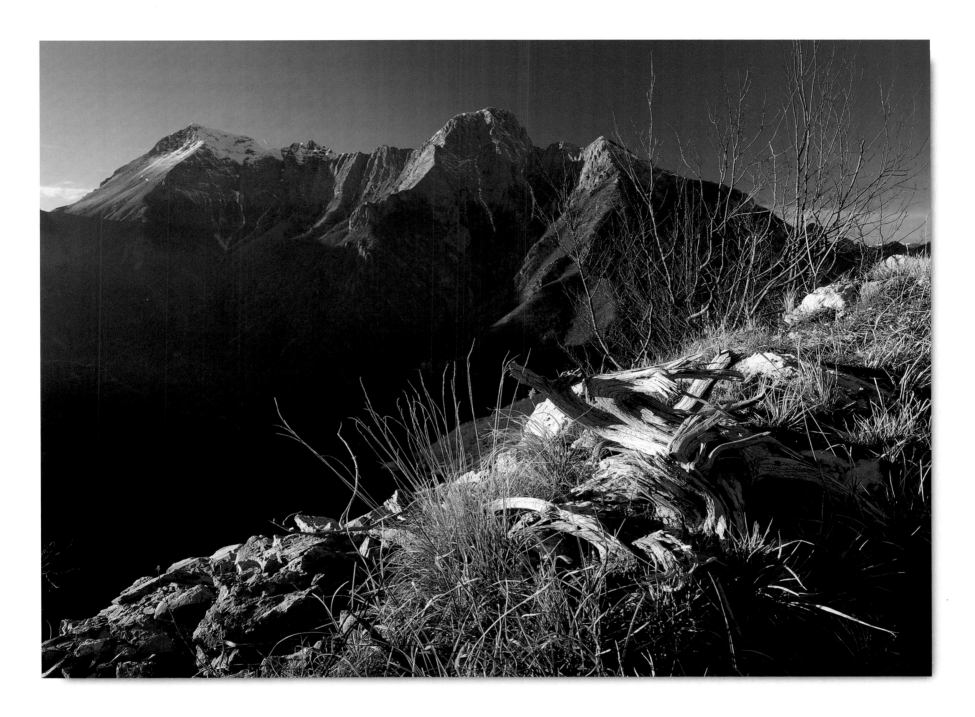

Andrea Pistolesi

WISTA FIELD CAMERA, RODENSTOCK 90MM LENS, F/45 AT 1 SEC.

Italy

POSITION: 11°01'E, 44°01'N
TIME: 7:00 A.M.

Uncarved Stone

Le Panie rises above the Garfagnana Valley in Italy's Tuscany region, part of the Apuan Alps, a range that has yielded quarried marble cherished by architects the world over. The eastern slope (pictured), is not quarried and is considered one of the wildest areas in the region. "I really enjoyed climbing back on these mountains with my old field camera after a long time [away]."

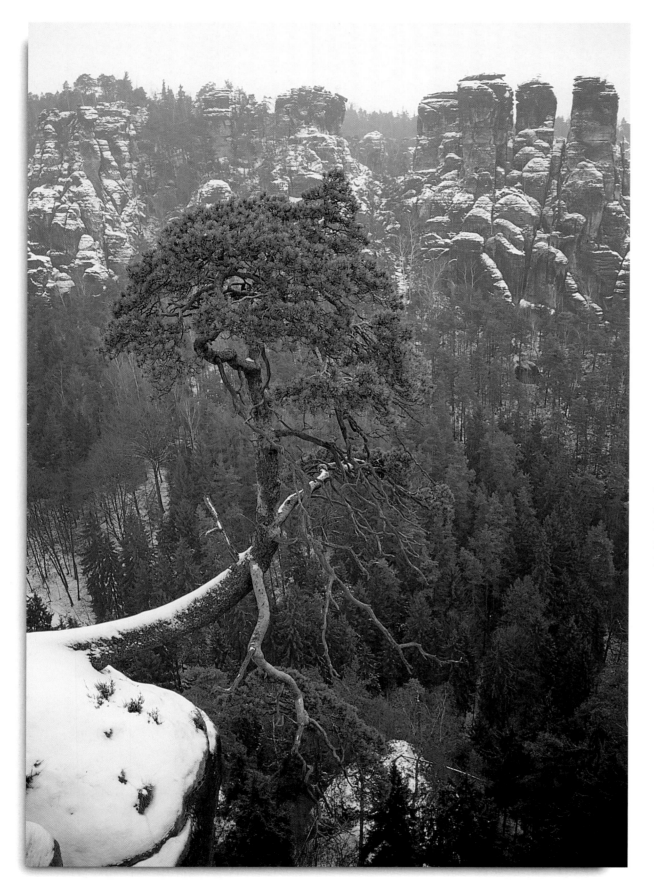

Fritz Pölking

NIKON F5, 24MM 2.8 LENS, F/8 AT 1/15 SEC.

Germany

POSITION: 13°45'E, 51°00'N
TIME: 8:00 A.M.

Perched Pine

Scotch pine, Sächsische Schweiz
National Park, Germany. This park
is located in the Elbe Sandstone
Mountains outside Dresden.

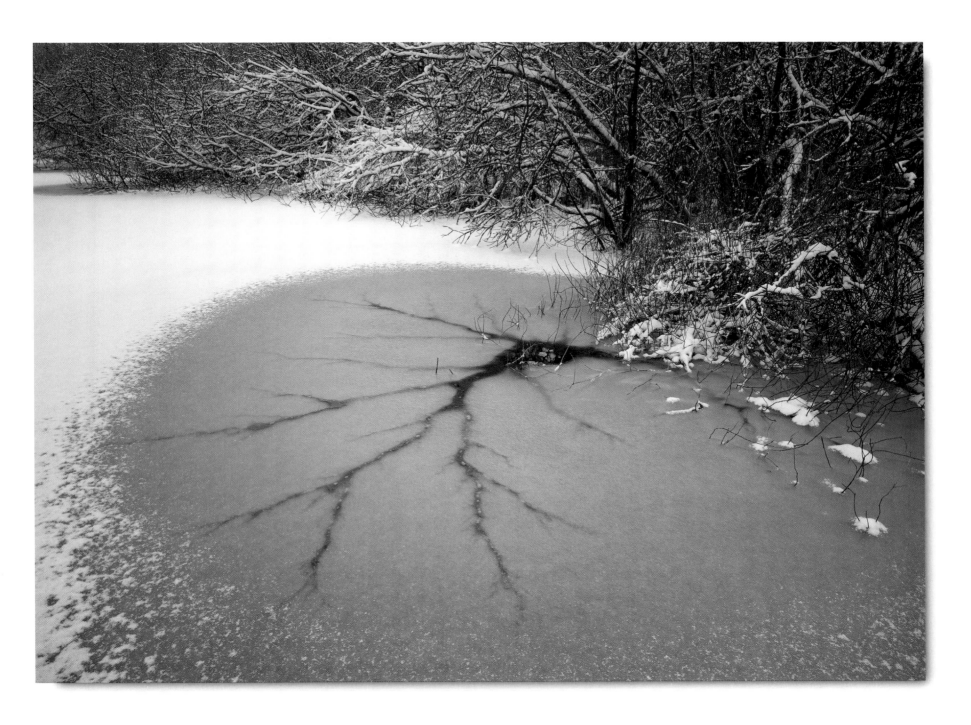

Bård Løken

WISTA FIELD CAMERA, 75MM LENS, F/32 AT 1 SEC., FUJICHROME VELVIA FILM PUSHED 1.5 STOPS.

Norway

POSITION: 10°50'E, 59°52'N
TIME: 12:00 P.M.

Ice "Tree"

The pattern in this ice appears to mimick the trees surrounding
this partially frozen pond outside Oslo, Norway.

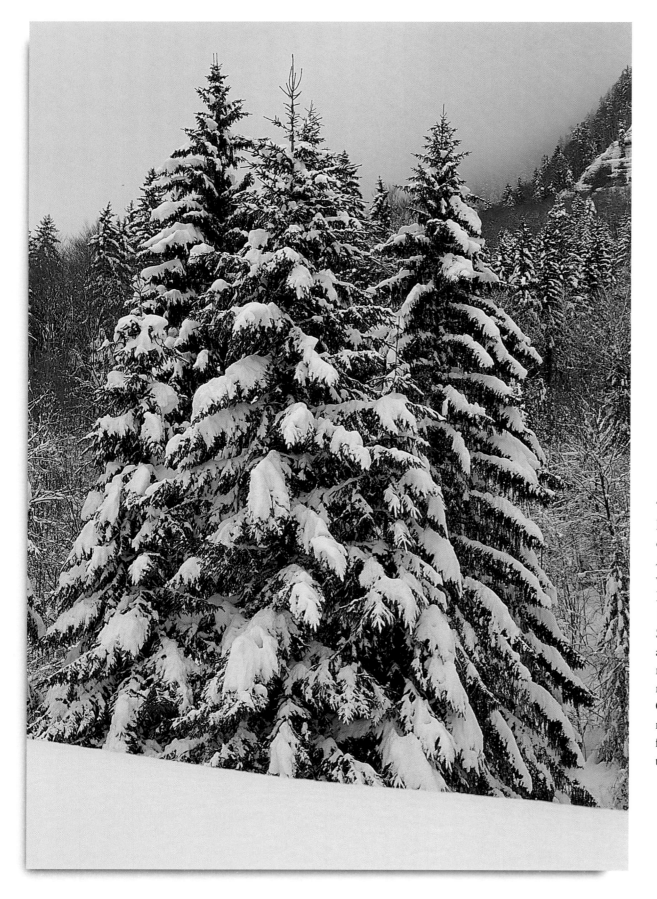

Eric Soder

NIKON F5, 50MM NIKKOR LENS, F/8 AT 1/25 SEC.

Switzerland

POSITION: 9°16'E, 47°15'N
TIME: 1:15 P.M.

Calm After the Storm

The tranquility of this pristine winter landscape is deceiving. These snow-covered spruce trees dotting the Alpstein area forest of the Swiss Alps were spared the fury of Hurricane Lothar, which during December 1999 swept through France and Switzerland, uprooting small trees and splitting the trunks of others like matchsticks. "Such violent storms are rather uncommon in Switzerland. On New Year's Day, the weather did not clear up as expected, so I went for landscape details rather than try to record grand landmark scenery."

Francesc Muntada

BRONICA ETRSI, ZENZA BRONICA 75MM 2.8 LENS
WITH NEUTRAL DENSITY AND 81B WARMING FILTERS,
F/16 AT 1/25 SEC., FUJICHROME VELVIA FILM.

Spain

POSITION: 2°01'E, 41°39'N
TIME: 10:30 A.M.

Castle of Stone

Situated in the populous
Catalonia region of Spain, Sant
Llorenç del Munt Nature Park is
home to peregrine falcons, the
endangered Bonelli's eagle, owls,
and other birds, many endemic
plants, and this rock feature,
La Cova del Drac. "In winter,
sunlight doesn't reach the forma-
tion walls until it is too high and
harsh. In spring, the walls catch
the first light of the day, the
image I wanted."

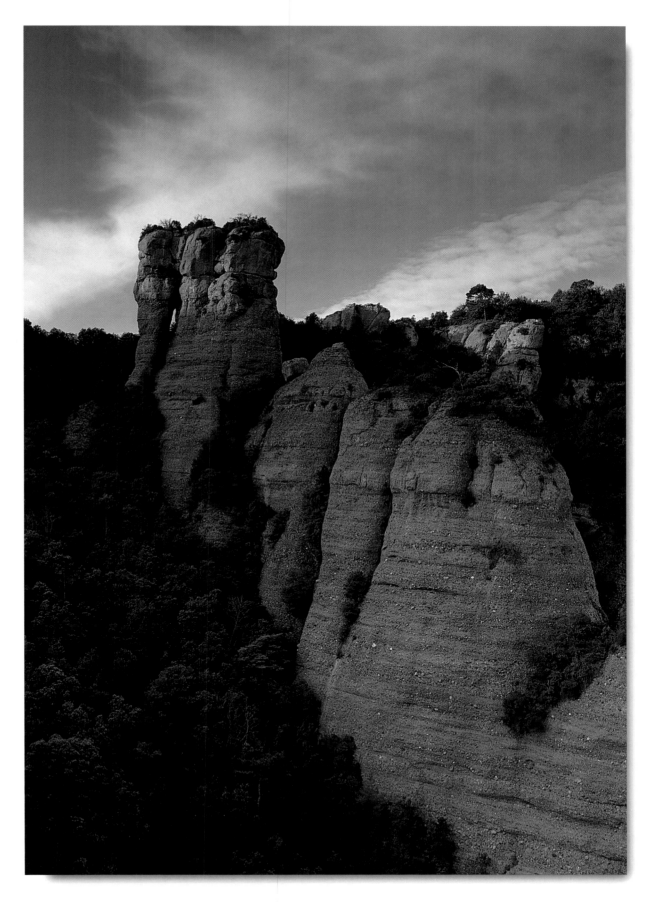

Geoff Doré

NIKON F801, MICRO-NIKKOR 105MM MACRO LENS WITH 81B WARMING FILTER, F/16 AT 1 SEC., FUJICHROME VELVIA FILM.

Flora Pariah

Bracken plants pepper the heath in England's New Forest, a 90,000-acre ecological stronghold of marshland, stands of pine, and ancient broad-leaved woods, including beech, birch, and oak trees. Bracken is an introduced plant species with toxic properties, making it of little use to wildlife other than for shade or cover.

England

POSITION: 1°42'W, 50°51'N
TIME: 11:30 A.M.

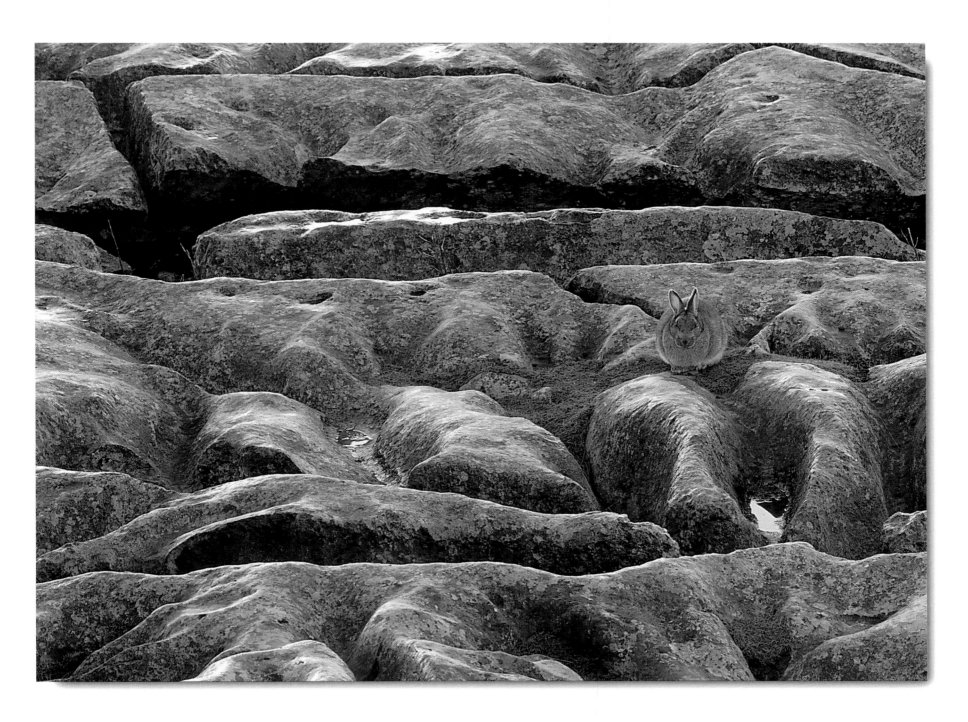

England

POSITION: 1°0'W, 54°00'N
TIME: 8:45 A.M.

Heather Angel

NIKON F5, 80-200MM 2.8 LENS, EXPOSURE UNRECORDED.

Ears to a New Year

Shortly after dawn broke, the presence of a rabbit was revealed by the glowing backlit ears. This simple scene above Malham Cove, in Yorkshire, England, epitomizes how the balance between the rock—exposed to the elements through eons of time—and the natural vegetation, is manipulated by the effects of browsing. Any plant that attempts to grow above the rock surface is constantly pruned by voracious herbivores.

Edward Parker

CANON EOS 1N, 28-70MM 2.8 LENS, F/8 AT 1 SEC.

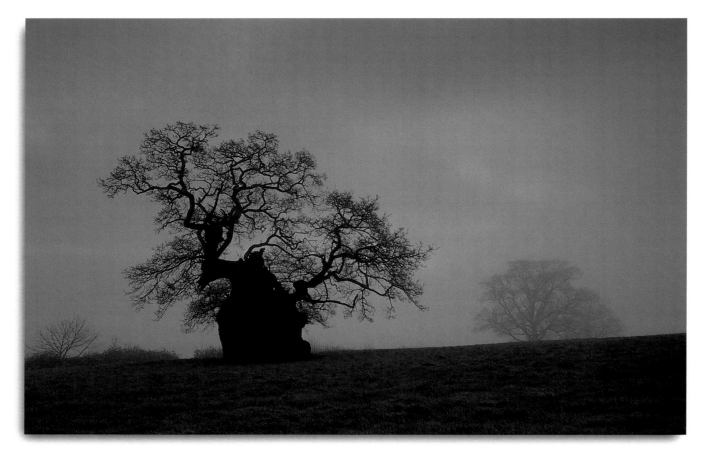

England

POSITION: 2°30'W, 51°00'N
TIME: 9:00 A.M.

Tree of Life

Oaks like this 1,000-year-old tree near Gillingham in the north of Dorset, England, provide habitat for more than 300 species of insects as well as many types of mosses and fungi. Its acorns and abundant insects make the oak important for birds and mammals alike. "Ancient oak trees are useless to commercial forestry, but as havens for biodiversity and as stores of carbon, they are extremely important."

Scotland

POSITION: 4°30'W, 57°30'N
TIME: 1:30 P.M.

Alan Watson ▶

MAMIYA RZ67, 50MM LENS, F/22 AT 4 SEC., FUJICHROME VELVIA FILM.

Still Stones

Pebbles, sandstone, and cliff, Primrose Bay, Moray Firth coast of northeast Scotland. Stormy conditions precluded Alan from photographing in the Caledonian Forest as planned, but this rocky landscape is another favorite, and a good fallback subject when the wind does not cooperate.

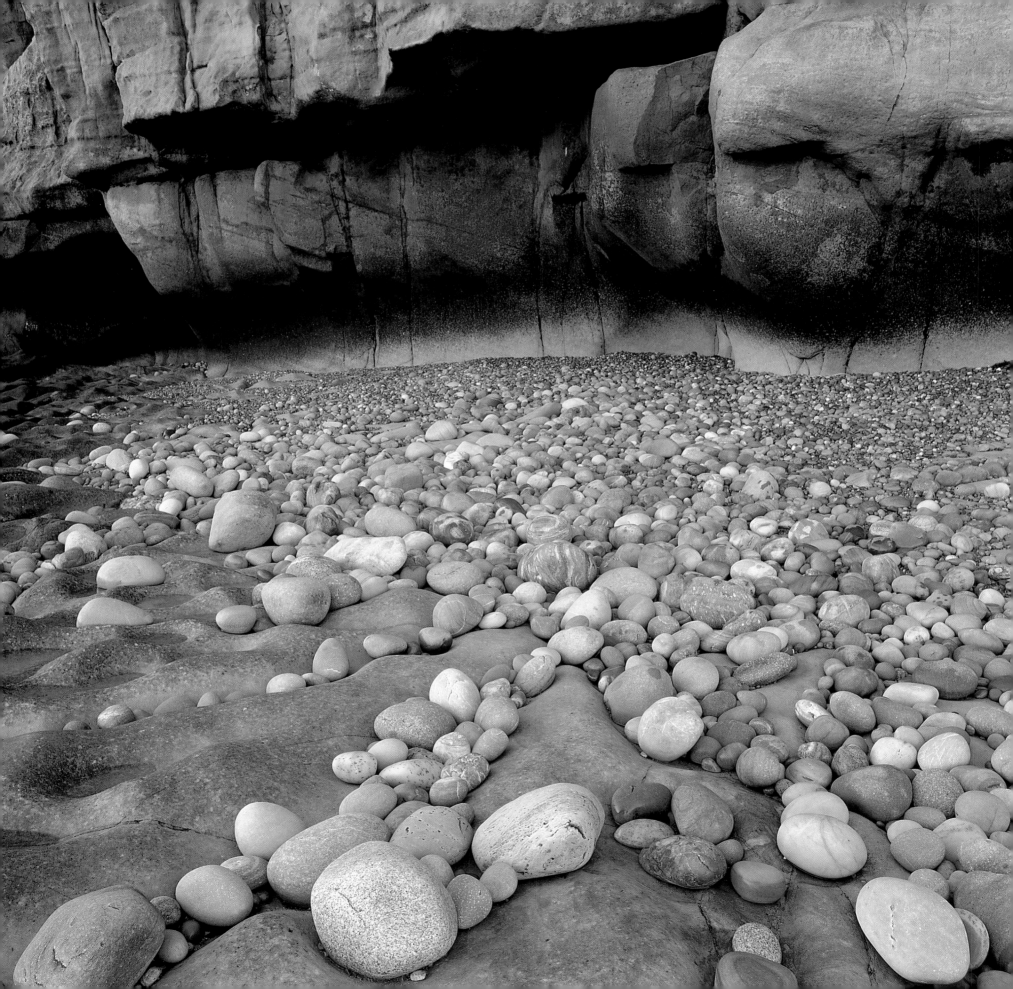

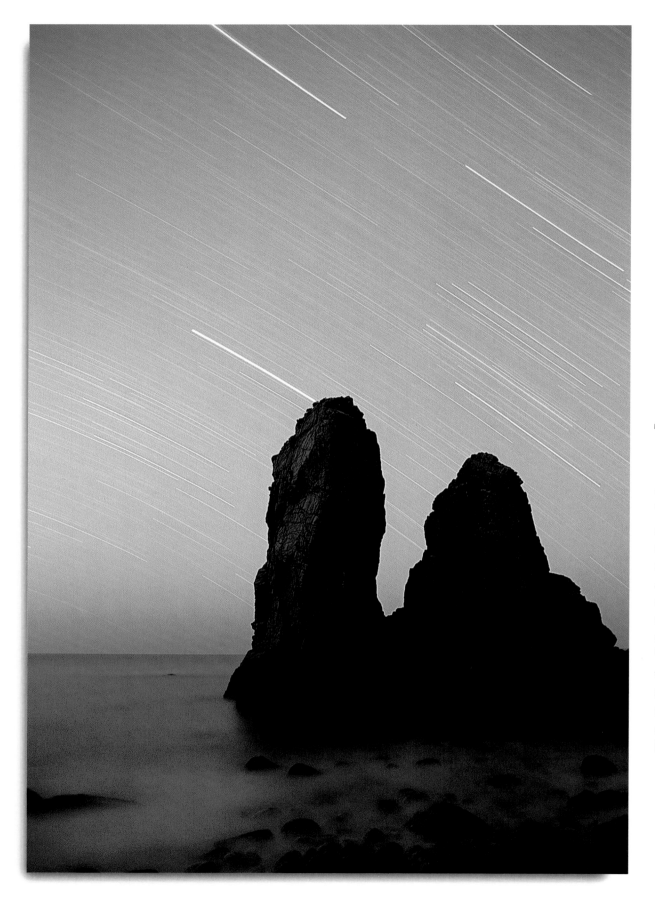

José Romão

NIKON F4 S, NIKKOR 24MM 2.0,
F/2.8, 2 HOURS.

Portugal

POSITION: 9°00'W, 39°00'N
TIME: 1:45 A.M.

Starscape

Twin pinnacles at Portugal's Cabo da Roca, the westernmost point of continental Europe, bask in the moon's glow as stars above the Atlantic Ocean etch trails of light during this pre-dawn composition. Night photography introduces a set of variables all its own. "Every bag contained just what was needed, in the order it was needed, including a checklist of equipment and settings to use and at what times, so I wouldn't be improvising on the spot."

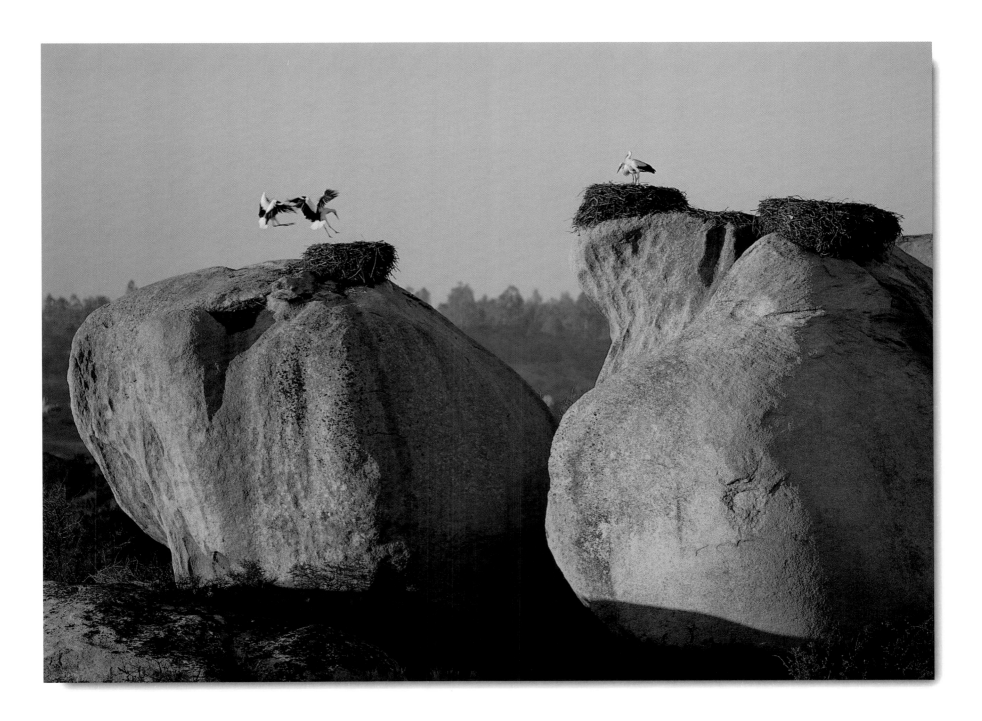

Francisco Márquez
NIKON F5, 300MM NIKKOR AF F.4 IF-ED LENS, F/4 AT 1/90 SEC., NIKON L1BC FILTER,
FUJICHROME VELVIA FILM.

Spain

POSITION: 7°30'W, 38°00'N
TIME: 5:55 P.M.

Empty Nests

Nesting pairs of white storks prepare nurseries for their young well in advance of breeding season at Los Barruecos, Spain. Then, like watchful homesteaders, they protect their real estate from intrusive competitors who would jump claims. Francisco made this image five minutes before the sun disappeared.

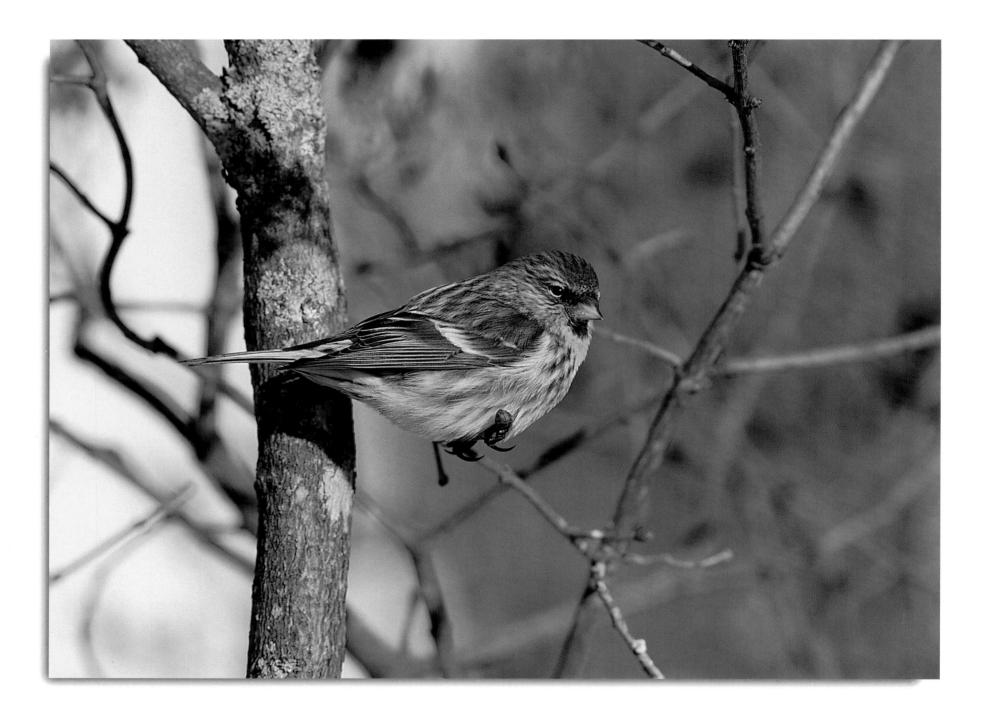

Wayne Barrett
CANON EOS-3, 300MM 2.8EF AND 1.4X TELECONVERTER, F/8 AT 1/60 SEC.

Arctic Flight

A redpoll, which spends most of the year in the Canadian Arctic, makes an appearance at lower latitudes in Prince Edward Island. Wayne had sunshine most of the day, providing ample opportunities to photograph winter landscapes, goldeneye ducks, chickadees, and tracks in the snow, including a fresh imprint made by a bird of prey snatching a snowshoe hare in the early hours of 2000.

Prince Edward Island, Canada

POSITION: 62°30'W, 46°15'N
TIME: 9:00 A.M.

56

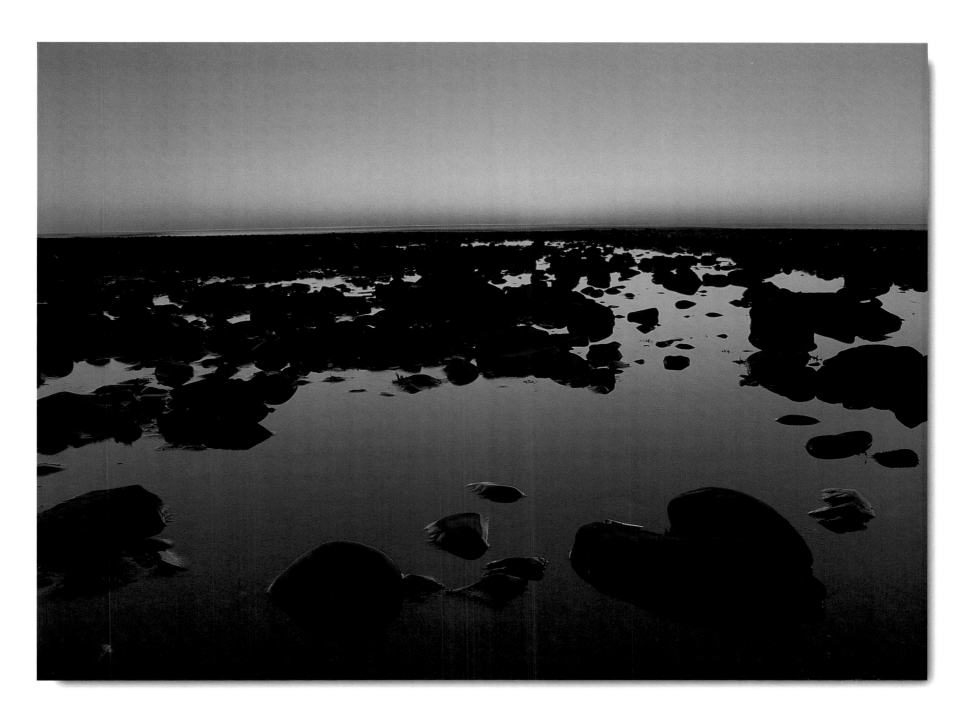

Nova Scotia, Canada

POSITION: 63°40'W, 44°40'N
TIME: 7:15 A.M.

Dale Wilson

NIKON F90, 28MM NIKKOR LENS, F/11 AT 1 MIN., WITH A 2-STOP
COKIN GRADUATED MAUVE FILTER.

Tidal Twilight

Dawn arrives at Hartlen Point tidal basin, near Halifax, Nova Scotia. Dale was one of many photographers who intended and/or attempted to photograph star trails for this project. "This attempt was foiled due to excessive cloud cover, so we snored in the New Year instead. By 5:00 a.m., the sky was as clear and pristine as possible."

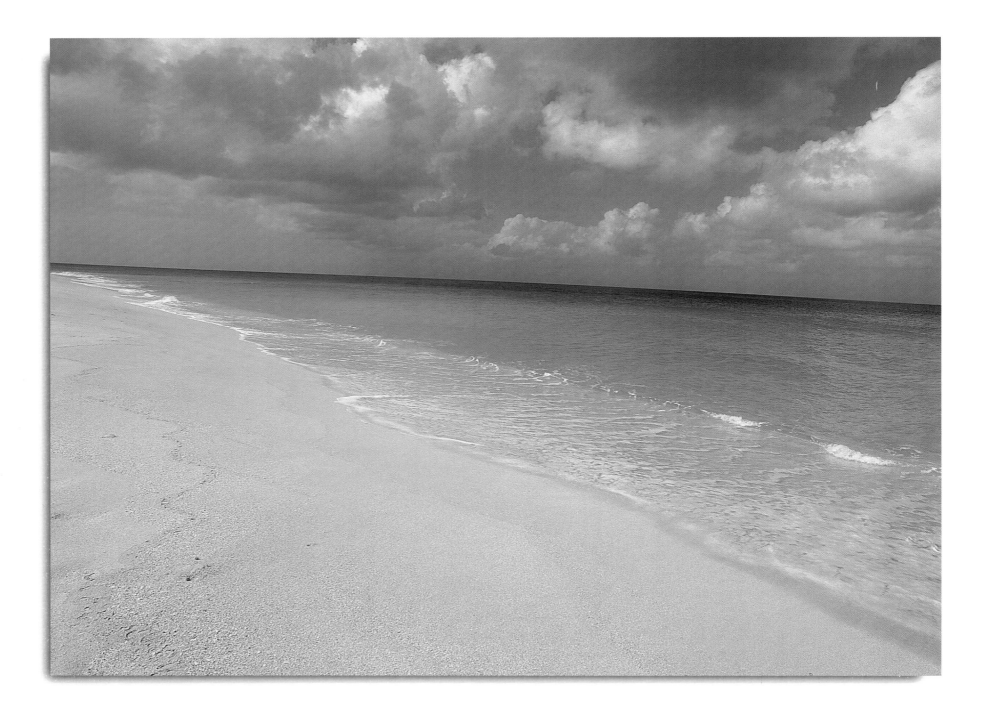

Carol Lee

NIKON N2000, 20MM LENS, F/11 AT 1/125 SEC.

A Postcard from Paradise

Pristine white beaches of the Caribbean, including this stretch along Sandy Point
National Wildlife Refuge on the island of St. Croix, provide tranquil nesting habitat
for endangered sea turtles and a sanctuary for scores of species of migratory and
resident birds. To Carol, a resident of the area, "It's paradise."

Virgin Islands, U.S.A.

POSITION: 64°30'W, 17°30'N
TIME: 11:40 A.M.

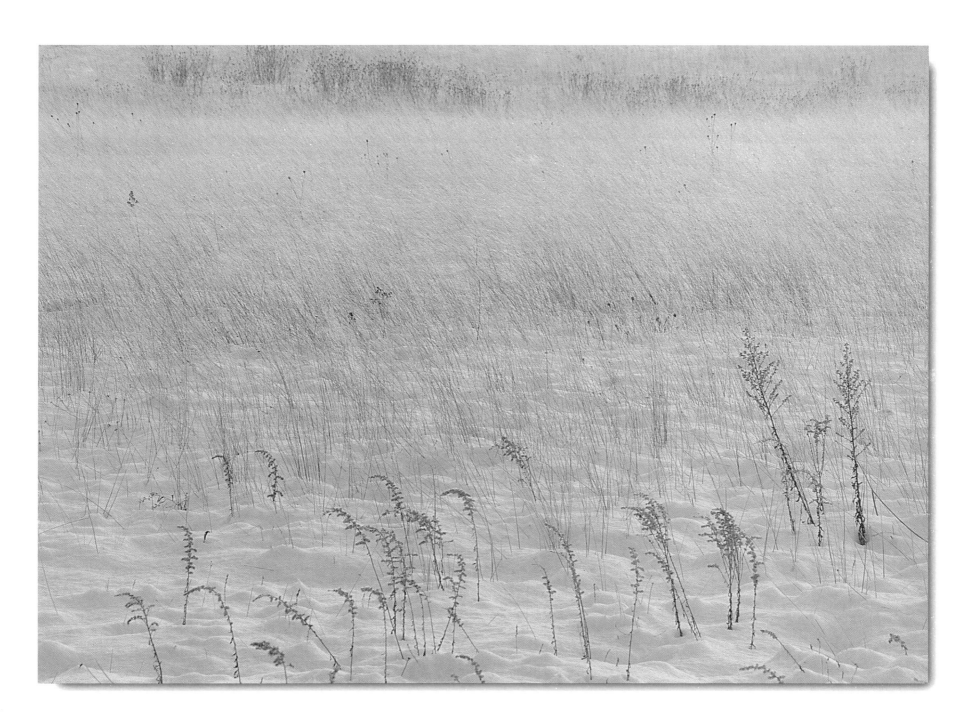

New Brunswick, Canada

POSITION: 66°00'W, 45°30'N
TIME 9:15 A.M.

Freeman Patterson

MINOLTA 9XI, 100-300MM ZOOM, AT FULL APERTURE, SHUTTER SPEED UNRECORDED.

Backyard Preserve

The woodlands that Freeman calls home are a nature preserve that he donated to the Nature Conservancy of Canada. Here, at Shamper's Bluff, New Brunswick, north of Saint John, a variety of subjects presented themselves throughout the day, including this field of frosted yellow grasses and other field plants, which Freeman overexposed one-and-a-half stops to accurately render the white snow.

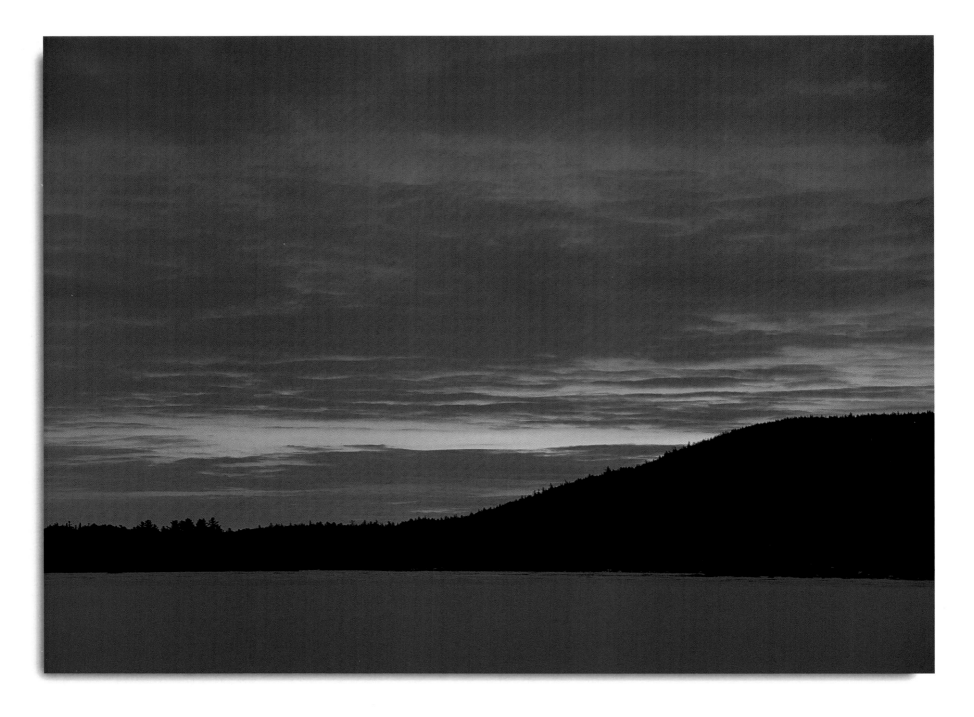

Bill Silliker, Jr.
NIKON F5, 180MM LENS, F/5.6, SHUTTER SPEED UNRECORDED, FUJICHROME PROVIA 100F FILM.

Wild Song

As the crisp blackness of night faded to crimson during the first sunrise of 2000 at Togue Pond in Maine's Baxter State Park, Bill discovered he had some wild company in the form of two coyotes that howled to greet the dawn. For him, their song at sunrise symbolized the creatures' resilience to eradication efforts by humans in years past. For now, at least, they are free to roam Baxter Park's more than 200,000 acres of wilderness.

Maine, U.S.A.

POSITION: 69°00'W, 46°00'N
TIME: 7:10 A.M.

Gary Braasch

NIKON N90, 50MM LENS, F/11, SHUTTER SPEED
UNRECORDED, WITH GITZO TRIPOD.

Patagonia, Chile

POSITION: 72°00'W, 53°00'S
TIME: 7:00 P.M.

*Greetings From the
"End" of the World*

A trio of curious Magellanic penguins approaches at Otway Gulf, Patagonia, 60 miles (97 kilometers) north of the farthest point of mainland South America, near Punta Arenas, Chile. Here, a colony of 8,000 Magellanic penguins nests in burrows and feeds offshore. Though not endangered, other penguin species are beset by the effects of climate change in Antarctica, and loss of habitat in areas north of Antarctica.

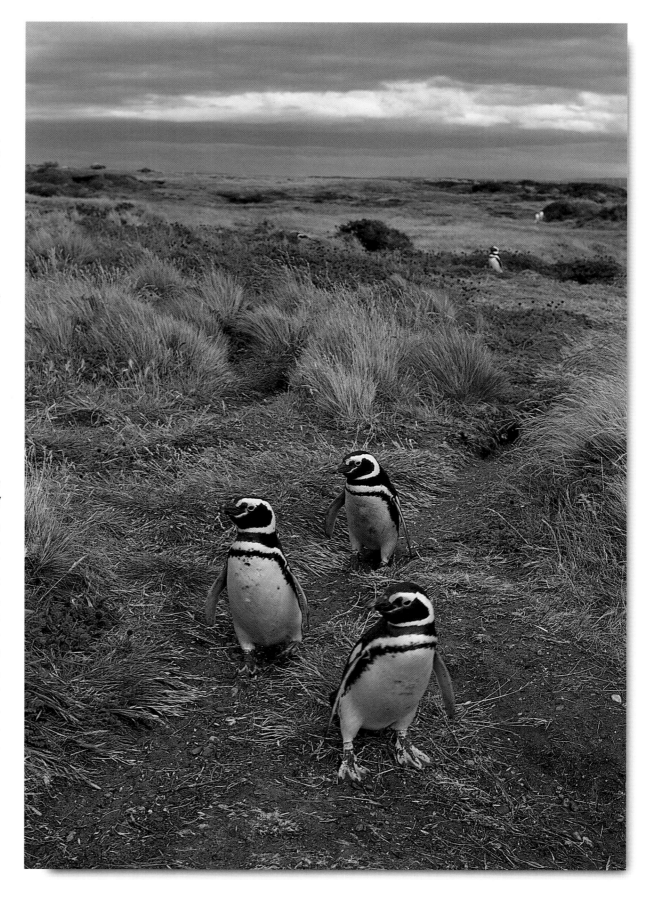

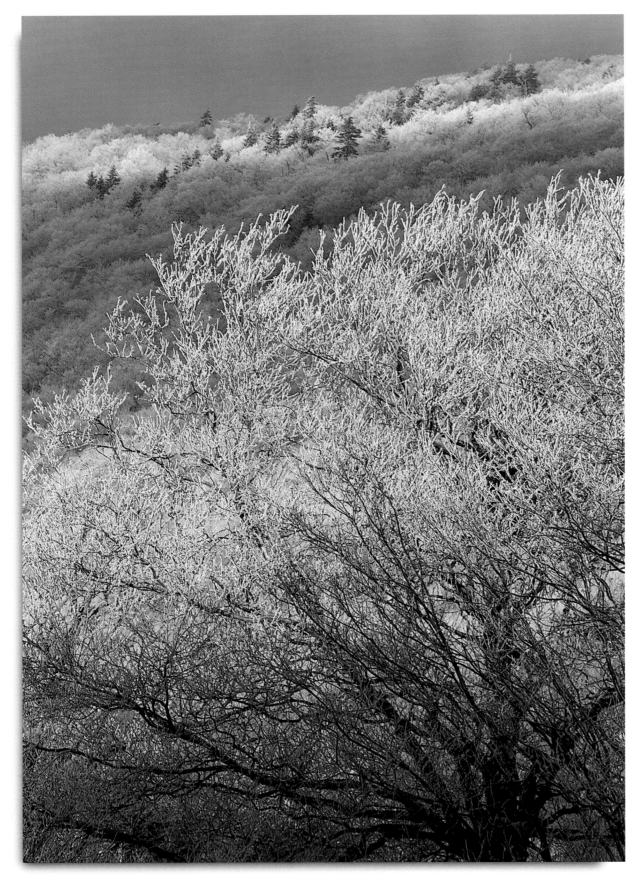

David Middleton

F5, 80-200MM LENS, F/22,
SHUTTER SPEED UNRECORDED.

Vermont, U.S.A.

POSITION: 73°00'W, 44°30'N
TIME: 8:20 A.M.

Forest of Frost

Bare and dormant, the broadleaf, deciduous forest in Vermont's rolling Green Mountains resembles nothing of the autumn display of red, burnt orange, and goldenrod that foreshadowed the onset of winter just weeks before. David made this image east of Darby, Vermont.

Winston Fraser

MINOLTA SRT 102, 70-210MM LENS,
F/11 AT 1/125 SEC.

Quebec, Canada

POSITION: 73°53'W, 45°32'N
TIME: 11:00 A.M.

Fresh Tracks

Animal tracks provide evidence of activity afoot at Oka Provincial Park, located along Lake of Two Mountains, outside Montreal. The park's wetlands and forests of maple, pine oak, and poplar provide habitat for more than 200 species of birds and mammals, including pine warblers, yellow-throated vireos, and 20 species of duck.

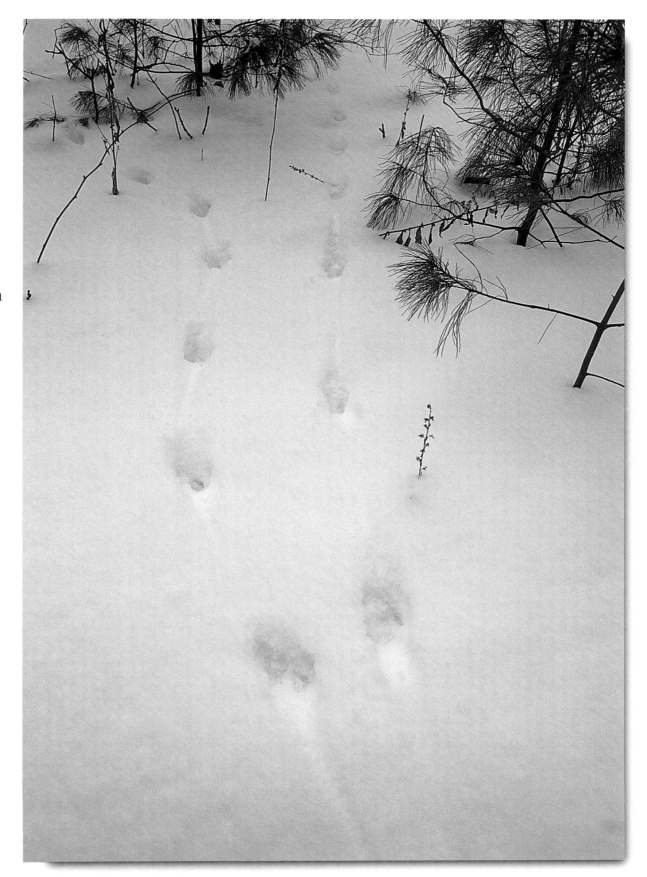

63

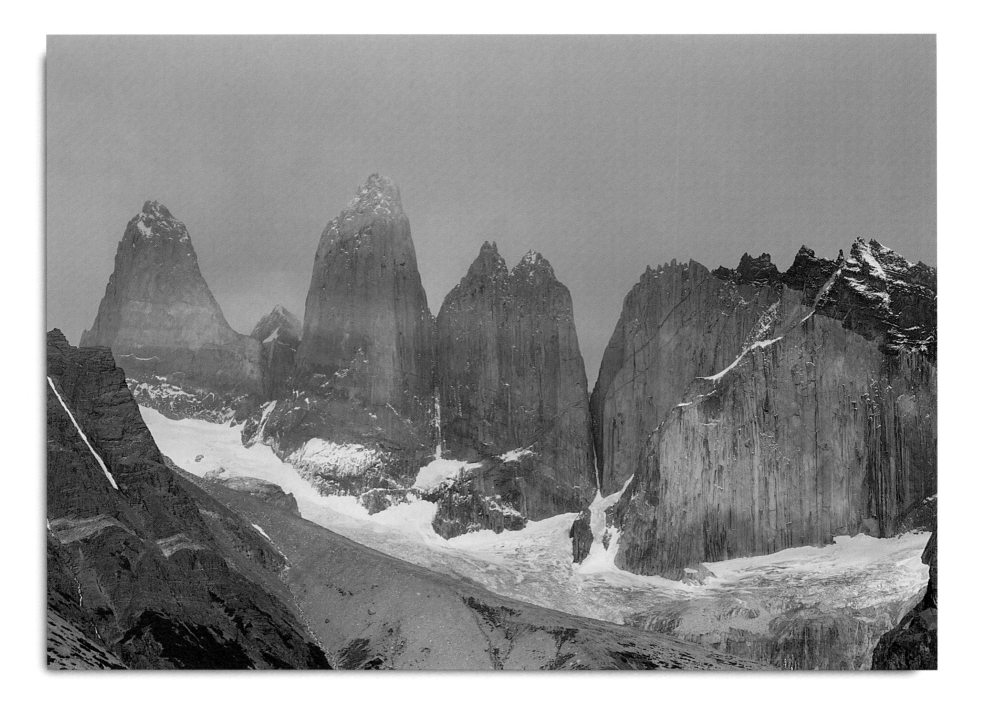

Enrique Couve

CANON EOS500N, CANON AF70-300MM 4.5, F/6.7 AT 1/250 SEC.

Rainbow Ridge

During a momentary break in storm activity, a rainbow appears against the slate-gray peaks in Torres del Paine National Park, Chile. "The location I chose was from the east, not the typical view. The wind and rain were incredibly strong, and when it became impossible to continue ascending, we turned around and it seemed the whole sky came down in snow."

Chile

POSITION: 74°00'W, 51°00'S
TIME 11:00 A.M.

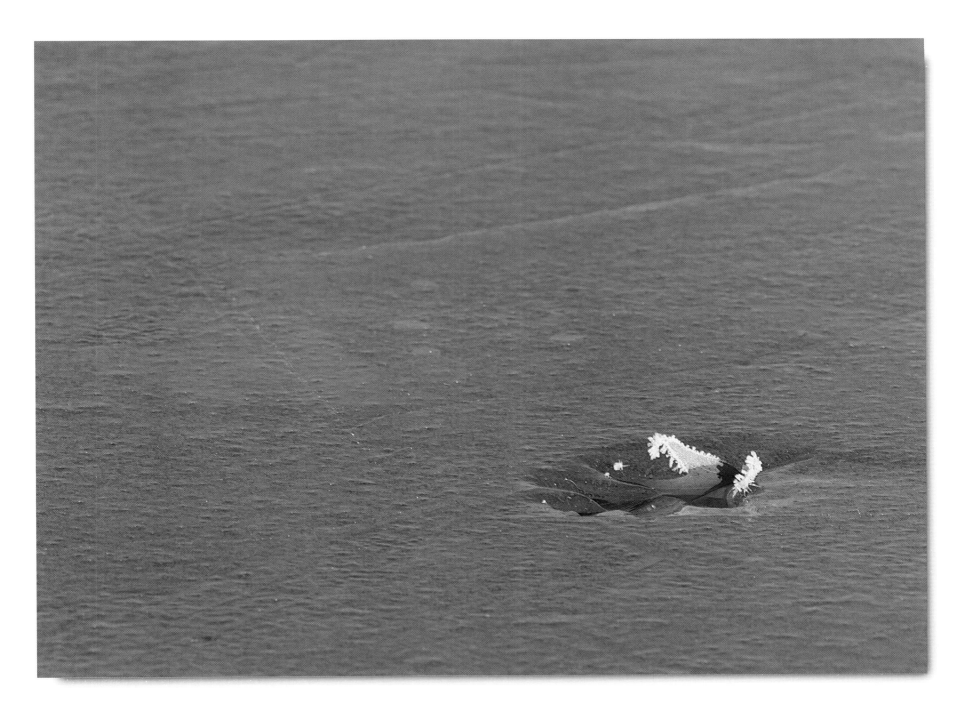

Pennsylvania, U.S.A.

POSITION: 77°20'W, 40°35'N
TIME: 8:40 A.M.

Mary Ann McDonald

CANON EOS 3, 20-35MM LENS, F/8 AT 1/30 SEC., FUJICHROME VELVIA FILM.

Union of Seasons

Fringed with frost, an oak leaf rests embedded in lake ice at Faylor Lake, Pennsylvania. An indentation was formed by repeated thawing and refreezing with the rise and fall of the air temperature above. "This one-day shoot was a great opportunity to test myself to produce quality work within a certain time frame."

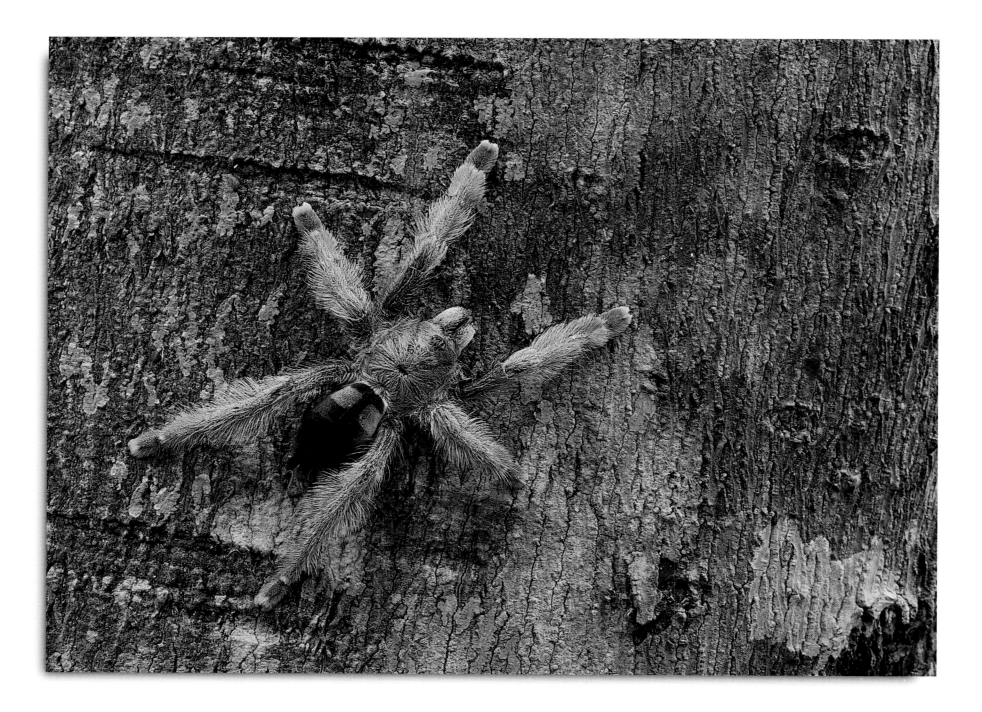

Alfredo Maiquez

NIKON F5, 200MM NIKON F.4 MACRO LENS, F/22 AT 1 SEC.

Y2K Bug

This tarantula is one of countless insects that thrive in the Darién rainforest of Panama. The area is an important ecosystem in Central America and includes the only latitudes in the Americas between Barrow, Alaska, and Punta Arenas, Chile, to be unimproved with a road. Motor vehicles navigate around the "Darién Gap" aboard vessels.

Panama

POSITION: 77°30'W, 8°00'N
TIME: 9:00 A.M.

Bill Ivy
CANON EOS RT, 35MM LENS, F/4 AT1/60 SEC.

Ontario, Canada

POSITION: 79°54'W, 44°18'N
TIME: 4:33 P.M.

Lake Ice Cometh
During the early stages of winter freeze-up, pancake ice forms along Lake Huron's Georgian Bay shore.

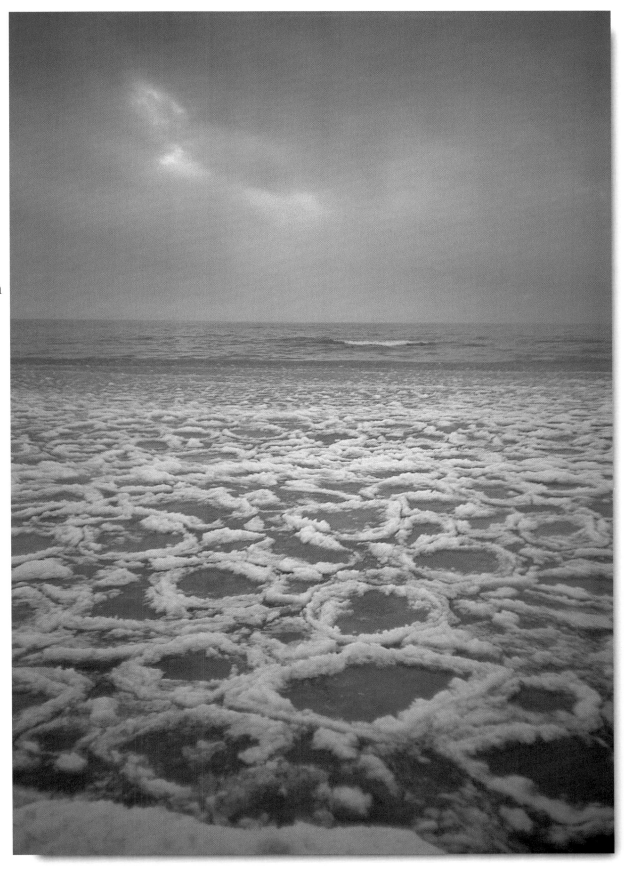

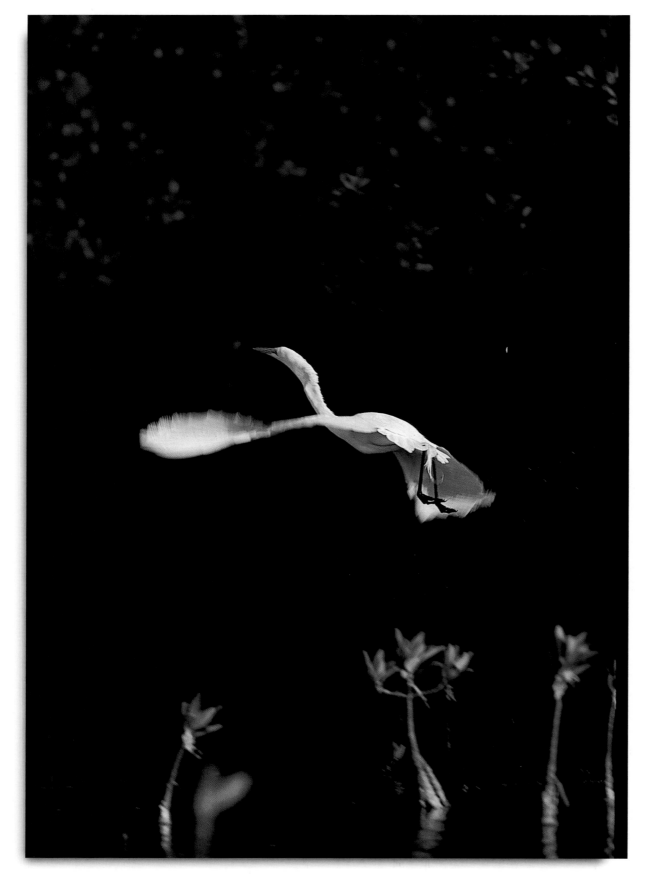

Tom and Therisa Stack
NIKON F4S, 300MM NIKKOR, F/8 AT 1/500 SEC.

Florida, U.S.A.

POSITION: 80°00'W, 25°00'N
TIME: 5:30 P.M.

Magic of the Mangroves

A great egret thrusts aloft amid mangroves at Florida Bay, at the eastern perimeter of Everglades National Park, Florida. These trees, which populate tidal flats, provide dense foliage for nesting sea birds, stabilize shorelines prone to erosion, and replenish vital nutrients to the base of many food chains. "Only recently have we learned how tremendously vital and interrelated the mangrove community is to the health of coral reefs. We believe that the mangroves are at least as important as the world's rain forests."

Steven Morello

NIKON N90, 500MM 1:4P NIKON LENS WITH NIKON
TC-14B 1.4 TELECONVERTER, F/8 AT 1/125 SEC.,
FUJICHROME VELVIA FILM.

Florida, U.S.A.

POSITION: 81°00'W, 26°00'N
TIME: 7:30 A.M.

Green Day

A green heron perches on a reed in Eco Pond at the southernmost tip of Everglades National Park. It is among many species of colorful water birds still common in the Everglades, and one of three birds (together with a purple gallinule and a tricolored heron) that Steve spotted on New Year's Day. "I wanted to photograph common birds for this project. So often we choose to like something because it is rare. I want people to appreciate these birds for their own beauty, not because of what we have done. The Everglades, however, are endangered and represent a real test of our race for the new millennium."

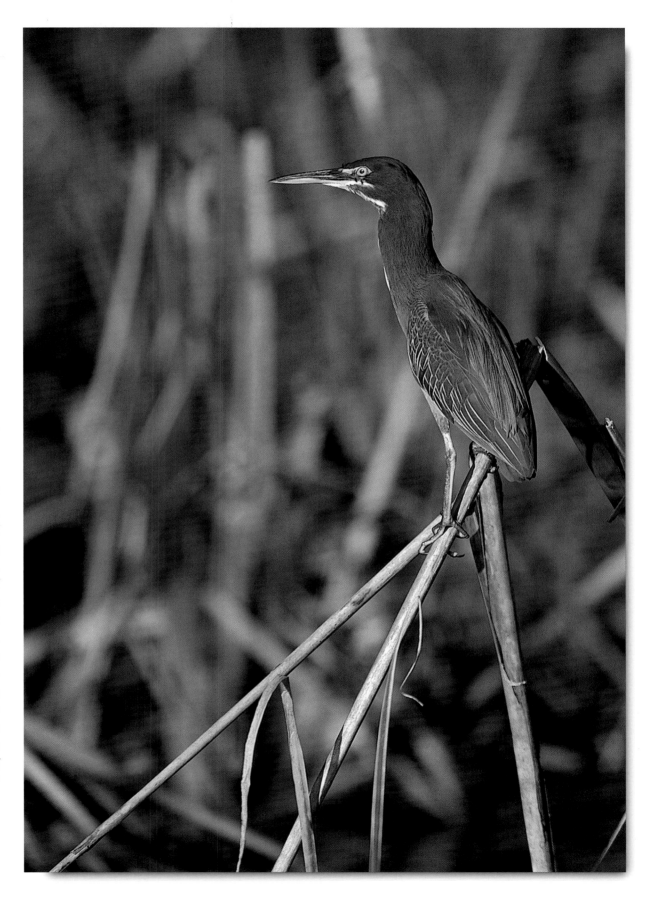

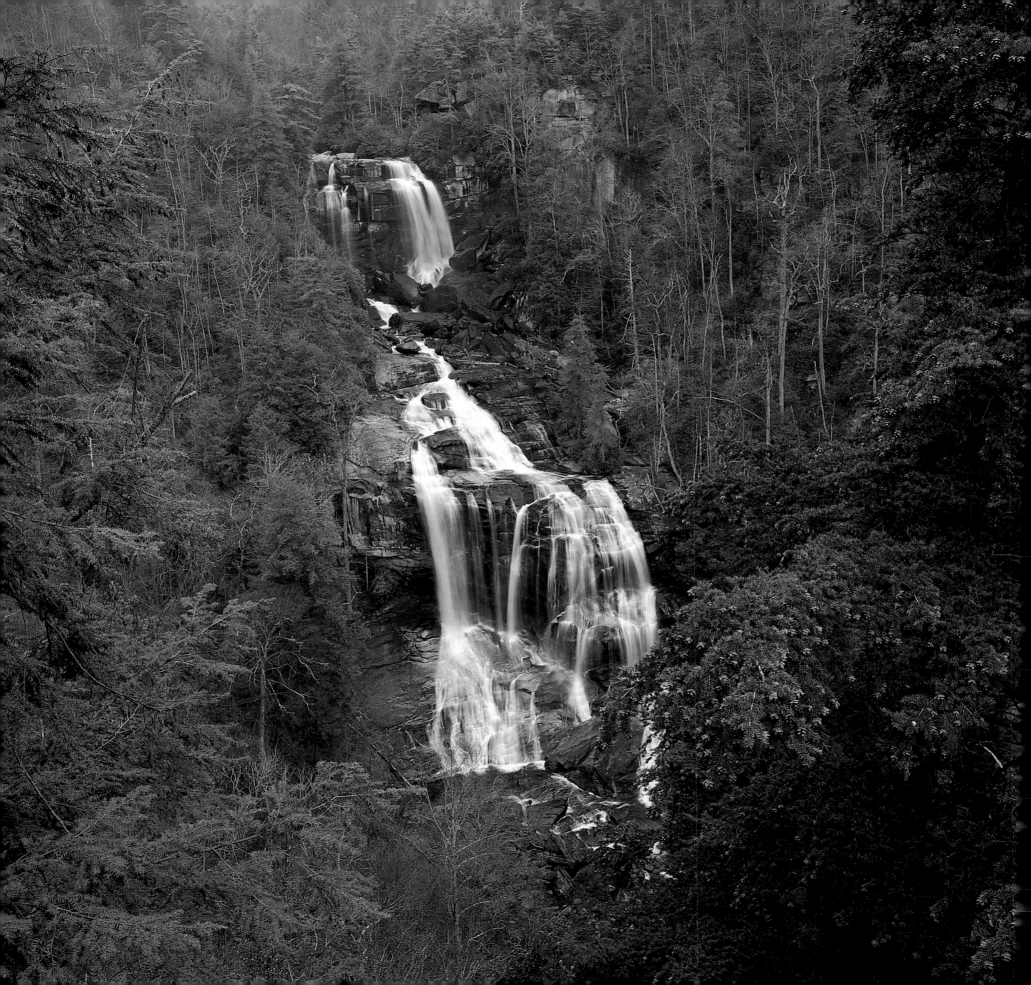

Tim Fitzharris

PENTAX 645, 45-85MM LENS WITH A ONE-STOP GRADUATED NEUTRAL DENSITY FILTER, F/22 AT 8 SEC., FUJICHROME VELVIA FILM.

Florida, U.S.A.

POSITION: 82°00'W, 27°00'N
TIME: 7:15 A.M.

Sunrise Serenity

Dawn at Estero Island, Florida, tints these stratus clouds but for a few minutes with various shades of fuscia, then peach and apricot until the sun is up and they take on a familiar gray-white. This island, part of the Caloosahatchee River estuary, is home to oystercatchers, pelicans, egrets, herons, sandpipers, and shorebirds—and it is one of Tim's favorite spots for photographing birds. As one of the few undeveloped stretches of sandbars, mudflats, tidal pools, and lagoons along the Florida Gulf Coast, it is ideal bird habitat.

◀ Jon O. Holloway

PENTAX 67, 55MM LENS, F/22, EXPOSURE UNRECORDED.

South Carolina, U.S.A.

Carolina Cascade

The cascading water of upper Whitewater Falls along the North and South Carolina border descends more than 400 feet, making it one of the highest waterfalls in the eastern United States. Despite flat light, Jon logged 250 miles and pushed until dusk during this one-day photo shoot.

POSITION: 81°00'W, 35°00'N
TIME: 12:00 P.M.

71

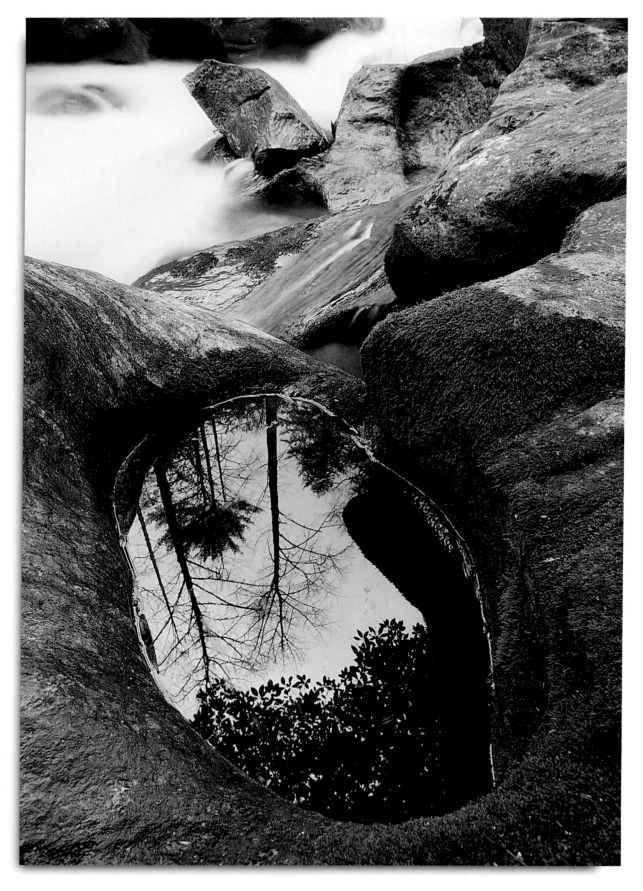

Kevin Adams

NIKON F100, 20MM LENS WITH POLARIZING AND
WARMING FILTERS, F/11 AT 8 SEC.

North Carolina, U.S.A.

POSITION: 83°00'W, 35°30'N
TIME: 9:10 A.M.

Standing Reflection

A pothole on the east
fork of the Chattooga
river holds a still pool
of water as the river
beside it meanders
through Nantahala
National Forest,
North Carolina.

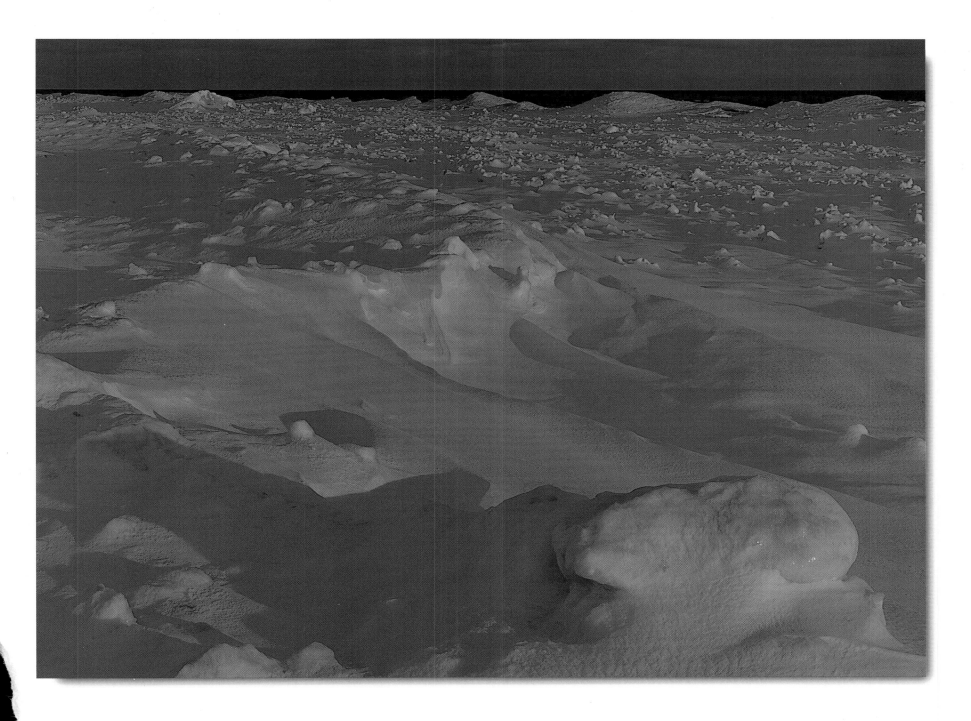

Rod Planck

NIKON F5, 85MM MICRO NIKKORTILT/SHIFT, F/16, SHUTTER SPEED UNRECORDED.

Michigan, U.S.A.

POSITION: 85°00'W, 46°30'N
TIME: 8:27 A.M.

Snow Aglow

Snowdrifts glow at sunrise along the Lake Superior shore near White Fish Point, Chippewa County, Michigan. "We had cloudy days on both sides of January 1. This shot was in the second burst of light to appear."

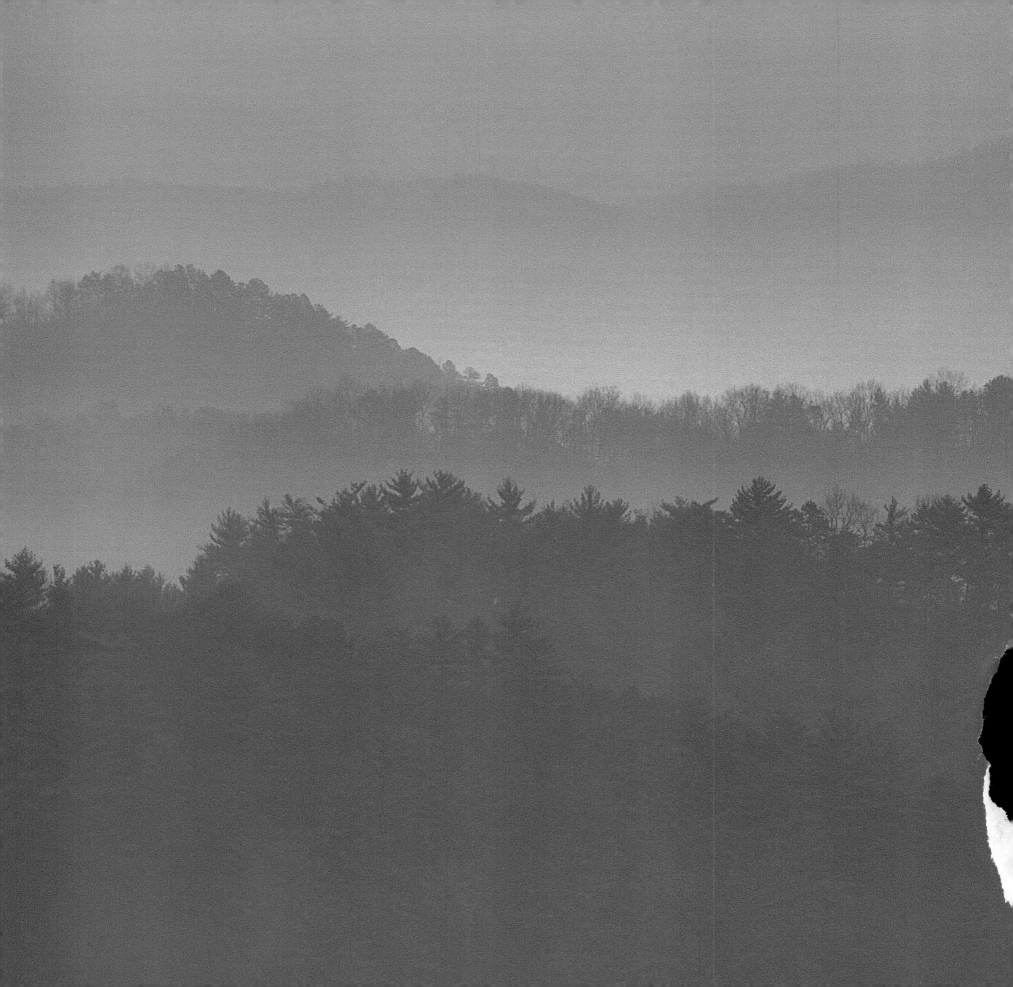

William Fortney
NIKON F5, 80-200MM NIKON ZOOM LENS WITH A
KR3 WARMING FILTER, F/8 AT 3 SEC.

Tennessee, U.S.A.

POSITION: 84°00'W, 35°30'N
TIME: 7:23 A.M.

Mountain Diversity

Great Smoky Mountains
National Park is a diverse ecosys-
tem in the Appalachian
Mountains with more than 1,800
varieties of flowering plants,
native fish, birds, and mammals,
and misty vistas like this view
from Foothills Parkway, near
Townsend, Tennessee.

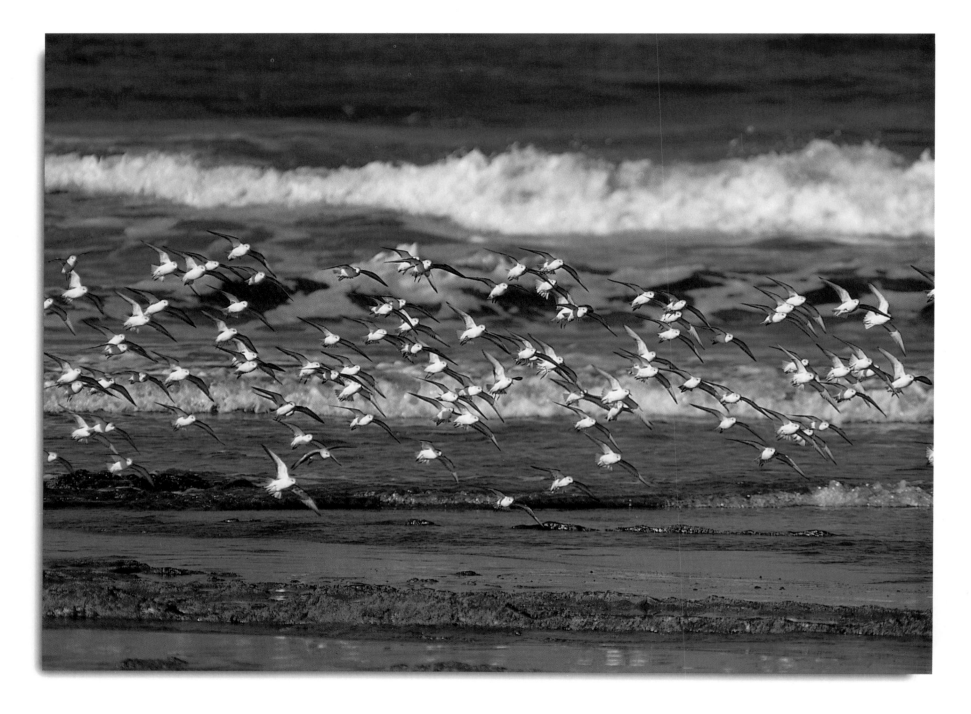

Thomas Blagden, Jr.

NIKON N90S, 300MM LENS, EXPOSURE UNRECORDED, FUJICHROME PROVIA F FILM.

Shore Soar

Sanderlings in a sea breeze glide in formation along the Pacific shore at Manzanillo de Ario, on the Nicoya Peninsula, Costa Rica. This area also contains protected mangrove estuaries, wild almond trees, and other wildlife.

Costa Rica

POSITION: 85°45'W, 9°45'N
TIME: 8:20 A.M.

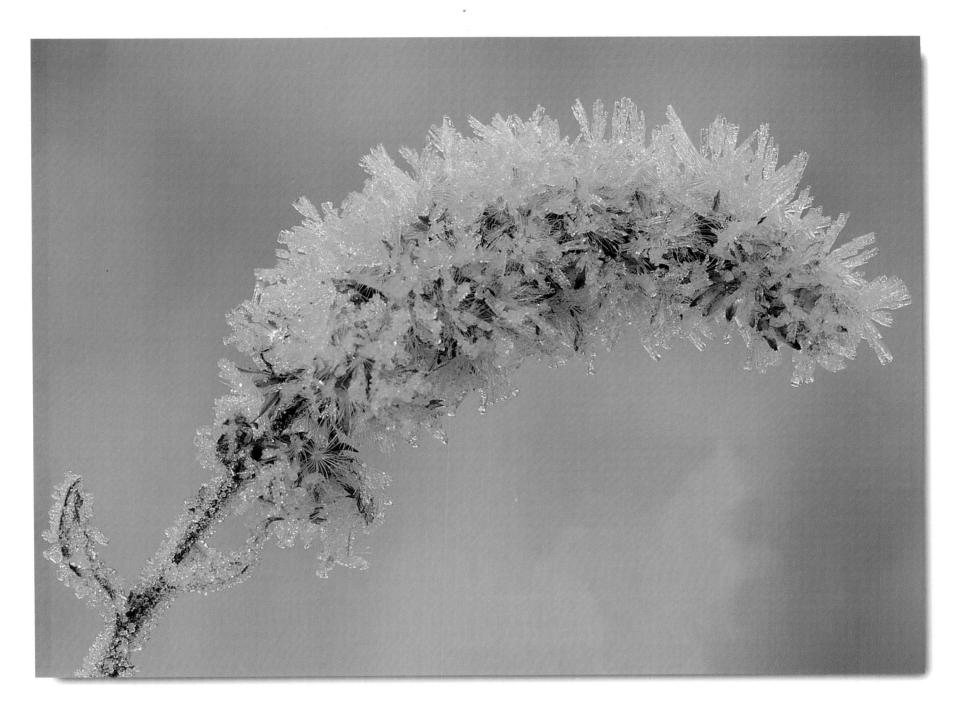

Cliff Zenor

NIKON F4S, 200MM MICRO NIKKOR, F/11 AT 1/8 SEC., FUJICHROME VELVIA FILM.

Indiana, U.S.A.

POSITION: 86°00'W, 41°00'N
TIME: 9:00 A.M.

Frosted Flower

Frost encases a faded goldenrod flower head with large crystals on a cold, foggy New Year's Day in north central Indiana. In spring, the frost will give way to brilliant yellow blossoms. It is just one detail among many features in the woodland marshes of the area. "Lakes, ponds, and wetlands in the Midwest are important places for wildlife, providing food, water, and safe havens."

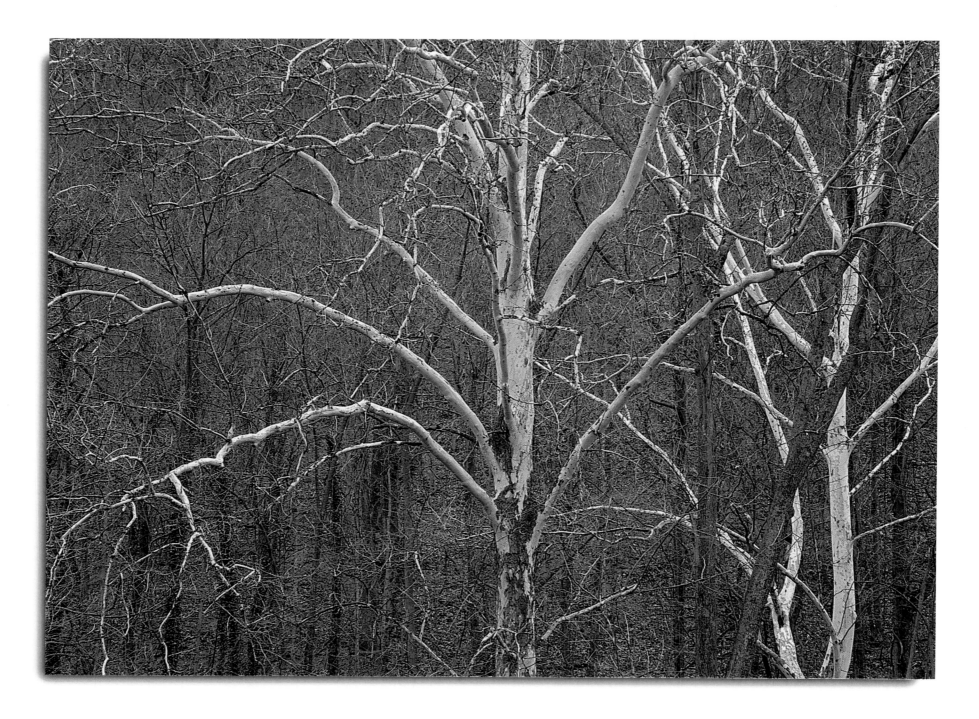

John Netherton

NIKON F5, 35-70MM NIKKOR LENS, F/16 AT 3 SEC.

Rain Delay

Raining and too cold for photographing salamanders, one of John's favorite subjects, he focused instead on the stately sycamore trees at Radnor Lake State Natural Area, six miles from downtown Nashville, Tennessee. "This is a special place I equate with Thoreau's Walden Pond."

Tennessee, U.S.A.

POSITION: 87°00'W, 36°00'N
TIME: 7:00 A.M.

Willard Clay

CAMBO 4X5, 120MM, F/45, EXPOSURE UNRECORDED.

Illinois, U.S.A.

POSITION: 88°00'W, 42°00'N
TIME: 9:30 A.M.

Dead River Vibrance

Reeds reflect the amber light of mid-morning in the frozen Dead River along Lake Michigan. The Dead River, at Illinois Beach State Park, is an important wildlife wetlands habitat.

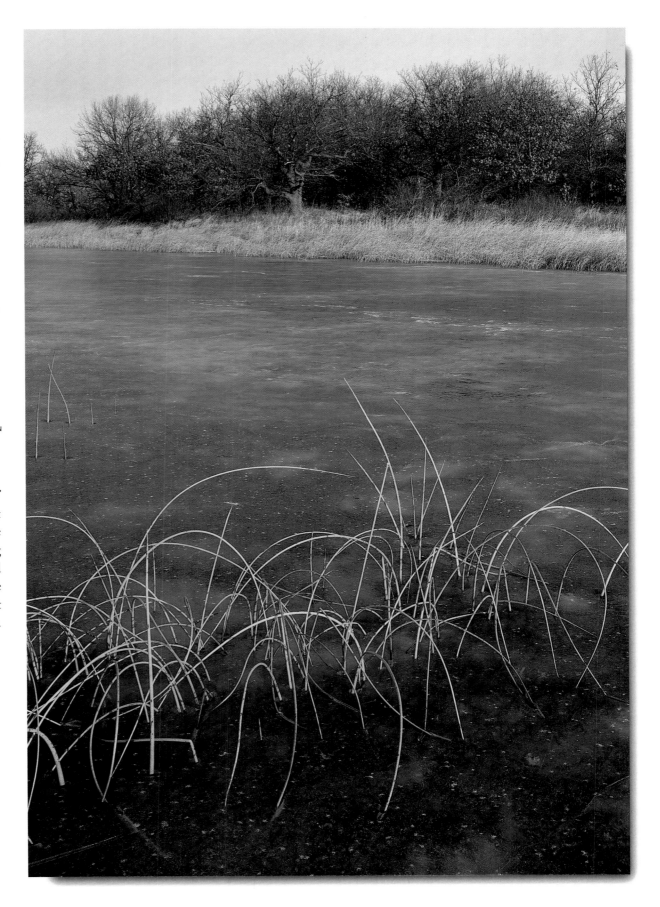

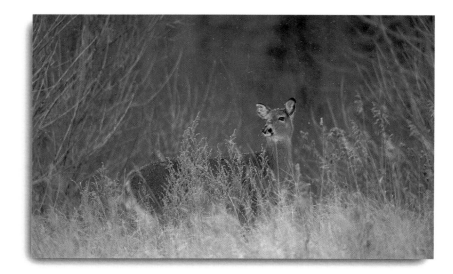

Jim Brandenburg

NIKON F-100, 500MM LENS, F/4 AT 1/500 SEC., FUJICHROME PROVIA 100F PUSHED ONE STOP TO ISO 200 FILM (DOE); NIKON N90S, 300MM LENS, F/2.8 AT 1/125 SEC., PROVIA 100F FILM (JAY); HASSELBLAD XPAN 35MM PANORAMIC FORMAT, 45MM LENS, F/8 AT 1/125 SEC., PROVIA 100F FILM (WOLVES).

Minnesota, U.S.A.

POSITION: 92°00'W, 48°00'N
TIME 7:30 A.M. TO 4:30 P.M.

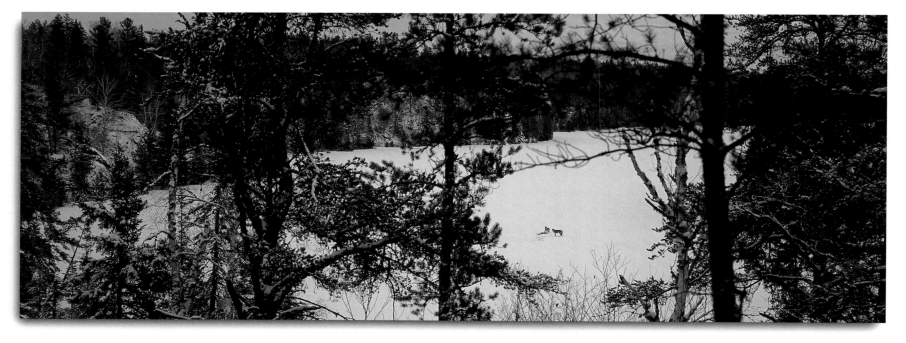

Cycle of Sustenance

In northern Minnesota's Boundary Waters Canoe Area Wilderness ecosystem, the interrelationships of predator, prey, and scavenger species exemplify cycles of life and death that occur every day throughout the planet. Here, timber wolves depend for their sustenance on the wealth of white-tailed deer herds. In turn, gray jays, ravens, and other animals feed on carcasses the wolves leave behind, which ultimately decompose and rejuvenate the soil for a new generation of herbivores. A white-tailed doe forages for food in a midmorning snowfall, always on the alert for its prime predator, the timber wolf; a pair of wolves challenge each other over a deer carcass at dawn; and a gray jay finds an opportunity for nourishment toward sundown, after the day's fray. "I always feel fortunate just to see a wolf, let alone photograph one. Today, I was lucky."

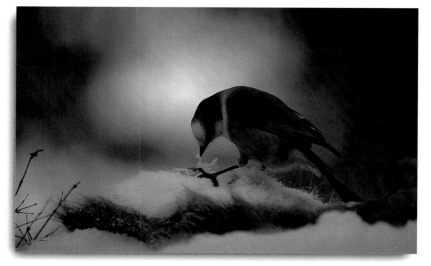

Mike Macri

NIKON FM2, NIKKOR 35MM 1.4 LENS, F/1.4 AT
15 SEC., FUJICHROME PROVIA 100F FILM.

Manitoba, Canada

POSITION: 94°11'W, 58°45'N
TIME: 12:10 A.M.

New Year's Fireworks

On a clear night, when conditions are right, charged particles from solar events collide with the Earth's atmosphere at the poles, causing the air to glow, a phenomenon called aurora borealis in the Northern Hemisphere and aurora australis in the Southern Hemisphere. Mike photographed these "northern lights" near his cabin on the Churchill West Peninsula in Manitoba.

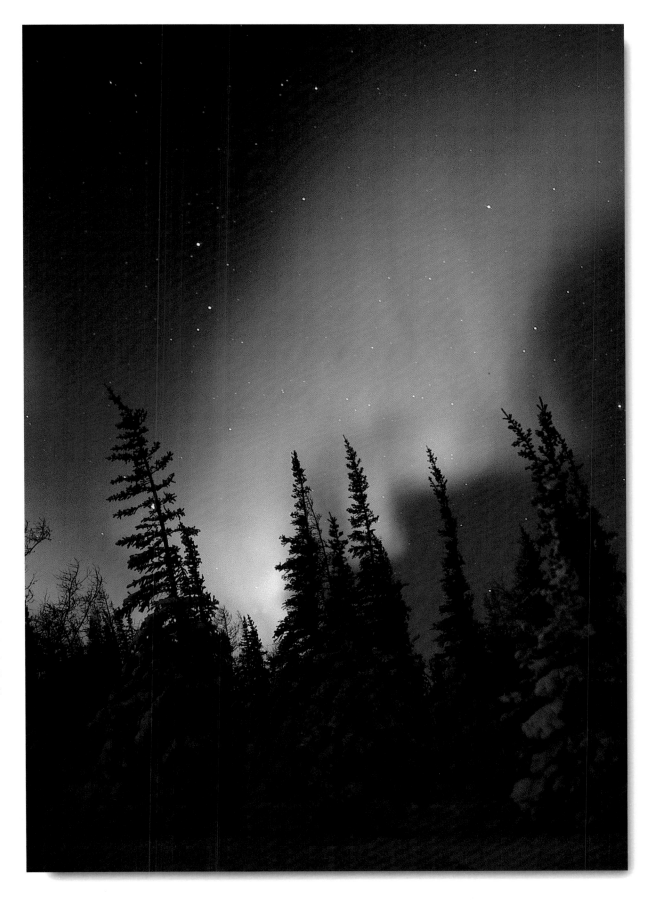

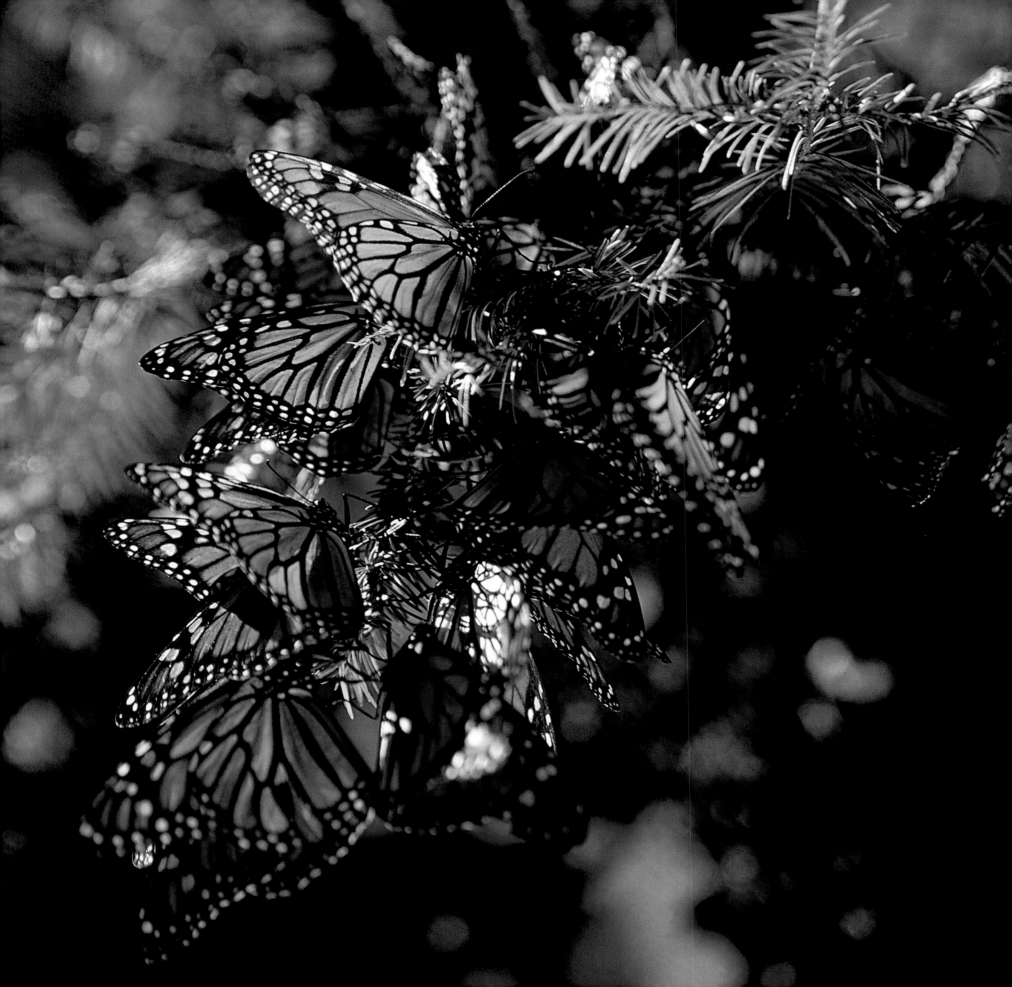

John Shaw

NIKON F5, NIKON 28-70MM LENS, GITZO TRIPOD, F/16, EXPOSURE UNRECORDED.

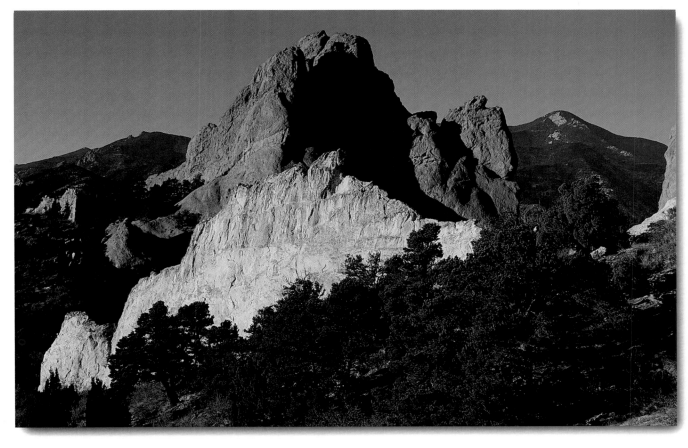

Colorado, U.S.A.

POSITION: 105°00'W, 39°00'N
TIME: 9:00 A.M.

Shimmering Stone

Garden of the Gods, at the base of the Rocky Mountains in Colorado Springs, Colorado, is an area of giant sandstone fins jutting upward. "Weather on January 1 was extremely varied. There was a thick cloud bank in the east at sunrise, but once the sun cleared that, it was a cloudless blue-sky day until about 1 p.m. Clouds rolled in, and we had snow squalls, which turned into a real snowstorm by nightfall."

◄ Carlos Hahn

CANON T90, 50MM, F/8 AT 1/30 SEC.

Forest Flutter

Monarch butterflies swarm by the thousands in the mountainous Santuario El Rosario reserve north of Angangueo, Mexico. Each year, the insects migrate to the forests of Michoacan state from across North America.

Mexico

POSITION: 100°18'W, 19°40'N
TIME: 10:00 A.M.

83

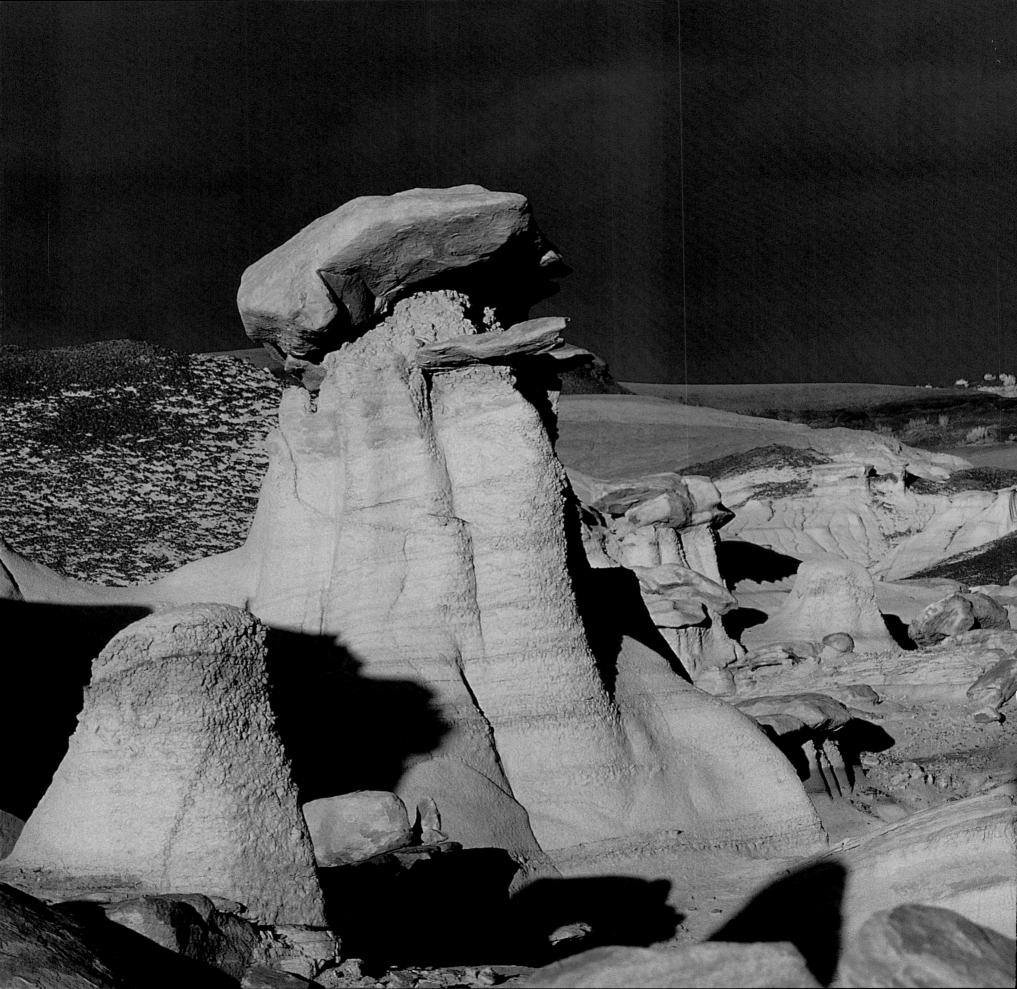

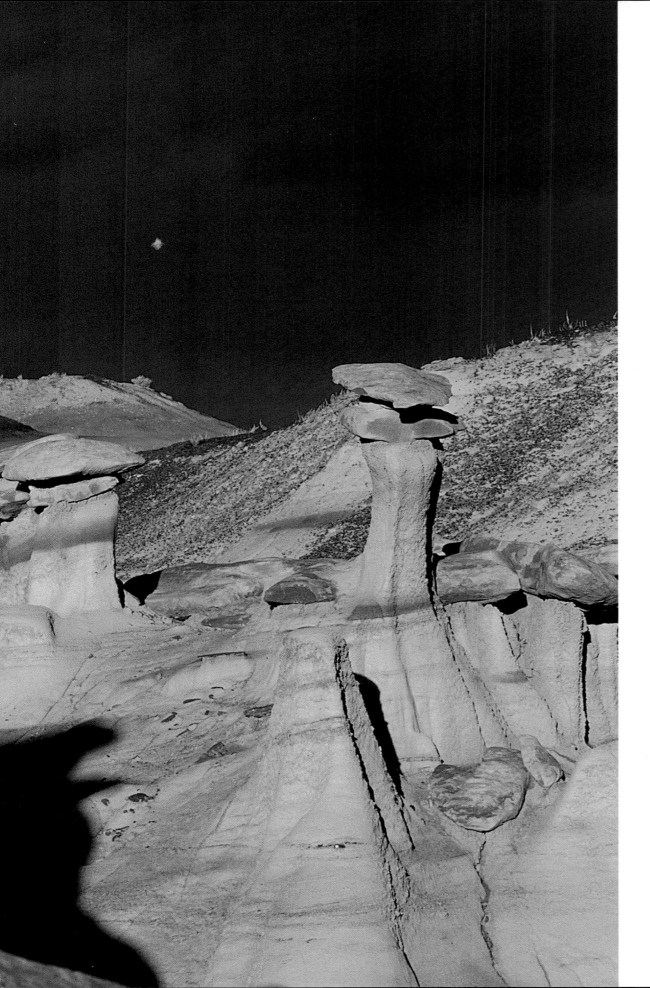

Michael Mauro

CANON EOS 3, 20-35MM ZOOM, F/22 AT 1/4 SEC.

New Mexico, U.S.A.

POSITION: 108°14'W, 36°16'N
TIME: 3:05 P.M.

New Light on Ancient Land

The Bisti Badlands Wilderness in northwestern New Mexico features canyons and sandstone hoodoos eroded over eons. Once teeming with prehistoric life, its barren landscape is filled with fossils. "I chose a location I had not photographed before so that my images of New Year's Day would be as new to me as they would be to others who see them. I hiked 8 miles starting at two hours before sunrise through rain, snow, wind and mud until the light in this shot finally arrived."

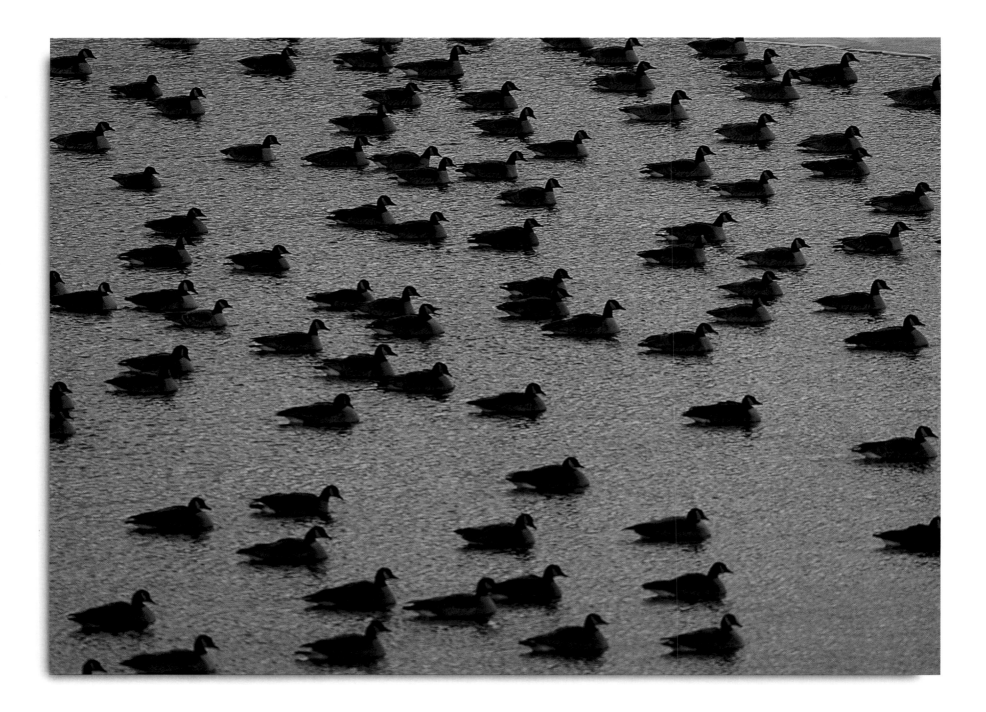

Wendy Shattil and Bob Rozinski

CANON EOS3, 600MM LENS, F/13 AT 1/30 SEC.

Fleet of Geese

Canada geese bob in a pocket of open water in the pre-dawn light at Colorado's Roxborough State Park. "This pattern caught our eye." The balance of the morning was spent photographing red rock formations, cottontail rabbits, a black-tailed prairie dog, and other animals.

Colorado, U.S.A.

POSITION: 105°06'W, 39°25'N
TIME: 7:10 A.M.

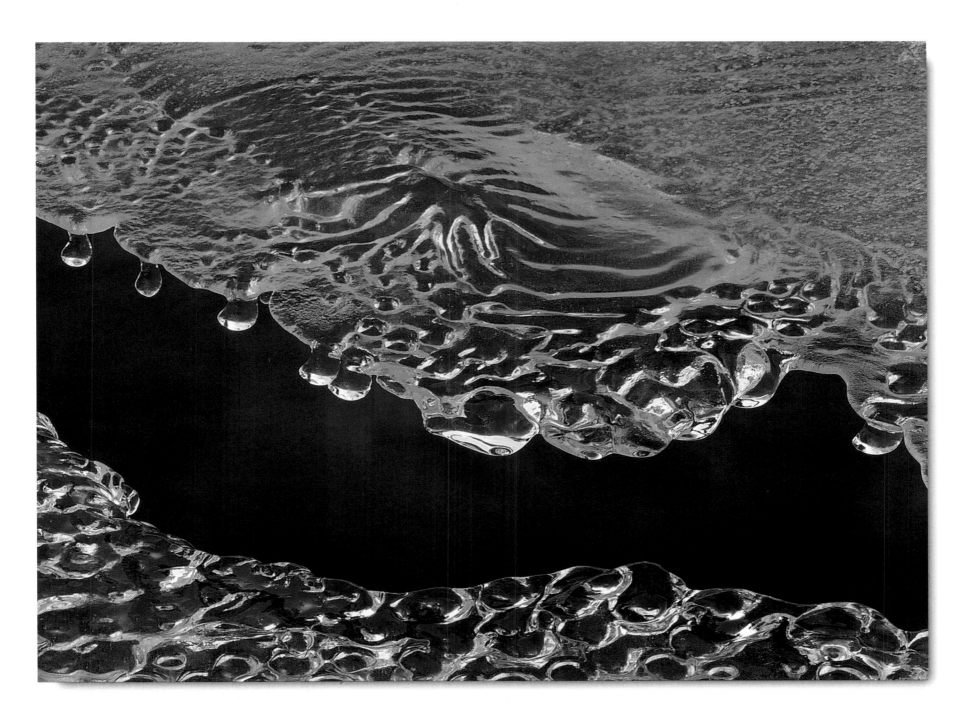

Jenny Hager

NIKON F4, 180MM LENS, F/32, AT 2 SEC.

Colorado, U.S.A.

POSITION: 105°00'W, 40°00'N
TIME: 1:00 P.M.

Another World

Ice along Boulder Creek in Boulder Canyon, Colorado, has an other-worldly look close up. "I had envisioned photographing snow-covered peaks, but they were socked-in getting fresh snow they hadn't had for weeks. So, I worked for a few hours trying to come up with something. Finally, I resorted to the 'macro' world."

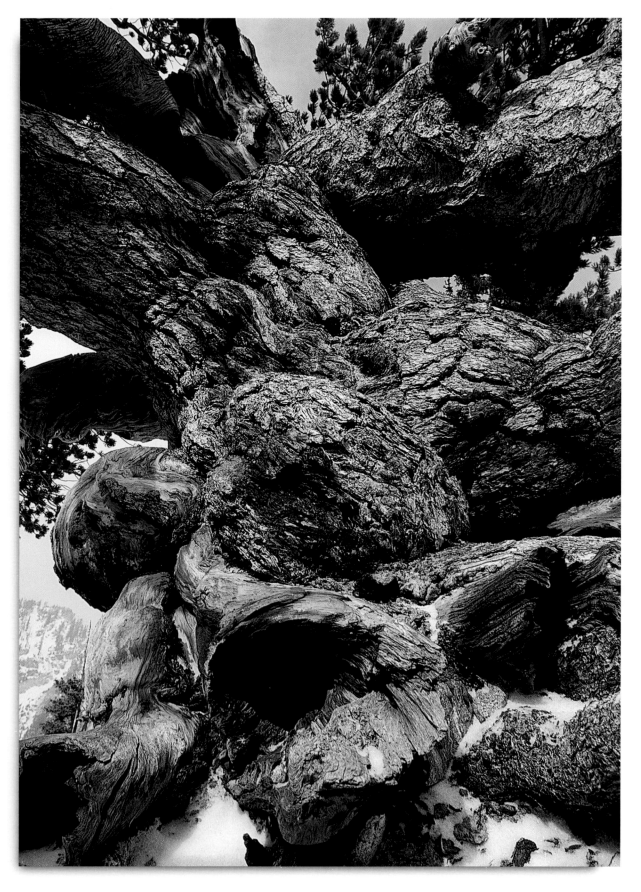

Glenn Randall

NIKON F4, 20MM NIKKOR LENS, F/22 AT 1/30 SEC.

Colorado, U.S.A.

POSITION: 105°39'W, 40°18'N
TIME: 10:15 A.M.

Hearty Limber

Limber pines near Lake Haiyaha, in Colorado's Rocky Mountain National Park, stand in high altitude, rocky terrain, exposed to powerful winds. The oldest of these trees average 700 years. "I chose to photograph this tree because it symbolizes nature's ability to endure."

Kathleen Norris Cook

FUJI GX 617, FUJINON W 180MM 1:6.7 LENS, F/22 AT 1 SEC., FUJICHROME VELVIA FILM PUSHED 3/4 STOP.

Colorado, U.S.A.

POSITION: 107°00'W, 38°00'N
TIME: 7:20 A.M.

The One That Got Away

A storm system at sunrise obliterates the mountain vistas from Horsefly Mesa in Colorado's San Juan Mountains (top, on January 1). "I scouted for a week in many of my favorite locations, and as I scouted, I shot film (bottom, on December 31). So, I do have a record of what might have been on New Year's Day."

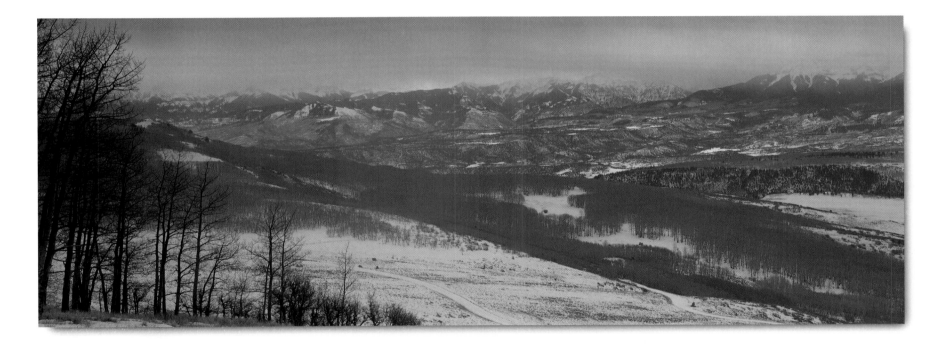

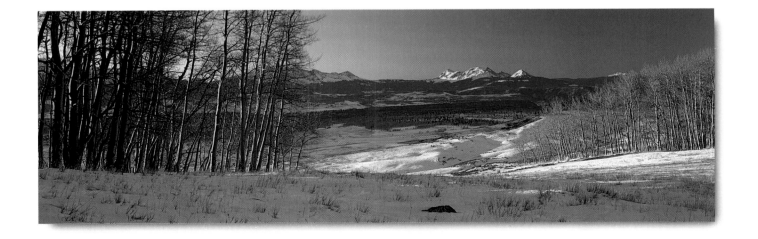

89

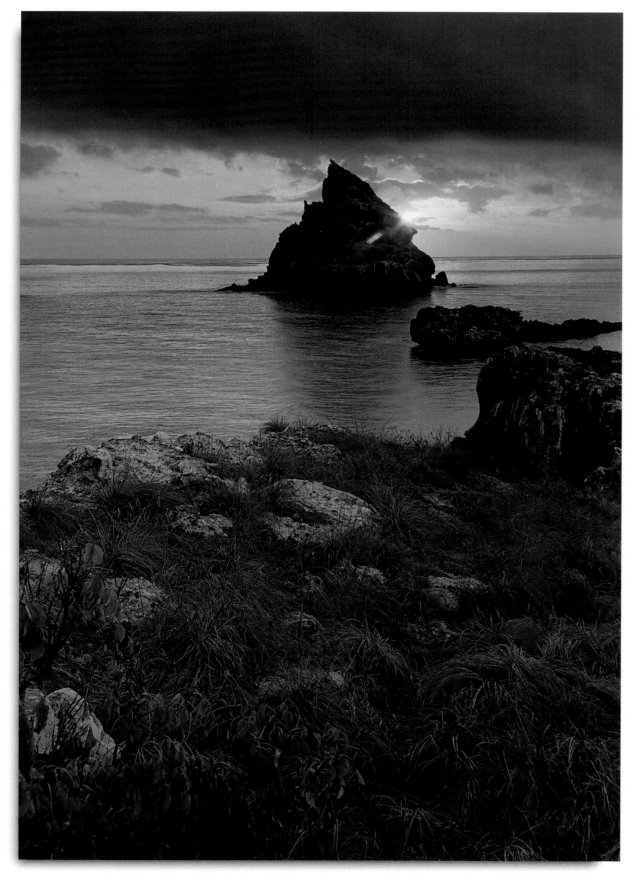

Pablo Cervantes

NIKON F4S, 80-200MM ZOOM AND FILL FLASH, F/16 AT 1/125 SEC., FUJICHROME ASTIA FILM.

Mexico

POSITION: 105°54'W, 21°52'N
TIME: 6:50 A.M.

Offshore Oasis

Sunrise illuminates Las Monas, a rock at Isla Isabela, just off the Nayarit coast, Mexico. Isabela Island is a national park where Pablo has often returned to create images of the landscape and its creatures, including rock crabs, frigatebirds, brown pelicans, blue-footed boobies, red-billed tropic birds, great blue herons, hummingbirds, and others. "I see beauty and drama here. It is one of the most spectacular and peaceful places I know."

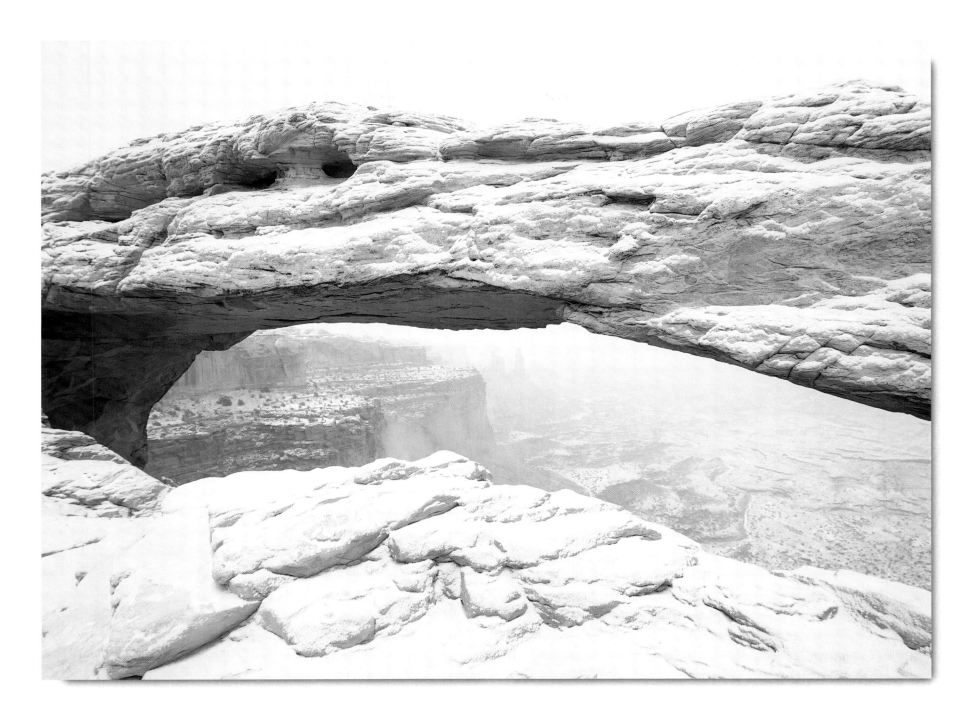

Utah, U.S.A.

POSITION: 109°30'W, 38°30'N
TIME: 8:15 P.M.

Tom Till

TOYO FIELD 45AII, 180MM LENS, F/64 AT 8 SEC., FUJICHROME VELVIA FILM.

Atypical Arch

Snow falling on Mesa Arch in Arches National Park is a rare sight on New Year's Day, according to Tom, who has lived in and photographed the landscape surrounding Moab for 25 years. Normally, the sandstone formation is bathed in an orange-red glow of sunlight reflected off the cliff below it, making it a popular site for sunrise photography.

91

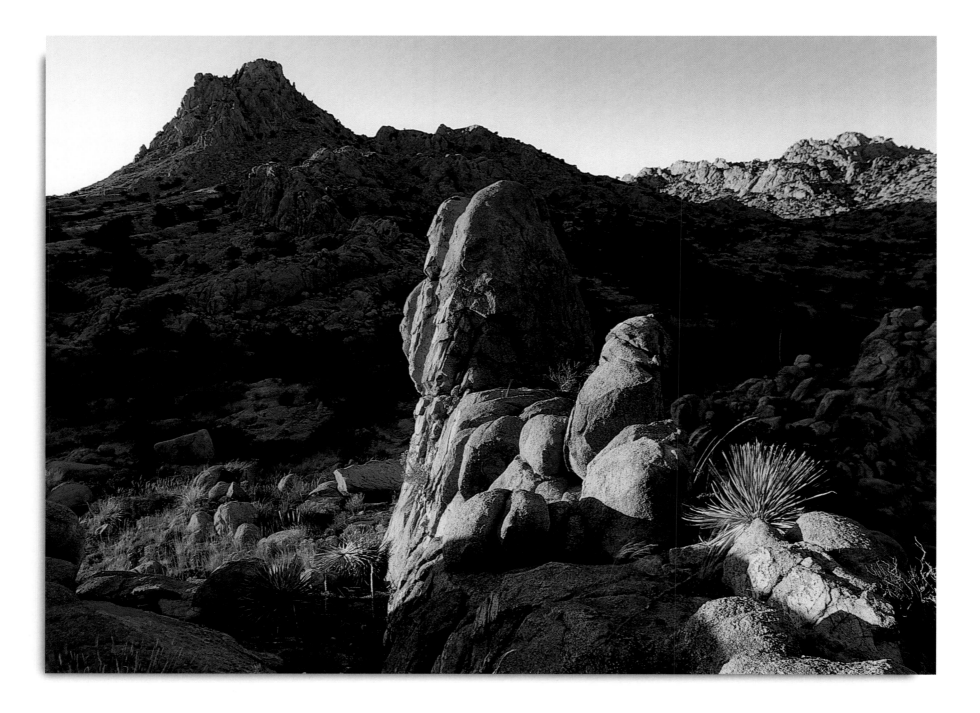

Mills Tandy

NIKON FE2, 20MM NIKKOR LENS, F/8 AT 1/8 SEC., FUJICHROME VELVIA FILM.

Dragoons at Sundown

Sandwiched between days featuring dramatic clouds and light, Mills encountered clear skies for photographing the Slavin Gulch area of southeastern Arizona's Dragoon Mountains, which features eroded Tertiary granite that harbors montane flora and fauna typical of the Sierra Madre Occidental of western Mexico.

Arizona, U.S.A.

POSITION: 110°00'W, 32°00'N
TIME: 5:15 P.M.

Michael H. Francis

CANON EOS3, 70-200MM ZOOM LENS,
EXPOSURE UNRECORDED.

Wyoming, U.S.A.

POSITION: 110°30'W, 44°30'N
TIME: 12:30 P.M.

Alone at Daybreak

Deep snowdrifts bury this tree and the volume of tourist traffic at Yellowstone National Park, Wyoming. Michael spotted this treetop in Hayden Valley. "It takes a hearty tree to survive in this area, as snowdrifts are often more than 20 feet deep." Although the park receives 3.5 million visitors annually, he and his wife had the popular Artist Point overlook all to themselves for the first sunrise of 2000.

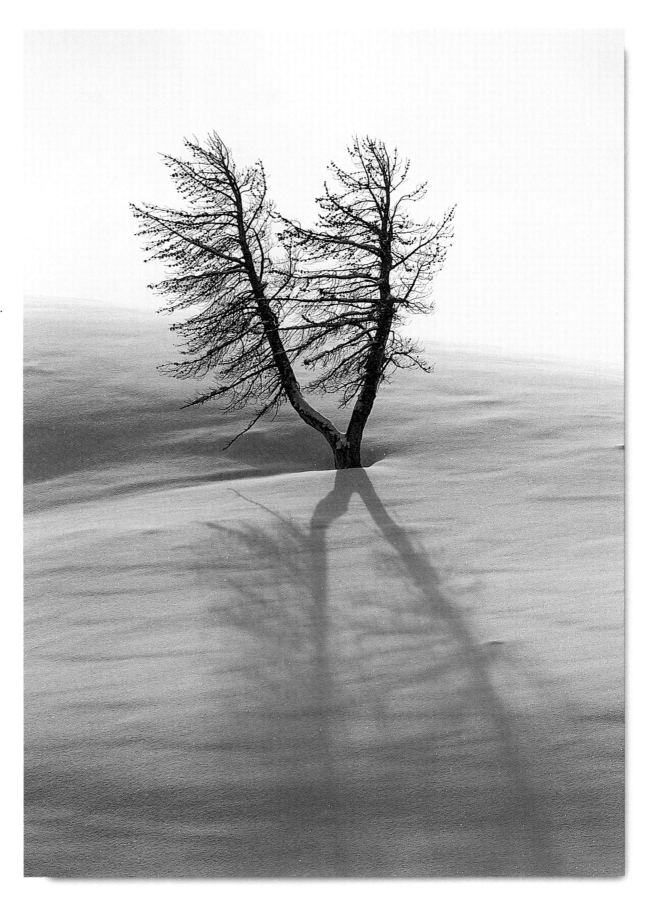

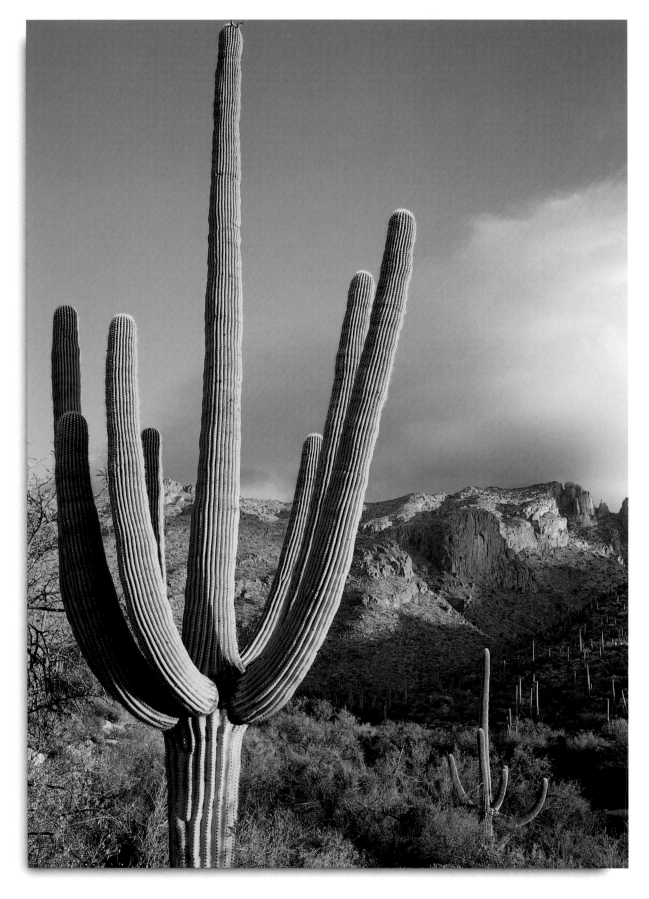

James Randklev

WISTA, 45SP, 135MM NIKKOR, 1 SEC.,
FUJICHROME VELVIA FILM.

Arizona, U.S.A.

POSITION: 111°00'W, 32°00'N
TIME: 7:50 A.M.

Sunrise Sentinels

Giant saguaro and ocotillo
are prominent features in
Finger Rock Wilderness,
Coronado National Forest,
in Arizona's Catalina
Mountains.

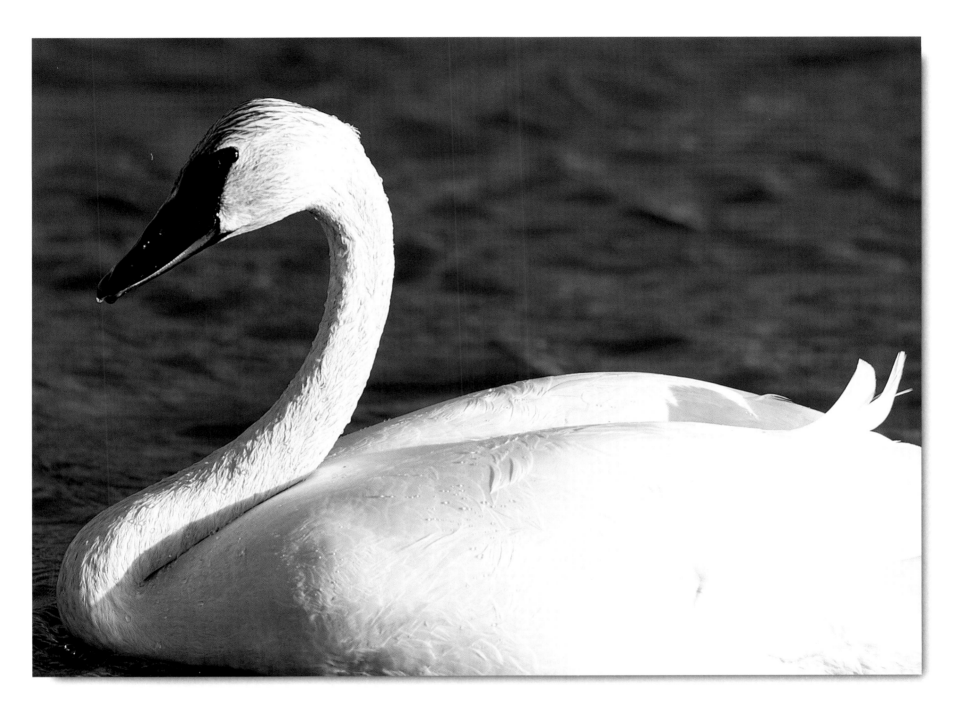

Windland Rice

NIKON N90S, 500MM LENS, F/8 AT 1/125, FUJICHROME VELVIA FILM.

Wyoming, U.S.A.

POSITION: 110°30'W, 43°30'N
TIME: 3:30 P.M.

Comeback Story

The largest of North American waterfowl, the trumpeter swan was once near extinction. Since the early 1930s, when 69 of the birds were counted in the contiguous United States, the total population in the U.S. and Canada now stands at around 10,000— thanks in part to breeding programs and protection legislation. Windland photographed this swan feeding on Flat Creek at National Elk Refuge in Jackson Hole, Wyoming.

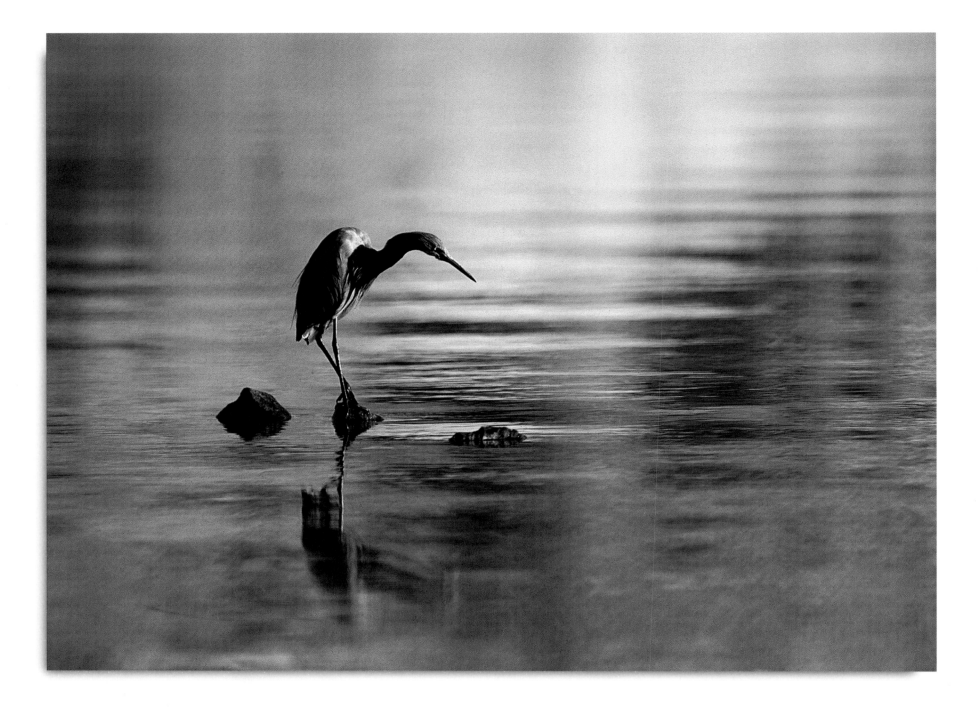

John Weller

NIKON F5, 600MM 4.0 AF-S NIKKOR LENS, F/4 AT 1/640 SEC., FUJICHROME PROVIA 100F FILM.

Hidden Hunter

Intent and unseen by its prey, a reddish egret searches for minnows
in the tidal zone of Bahia Concepcion, Baja California Sur, Mexico.

Mexico

POSITION: 112°00'W, 27°00'N
TIME: 9:30 A.M.

Jeff Foott

ARCA SWISS 4X5, 90MM, F/32 AT 4 SEC.

Utah, U.S.A.

POSITION: 112°25'W, 37°49'N
TIME: 1:45 P.M.

Chasing a Waterfall

Darting from a snowstorm in Bryce Canyon National Park, Utah, after shooting numerous rolls at Queen's Garden, Jeff found blue sky at the Hoodoos in Grand Staircase Escalante National Monument and this view of Lower Calf Creek Falls. "I jogged 45 minutes with my 4x5 to reach the falls in good light."

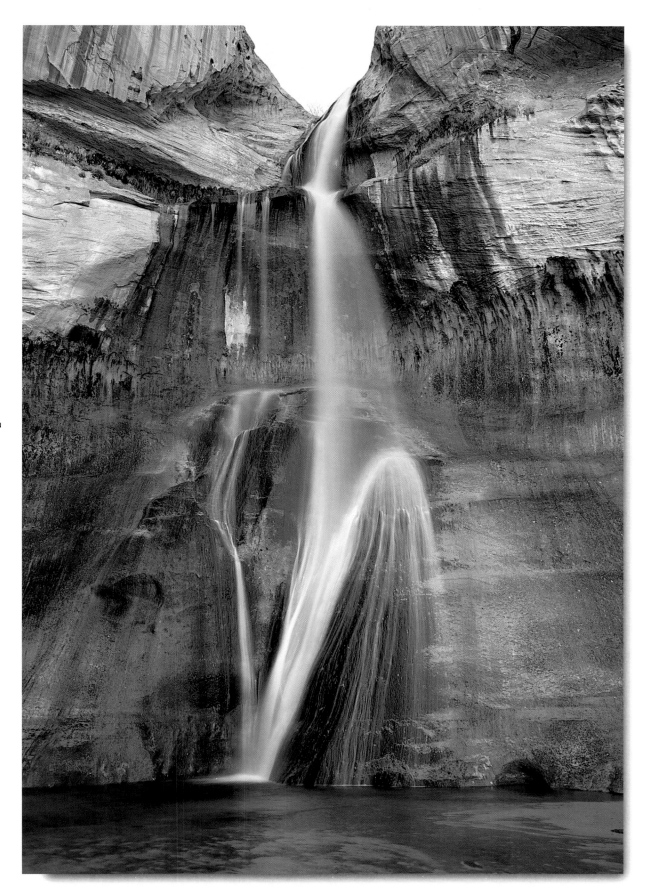

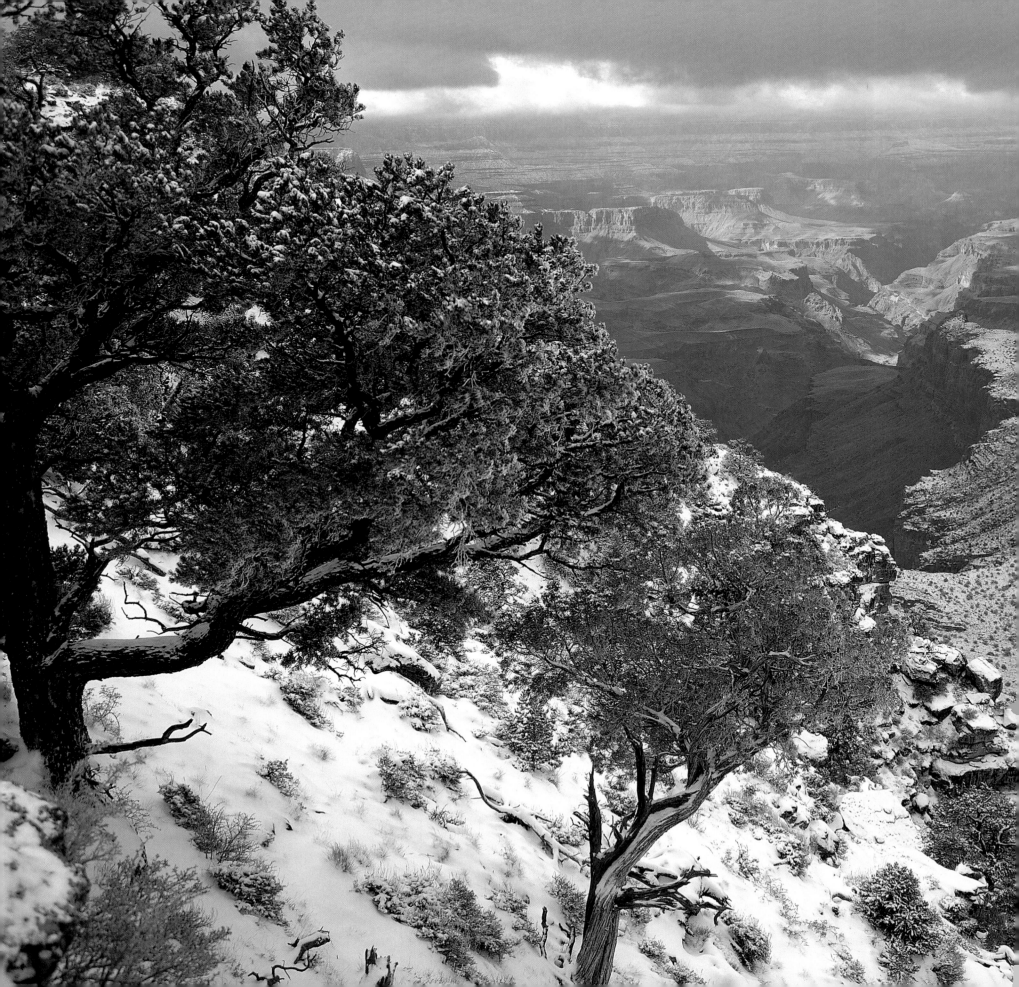

Jack Dykinga
ARCA-SWISS FC LINE, SCHNEIDER 75MM SUPER ANGULON LENS, F/32 AT 8 SEC.

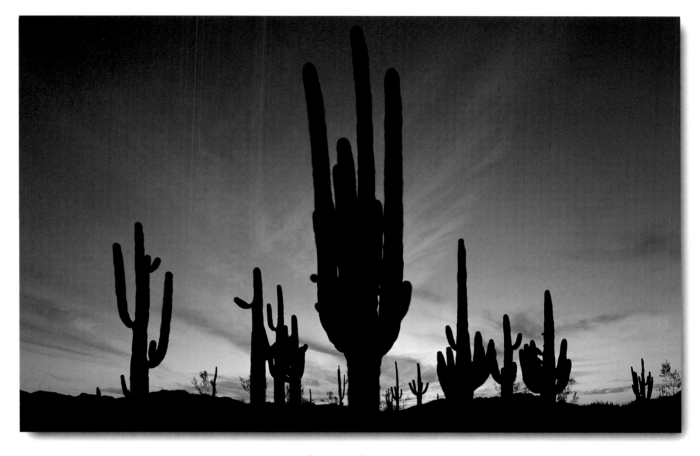

Arizona, U.S.A.

POSITION: 113°15'W, 32°00'N
TIME: 7:30 P.M.

Saguaro Sunset

These saguaro cacti in Arizona's Cabeza Prieta National Wildlife Refuge stand in what may become Sonoran Desert National Park, under a conservation proposal being studied by the United States Congress.

◀ Tom Bean
PENTAX 6X7, WIDE-ANGLE LENS, F/11 AT 1/60 SEC.

Winter Respite

After a snowstorm blanketed Grand Canyon National Park on New Year's Eve and New Year's Day—the first measurable precipitation in northern Arizona in a record 99 days—sunlight broke through the clouds to illuminate the canyon below at the South Rim overlook near Desert View.

Arizona, U.S.A.

POSITION: 112°00'W, 36°00'N
TIME: 12:30 P.M.

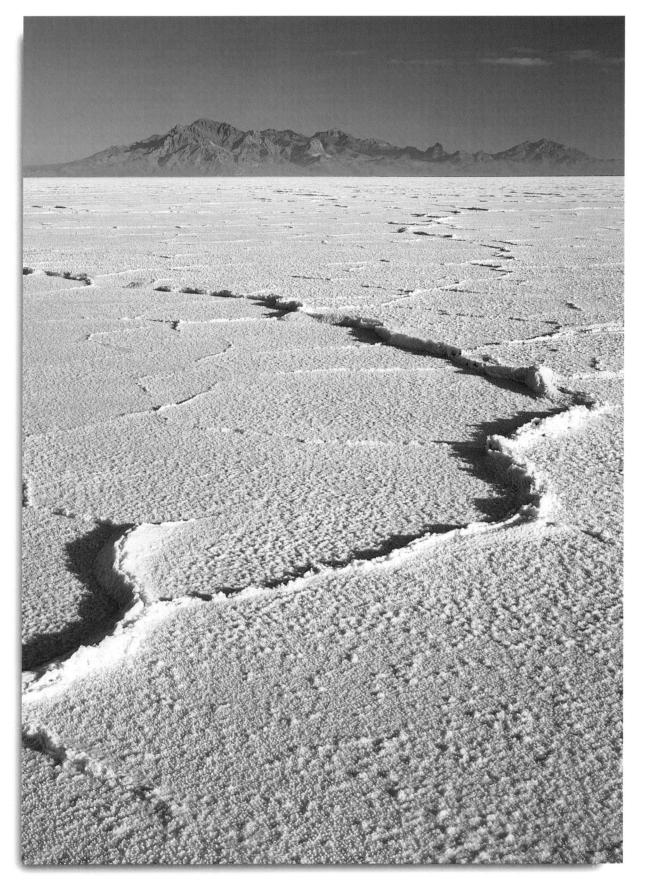

Scott T. Smith

TOYO 45A, 90MM LENS, F/45 AT 2 SEC.,
POLARIZER, FUJICHROME PROVIA FILM.

Utah, U.S.A.

POSITION: 113°30'W, 40°30'N
TIME: 9:15 A.M.

Salt of the Earth

Like nomads wandering through the desert, shallow pools of water drift in wind currents around the dry lake bed at Bonneville Salt Flats in the Great Salt Lake Desert. As the water recedes, salt crystals form criss-cross pressure ridges as the molecules expand in a liquid-to-solid metamorphosis. The Silver Island Mountains stand in the distance.

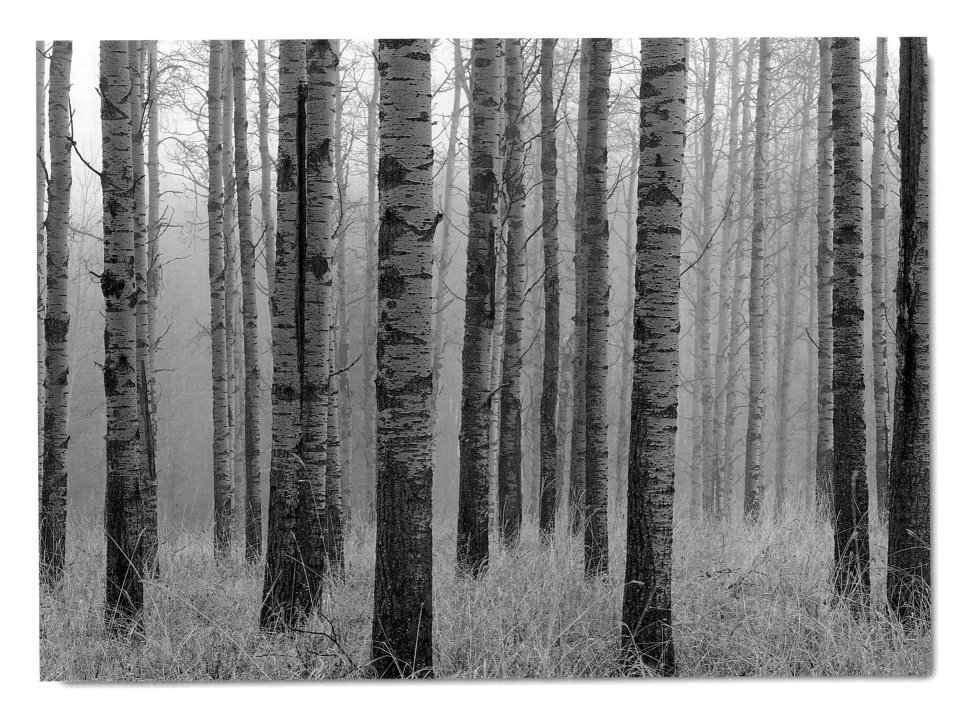

Darwin Wiggett

MAMIYA 645 PRO, 150 MM LENS WITH A WARMING FILTER, F/16, EXPOSURE NOT RECORDED, FUJI PROVIA 100F FILM.

Alberta, Canada

POSITION: 114°00'W, 51°00'N
TIME: 11:00 A.M.

Forest Fog

Fog enshrouds an aspen forest in the foothills behind Darwin's home in Water Valley, Alberta. Large tracts of intact forest are rare in this region of Canada. "These forests are endangered from two sources—clearing for agriculture and logging for paper pulp mills."

101

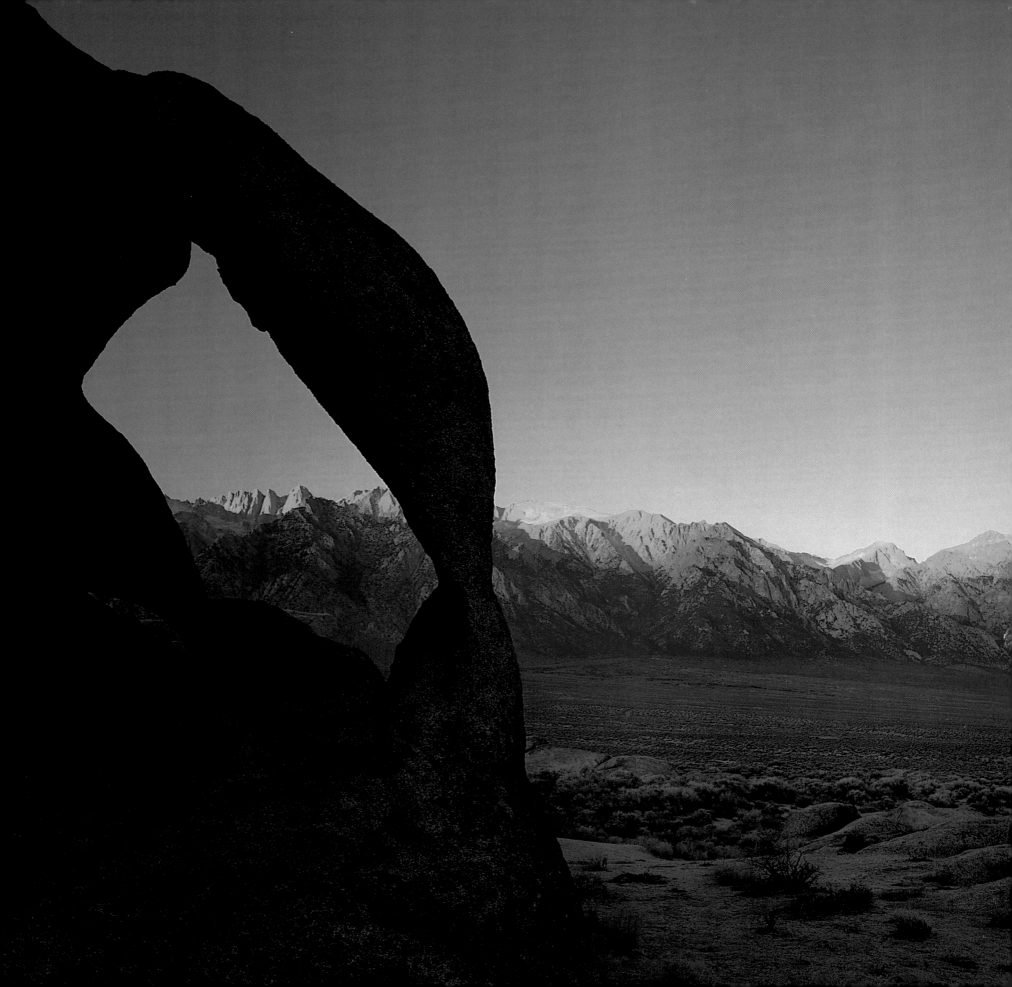

David Muench

LINHOF TECKNIKA IV, 75MM NIKKOR LENS,
F/22 AT 1/2 SEC., FUJICHROME VELVIA FILM.

California, U.S.A.

POSITION: 118°00'W, 36°30'N
TIME: 7:00 A.M.

Sacred Ground

One span of a triple arch in California's Alabama Hills frames the ridgeline of the Sierra Nevadas at sunrise, including Mt. Whitney. "To me, this location, at the base of Mt. Whitney, is a sacred place on this planet."

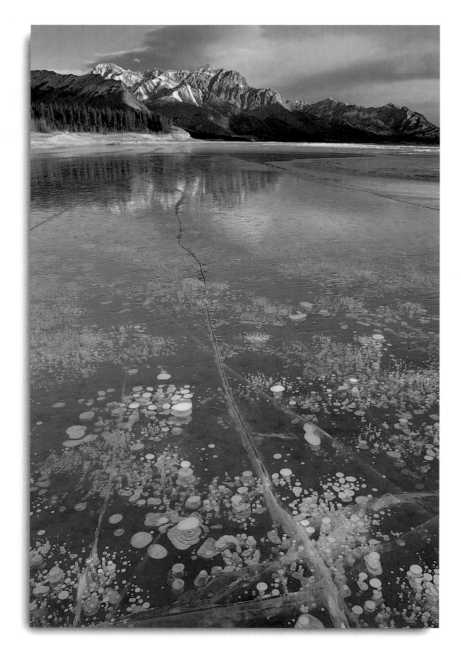

Daryl Benson
PENTAX 645, 45-85MM ZOOM, F/22 AT 25 SEC.

Alberta, Canada

POSITION: 117°00'W, 51°54'N
TIME: 7:00 A.M.

Frozen River

Ice bubbles, and cracks and pressure ridges form on the frozen, wind-swept North Saskatchewan River, Koontenay Plains, Alberta. This area of Canada is in a rain shadow and often has clear skies when the rest of the mountains are clouded. Prevailing winds keep snow from accumulating on the ice in winter. "If you arm yourself with very warm clothing and a good set of ice cleats, you can wander out into the river's surface and explore these features."

California, U.S.A.

POSITION: 118°00'W, 34°00'N
TIME: 9:20 A.M.

Robert Glenn Ketchum ▶
PENTAX 645, 150MM LENS, F/22 AT 1 SEC.

Deciduous Diversity

Morning light in a canyon in the Santa Monica Mountains illuminates native sycamores and extremely southern hardwoods, which find their canopy slowly being crowded by an invasive "silk floss" tree, a South American species that adapts remarkably well. "The Santa Monica Mountains National Recreation Area sits adjacent to Los Angeles, presenting one of the most extraordinary interfaces of wild lands and urban development in the United States."

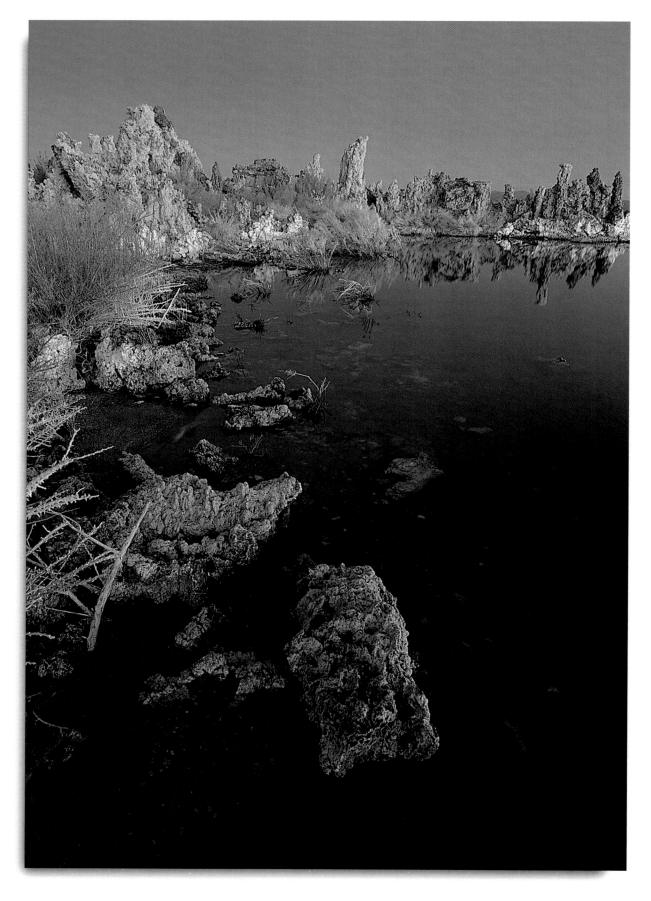

B. Moose Peterson

NIKON F5, 17-35MM 2.8, F/5.6,
SHUTTER SPEED UNRECORDED.

California, U.S.A.

POSITION: 119°00'W, 38°00'N
TIME: 5:35 A.M.

Water Rising

South Tufa Reserve along
the shores of California's
Mono Lake features these
unique structures. After a
recent court ruling reversed
the trend of water diversion
from this major stopover
for millions of migratory
birds, the lake's level has
begun to rise again.

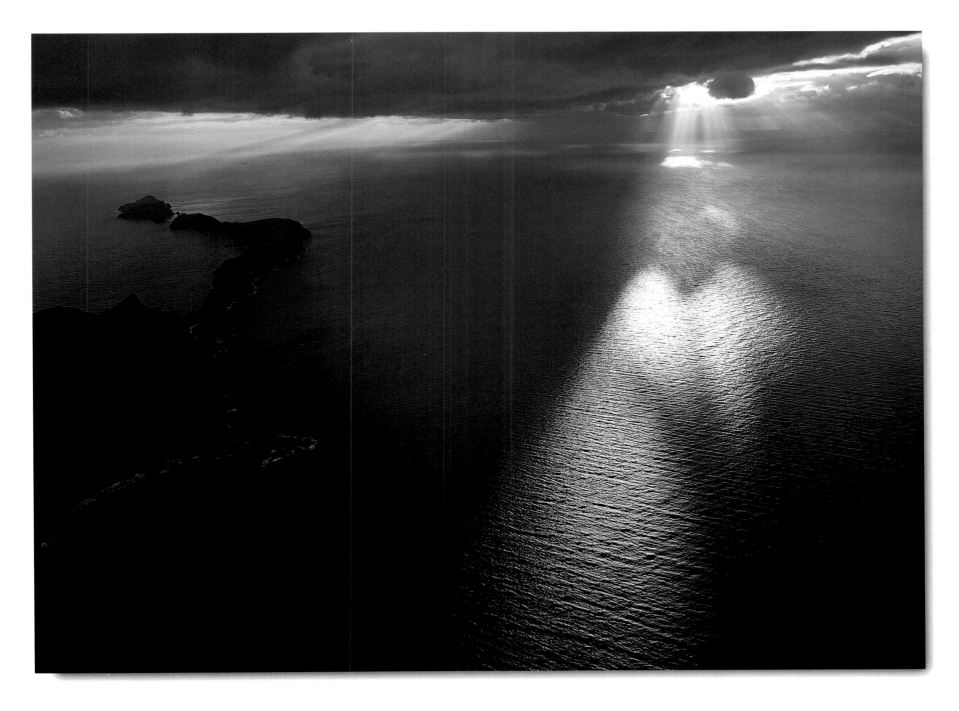

California, U.S.A.

POSITION: 119°30'W, 34°00'N
TIME: 7:50 A.M.

Marc Muench
CONTAX 6X4.5, 35MM LENS, F/3.5 AT 1/125 SEC.

Thriving Islands

Anacapa Island is part of Channel Islands National Park, which encompasses an archipelago off the coast of southern California that is rich in marine mammals, sea birds, and fish habitat. Marc made this image from a helicopter cockpit at 2,500 feet.

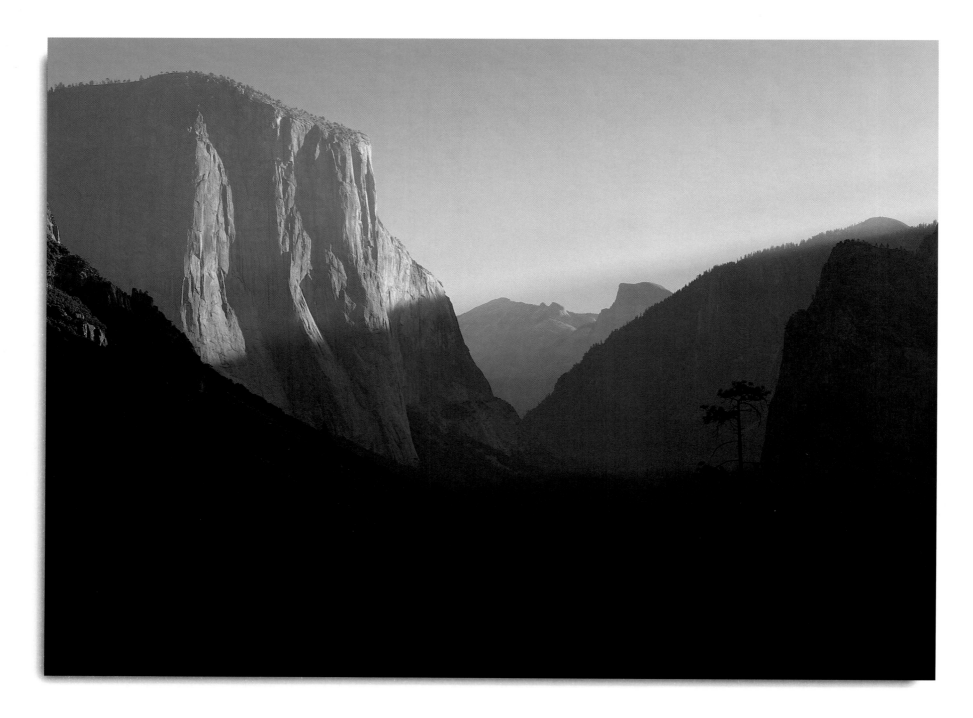

William Neill

WISTA FIELD 45SP, RODENSTOCK SIRONAR-N 210MM 5.6 LENS, F/45 AT 1/2 SEC.

Wilderness Legacy

Half Dome, El Capitan, and Cathedral Rocks, iconic features of Yosemite National Park, California, all can be seen from the Tunnel View overlook. Set aside for preservation by President Abraham Lincoln in 1864, Yosemite is considered the birthplace of the modern conservation movement. "Our decisions about protecting Yosemite today, and forward for the next 100 years, will be watched as a benchmark for our success or failure in protecting and preserving ecosystems and biodiversity worldwide."

California, U.S.A.

POSITION: 119°30'W, 37°30'N
TIME: 8:00 A.M.

Lewis Kemper

WISTA 4X5, 150MM LENS, F/45 AT 30 SEC.

Nevada, U.S.A.

POSITION: 120°00'W, 39°00'N
TIME: 7:15 A.M.

Clear Vision

Third Creek flows into Lake Tahoe near Incline Village, Nevada. Known for its clear water, which is threatened by development, Lake Tahoe is the largest alpine lake in North America. "If man can develop a balance between use and abuse, the lake will remain clear."

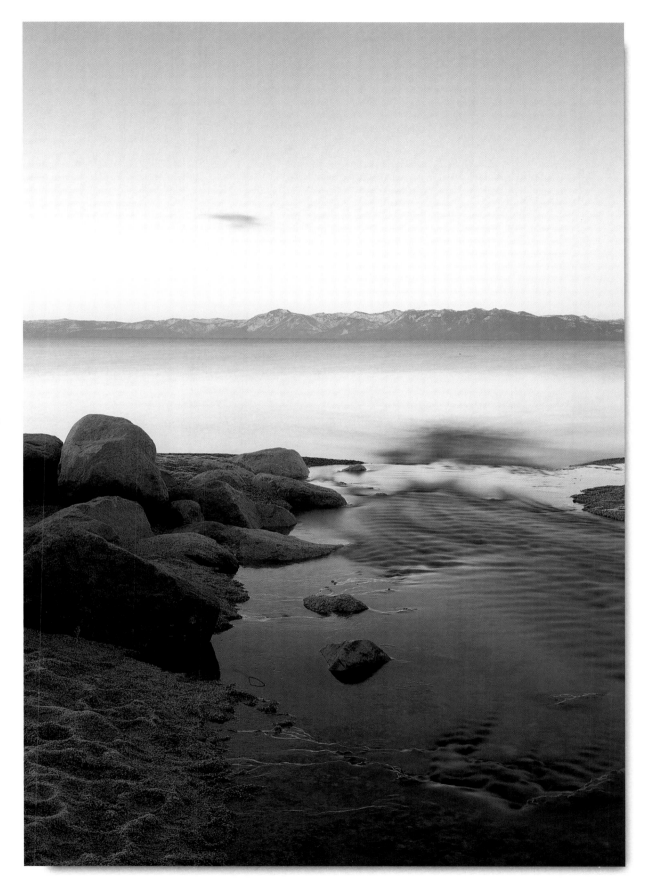

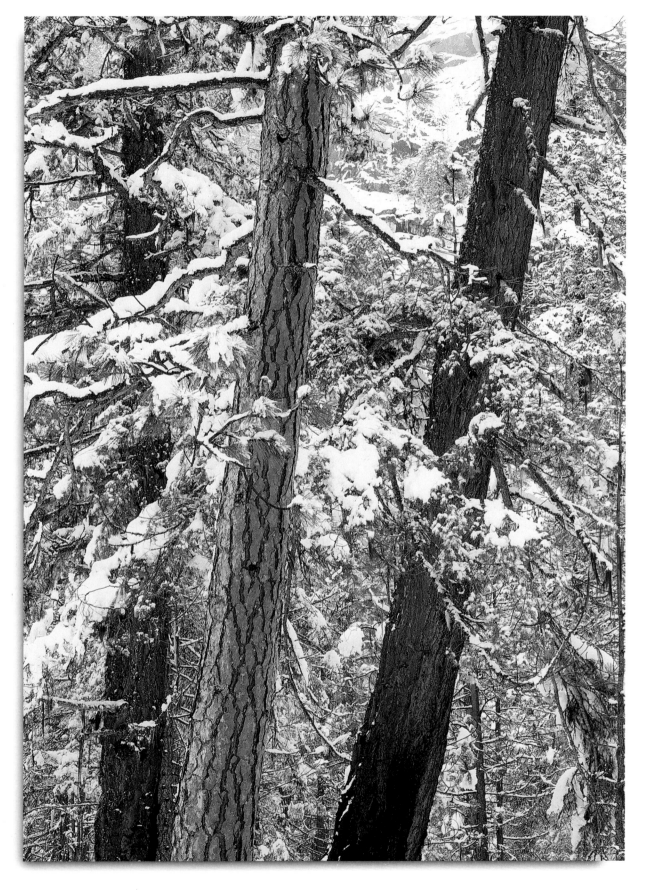

Pat O'Hara

MAMIYA 645 PRO, MAMIYA SEKOR 150MM 3.5 LENS, EXPOSURE UNRECORDED.

Washington, U.S.A.

POSITION: 121°00'W, 48°00'N
TIME: 2:00 P.M.

Rugged and Remote

The light bark of a ponderosa pine contrasts with a sea of winter near Rainbow Falls, in Chelan National Recreation Area, Washington. Nearby Stehekin is the most remote community in the contiguous United States and is at the end of 55-mile-long Lake Chelan, which links the Lake Chelan-Sawtooth Wilderness, North Cascades National Park and Glacier Peak Wilderness.

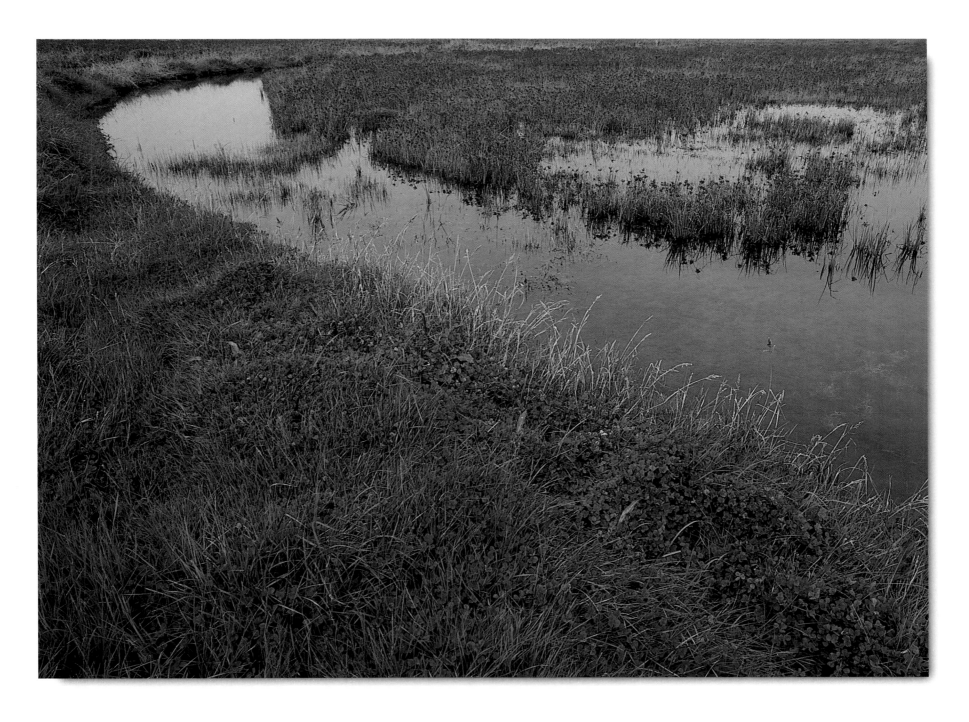

Kerry Drager

California, U.S.A.

NIKON FM2, 24MM LENS, F/16 AT 1/15 SEC., FUJICHROME VELVIA FILM.

POSITION: 121°30'W, 38°30'N
TIME: 9:00 A.M.

Partnership of Preservation

Freshwater wetlands, grasslands, and valley oak riparian forest are
components of the Cosumnes River Preserve, an 11,500-acre preserve
at the eastern edge of the Sacramento–San Joaquin Delta. It is owned
by a partnership of conservation groups and government agencies.
The Cosumnes River is the last undammed river flowing from the
Sierra Nevada range into California's Central Valley.

111

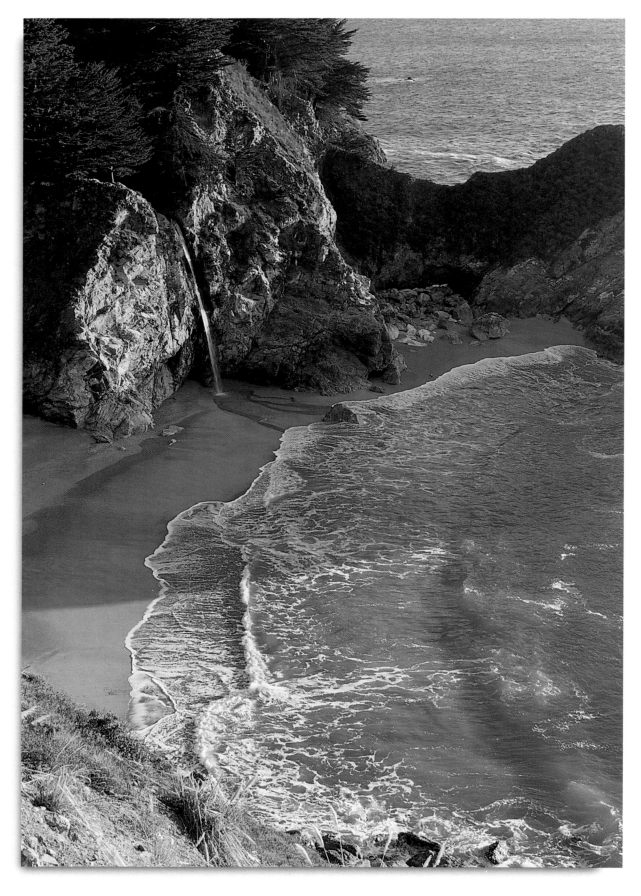

Norbert Wu

NIKON 8008S, 80-200MM 2.8 NIKKOR LENS, EXPOSURE UNRECORDED.

California, U.S.A.

POSITION: 121°30'W, 36°30'N
TIME: 4:00 P.M.

Cozy Cove

Julia Pfeiffer Burns State Park is among the numerous picturesque features of the central California coastline. The day after Norbert made this image, he was on the road again to Antarctica.

Steve Terrill

PENTAX 6X7, 75MM SHIFTLENS, F/22 AT 6 SEC.,
FUJICHROME VELVIA RATED AT 40 ASA.

Oregon, U.S.A.

POSITION: 122°00'W, 45°30'N
TIME: 8:13 A.M.

Scenic Drop

Drifting fog and yellow lichens on a basalt cliff frame Latourell Falls in the Columbia River Gorge National Scenic Area, Multnomah County, Oregon— one of many falls, including well-known Multnomah Falls, to drop into the gorge in Mt. Hood National Forest.

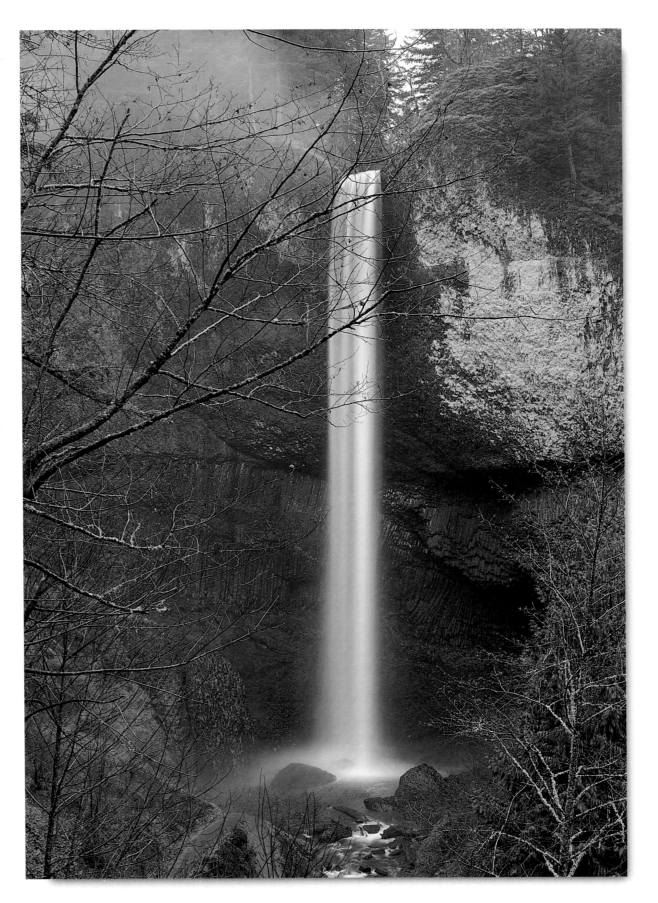

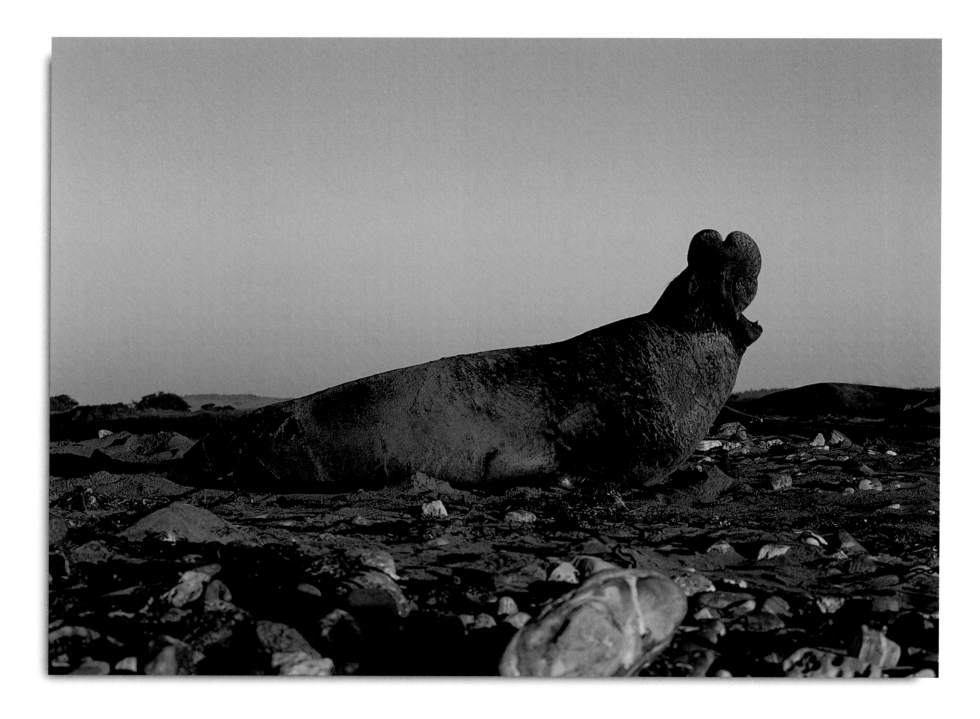

Karen Ward

NIKON F4, 500MM LENS, EXPOSURE UNRECORDED.

California, U.S.A.

Seal Song

An elephant seal calls to others in its rookery at Año Nuevo ("New Year") State Reserve, north of Santa Cruz, California. An endangered species, it is a deep-diving marine mammal that feeds on squid at depths of more than a mile. It is the largest aquatic carnivore in the northern hemisphere, and males can weigh up to 6,000 pounds.

POSITION: 122°00'W, 37°00'N
TIME: 8:20 A.M.

Kennan Ward

NIKON F4, 300MM LENS, EXPOSURE UNRECORDED.

California, U.S.A.

POSITION: 122°00'W, 37°00'N
TIME: 6:10 A.M.

Surf Bird

A marbled godwit forages in the surf in the dawn light at Año Nuevo ("New Year") State Reserve, north of Santa Cruz, California. Toting four cameras and seven lenses as he worked throughout the morning, Kennan also photographed monarch butterflies, a red fox, mule deer, and elephant seals.

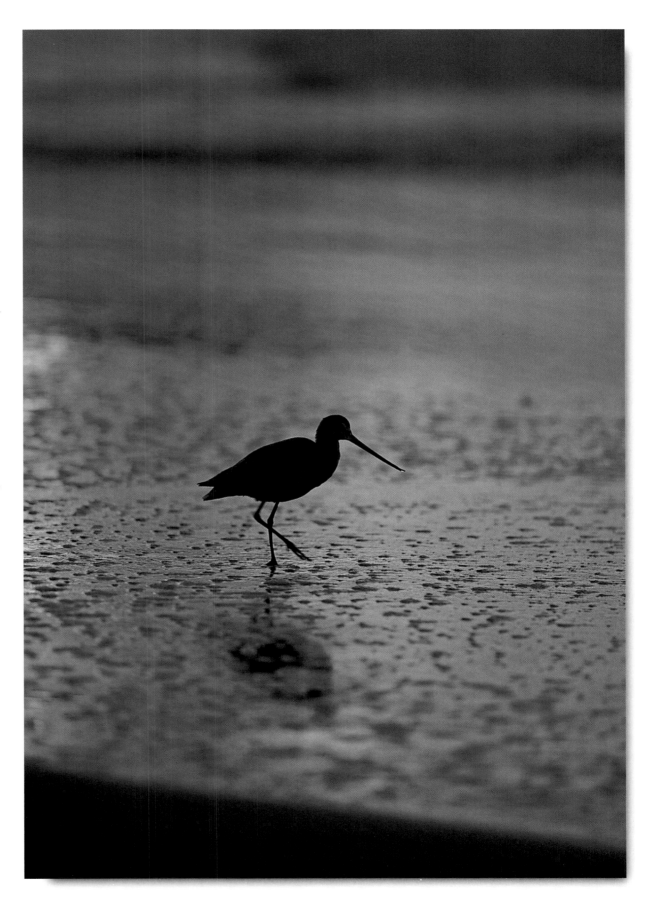

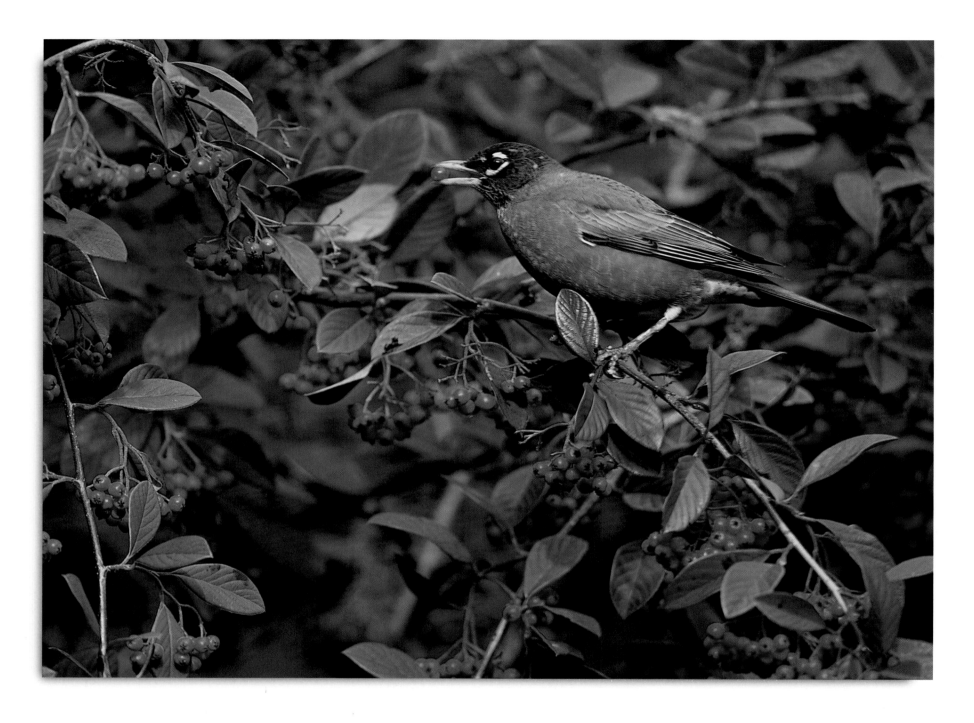

Thomas D. Mangelsen

NIKON F5, 300MM 2.8 LENS WITH A 2X TELECONVERTER, F/8 AT 1/125 SEC.

Berry Blind

A robin feeds on berries in Tomales Bay State Park,
Point Reyes National Seashore, California.

California, U.S.A.

POSITION: 122°52'W, 37°07'N
TIME: 8:20 A.M.

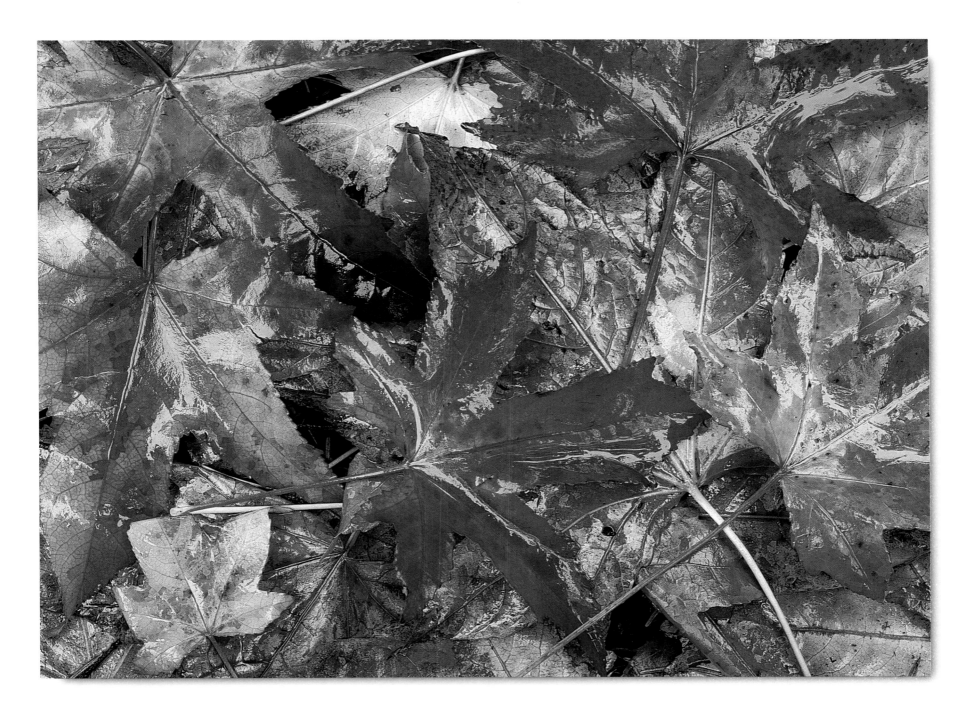

Oregon, U.S.A.

POSITION: 123°00'W, 44°00'N
TIME 9:50 A.M.

Byron H. Dudley
NIKON FM-2, 50MM NIKKOR LENS, F/5.6 AT 1 SEC., FUJICHROME VELVIA FILM.

Autumn Remnants

Fallen leaves carpet the floor of Oregon's Willamette Valley and are pitter-pattered with rain throughout winter. Byron awoke before dawn to the sound of heavy rain on the roof, and then found these sweetgum leaves in the woods outside Eugene on an overcast New Year's Day.

117

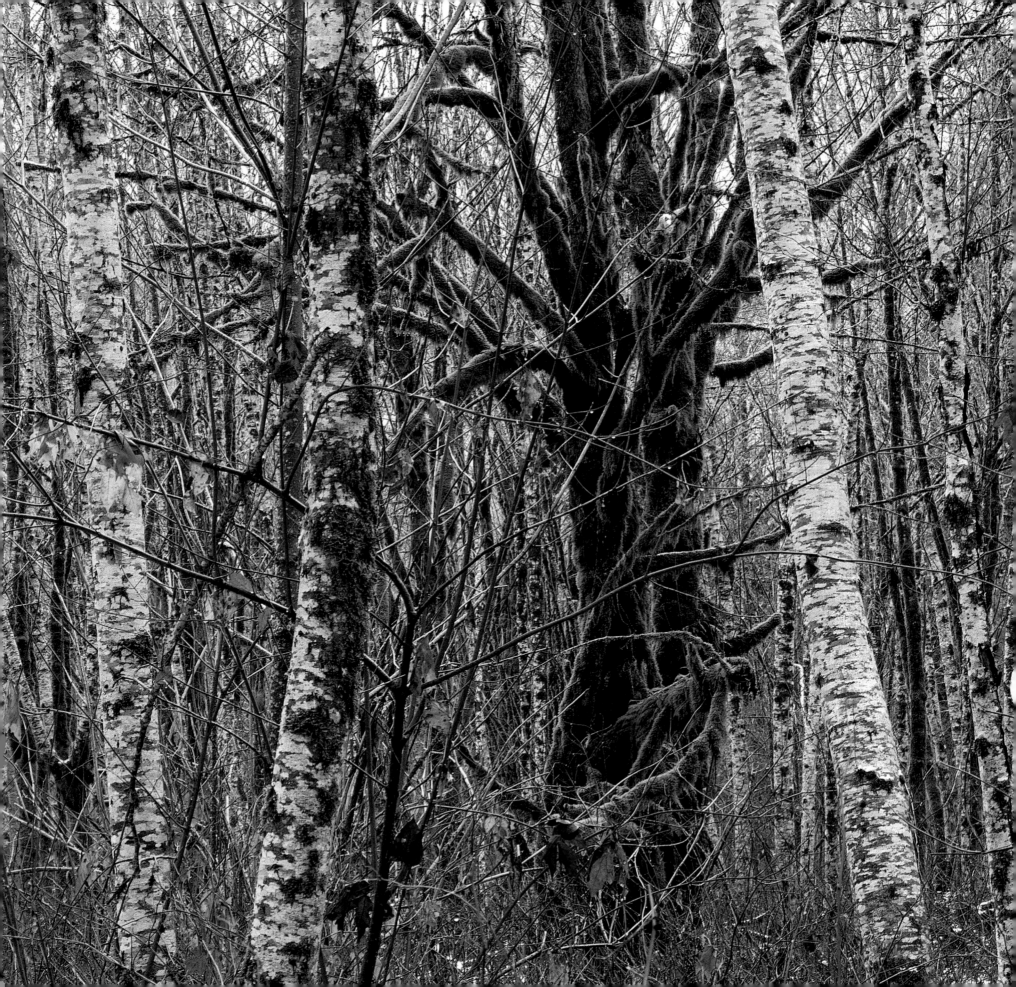

Larry Ulrich

ARCA SWISS F LINE 4X5, 180MM SCHNEIDER 5.6 LENS,
F/32 AT 4 SEC., FUJICHROME VELVIA FILM.

California, U.S.A.

POSITION: 124°00'W, 41°00'N
TIME: 11:50 A.M.

Redwood Stream

Coast redwoods stand on a slope along
Prairie Creek in California's Prairie Creek
Redwoods State Park. An unseasonably long
dry spell and clear skies worried Larry that he
would be unable to photograph redwoods, a
subject he has mastered. At dawn, he staked
out a spot for a sunrise image, when instead,
it began to rain, providing ideal even light
for photographing the giant trees, many of
which are several thousand years old.

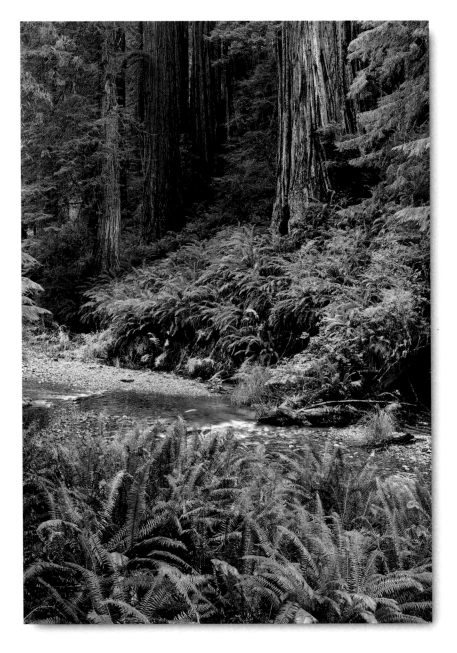

◀ Graham Osborne

PENTAX 6X7, 200MM LENS WITH POLARIZER, F/32 AT 15 SEC.

Wooded Valley

Alders and vine maples thrive in the Squamish Valley, British Columbia,
along Canada's Squamish River.

British Columbia, Canada

POSITION: 123°00'W, 49°30'N
TIME: 4:00 P.M.

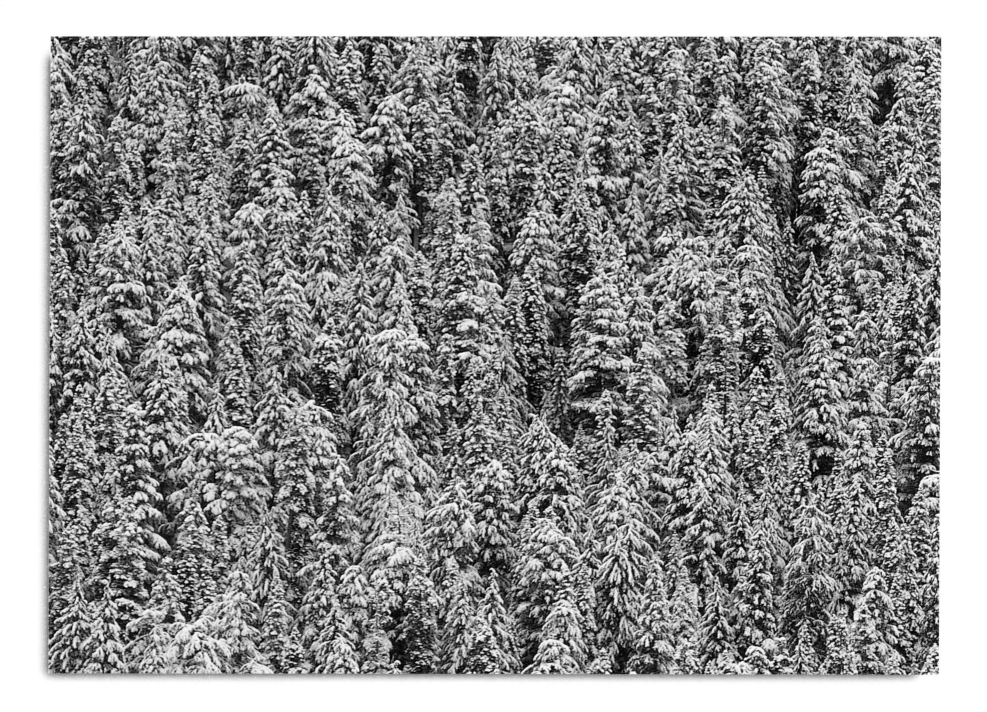

Wendy Shymanski

NIKON F4, 300MM NIKON LENS, F/8 AT 1/30 SEC.

Winter Woodland

Draped in a cloak of white, dense stands of old growth forest appear frozen
in time in the Shames River Valley, west of Terrace, British Columbia.
Western hemlock, Pacific silver fir, and other conifers are an average of
250 years old.

British Columbia, Canada

POSITION: 128°30'W, 54°30'N
TIME: 11:45 A.M.

120

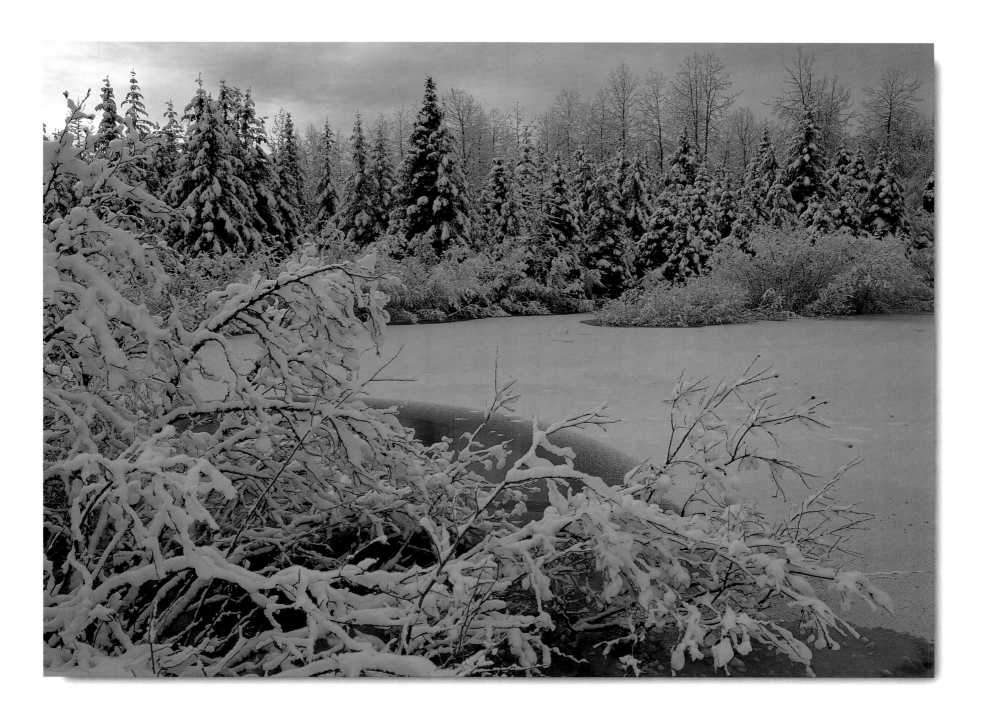

Alaska, U.S.A.

POSITION: 135°00'W, 58°00'N
TIME 2:20 P.M.

Jeff Gnass

PENTAX 67, 55MM LENS, F/22, EXPOSURE UNRECORDED, FUJICHROME VELVIA FILM.

Pond of Powder

Snow-covered willows and spruce forest surround a secluded
frozen pond in winter in the overgrown moraine area of
Mendenhall Glacier, Tongass National Forest, Alaska.

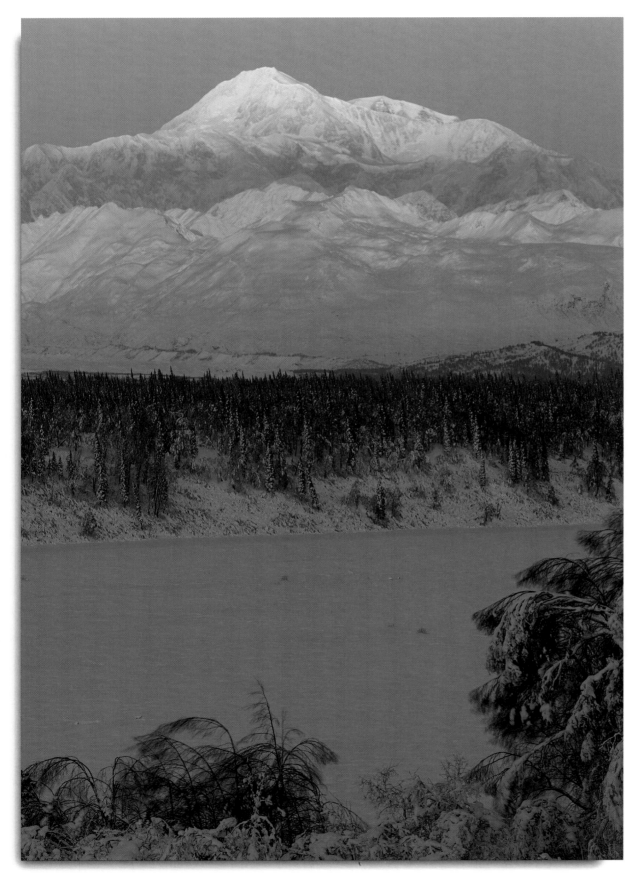

Fred Hirschmann

TOYO 45AR FIELD CAMERA,
500MM NIKKOR T LENS, F/32 AT 2 SEC.

Alaska, U.S.A.

POSITION: 151°00'W, 63°00'N
TIME: 10:00 A.M.

Sunrise on the Summit

First light of sunrise strikes the 20,320-foot summit of Mt. McKinley, North America's highest point, in Denali State Park, Alaska. "I had a beautiful, albeit windy and cold, day. Temperatures ranged between −10°F and −30°F and winds were between 10 and 20 knots. The biggest difficulty was waiting for lulls in the wind to work with the field camera."

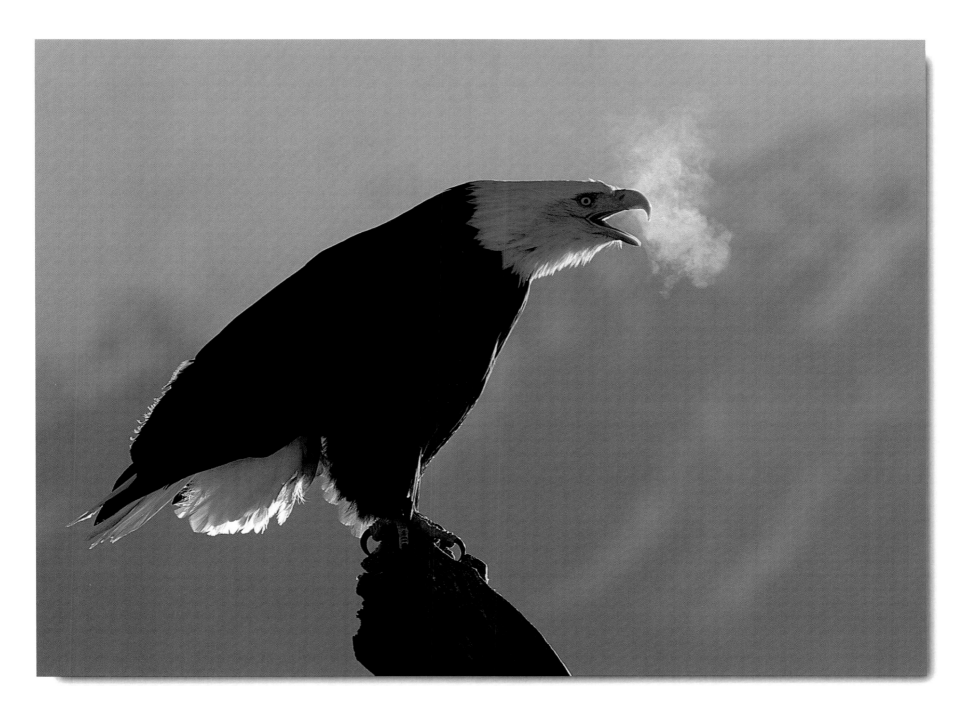

Norbert Rosing

LEICA R8, 280MM APO-TELYT-R 4.0, F/5.6 AT 1/250 SEC., FUJICHROME VELVIA FILM.

Alaska, U.S.A.

POSITION: 151°24'W, 59°36'N
TIME 12:15 P.M.

Eagle's Cry

A bald eagle lays claim to a strategic perch at feeding grounds on Alaska's Kenai Peninsula, near Homer. Norbert took flight from his home in Germany at the chance to photograph them on the first day of 2000. Just before dawn on January 1, the sky cleared, enabling him to shoot 15 rolls of film during more than five hours of prime sunlight.

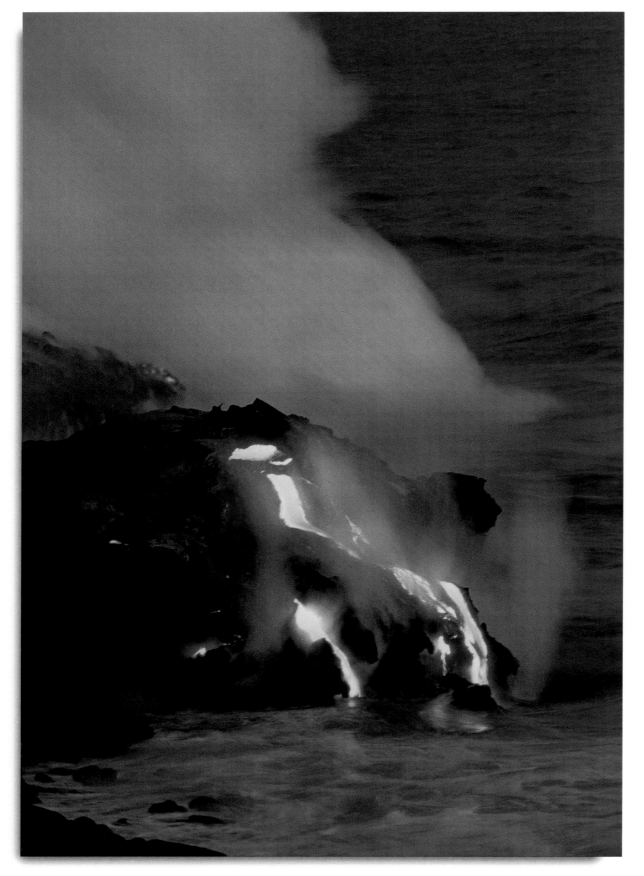

James D. Watt

NIKON, 80-200MM LENS WITH X2 EXTENDER, F/4 AT SEVERAL SECONDS.

Hawaii, U.S.A.

POSITION: 155°30'W, 19°30'N
TIME: 5:45 P.M.

A New World

Lava pours from a flow at Hawaii's Volcanoes National Park (on the big island), creating new real estate for inhabitants of the future both above and below water. James, a Kailua-Kona resident, lived an assignment photographer's dream on New Year's Day, photographing palm trees at sunrise, green sea turtles on his morning dive, a humpback whale midmorning from a boat offshore, a newly formed black sand beach and a rare nene goose (only 200 left) in the afternoon, and the lava flow from dusk until midnight.

Richard A. Cooke III

CANON EOS 1N, 17-35MM ZOOM WITH A POLARIZER, F/4 AT 1/320 SEC.

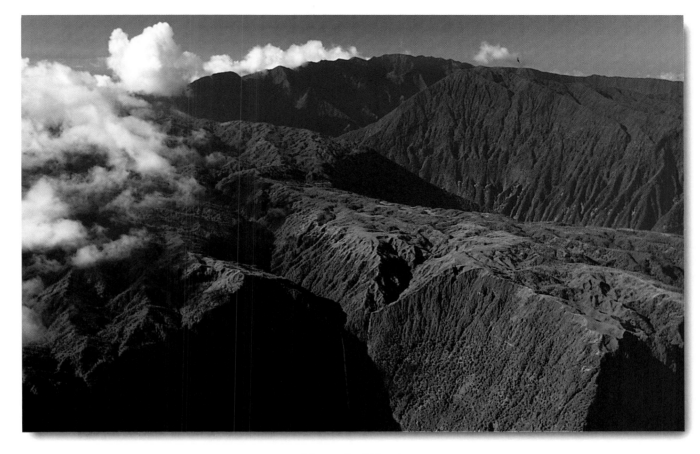

Hawaii, U.S.A.

POSITION: 157°00'W, 21°6'N
TIME: 10:15 A.M.

Untouched Tropics

From the vantage of a helicopter, the north shore of Molokai looks much as it must have to a shorebird in the same spot on January 1, 1000. Papalaua waterfall is in the foreground, Wailau Valley is behind it, and the mesa behind Wailau is Olokui, the most complete and protected area of ancient Hawaiian forest. "Everything in the photo is conservation land and protected forever."

Bronwyn Cooke

CANON EOS ELAN2, 75-300MM ZOOM WITH A STABILIZER, F/4 AT 1/60 SEC.

Great Grove

Late afternoon sunlight illuminates these coconut palms at Kapuaiwa, Molokai, and are in Hawaii's largest palm grove.

OVERLEAF

Hawaii, U.S.A.

POSITION: 157°00'W, 21°6'N
TIME: 4:45 P.M.

125

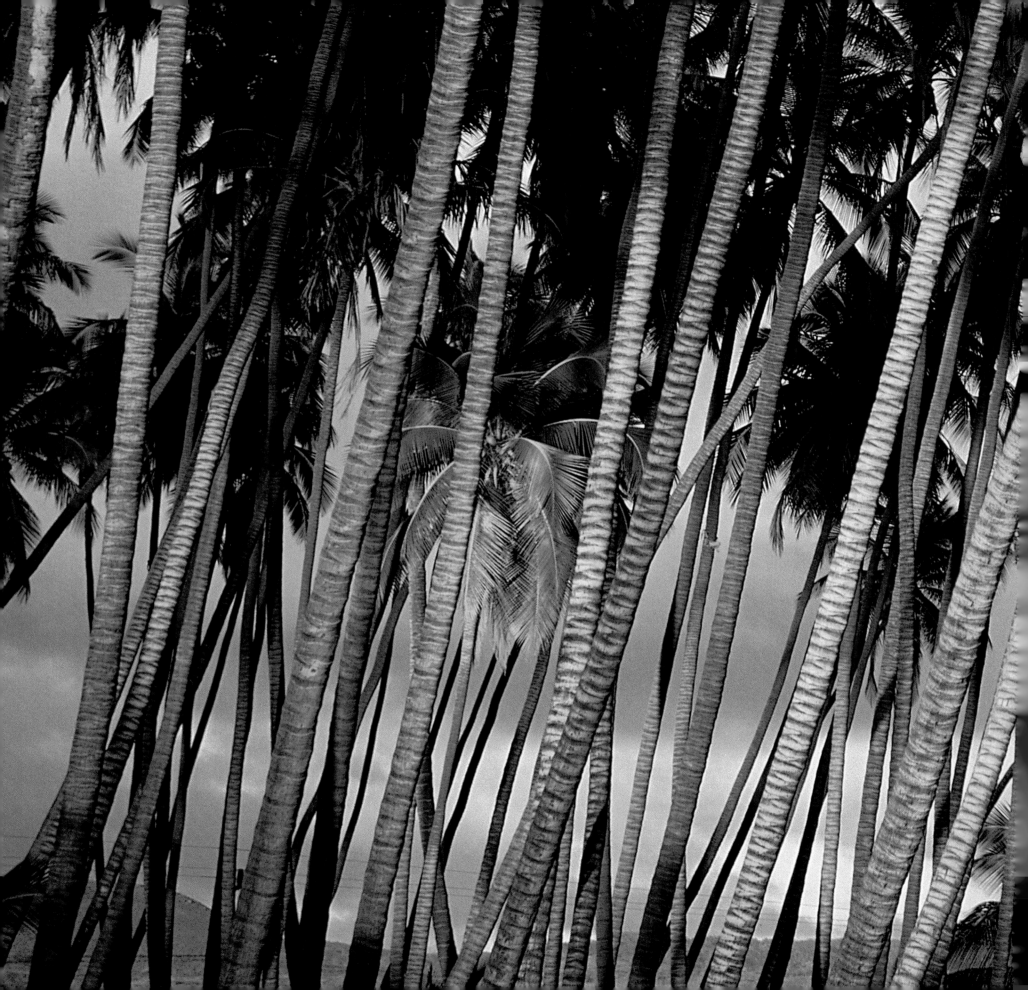

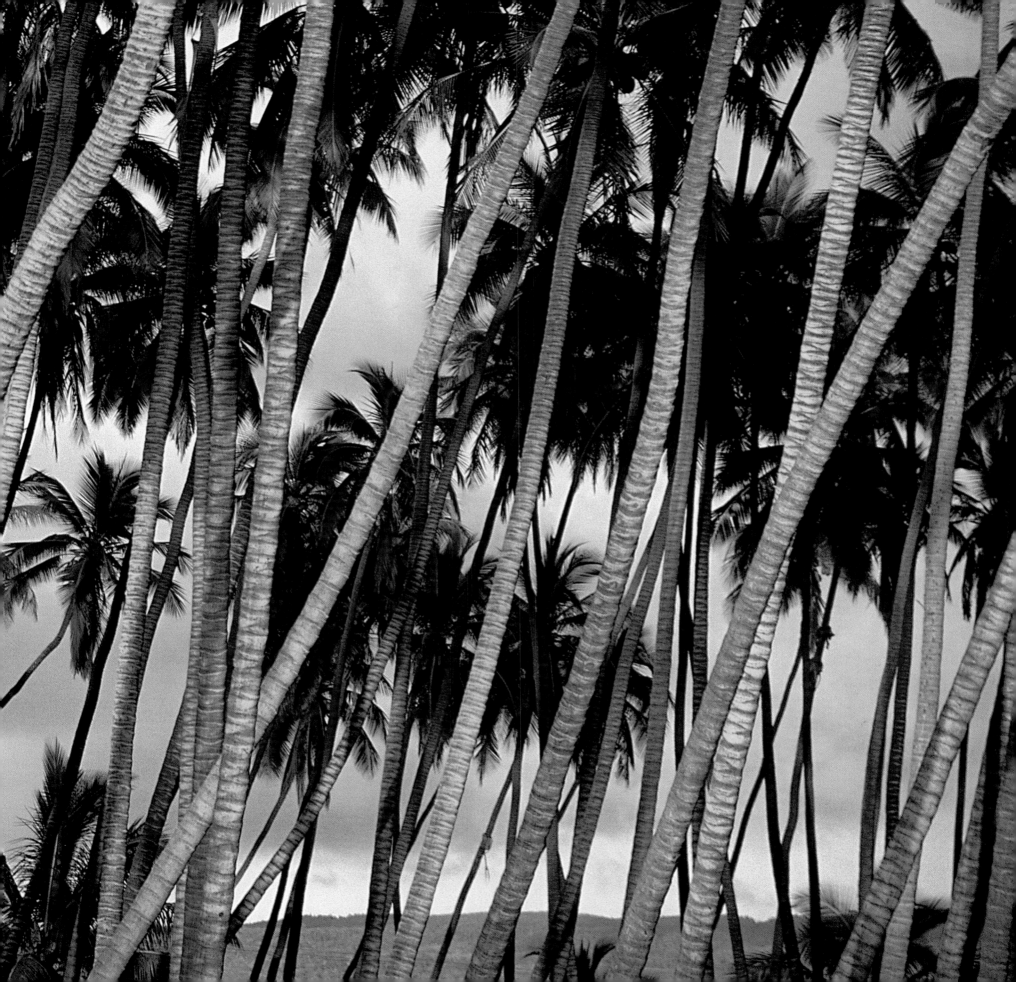

Photographer Biographies

Kevin Adams (p. 72)
Kevin's work as a nature photographer stems from a lifelong love affair with nature, particularly the mountains and coast of his home state, North Carolina. For the past 12 years, he has roamed the state creating images that have appeared regularly in calendars, books, and magazines, including *Backpacker, Birder's World, Natural History, Nature's Best, Nature Photographer,* and others. He is the author of the books *North Carolina Waterfalls* and *Wildflowers of the Southern Appalachians.* Kevin shares his knowledge as a regular photography workshop speaker. His current project is a hiking guide to Great Smoky Mountains National Park. He lives in High Point, North Carolina.

Jagdish Agarwal (p. 35)
Jagdish is a freelance photographer based in Bombay, India, where he owns and manages Dinodia Picture Agency, the world's largest image library dedicated to stock photographs of India. Born in Dinod, Haryana, India, in 1948, he began photographing at age 13 with a box camera given to him as a gift. Later, as a member of Bombay's Natural History Society, he trekked throughout India amassing a personal image file of 100,000 frames in 10 years. His agency now represents many photographers. Jagdish lives in Bombay, India.

Oriol Alamany (p. 8, 18)
Oriol and his wife Eulàlia Vicens have worked and traveled together as professional nature and travel photographers since they met in Morocco in 1984. Based in Barcelona, Spain, they specialize in photographing the natural areas in Australia, southern Africa, and Spain. Oriol's photographs and articles have appeared in Spain, France, Germany, the United Kingdom, and the U.S. Oriol is the author of *Fotografiar la Naturaleza,* a book on nature photography techniques, and *Fotógrafos de la Naturaleza,* a book about the world history of nature photography.

Theo Allofs (p. 17)
Born and raised in Germany, Theo and his wife, Sabine, moved to Canada's Yukon Territory in 1990, where they live in a log home they built near Kluane National Park. Trained as a geologist, Theo followed his dream to pursue photography as a profession, specializing in wildlife and landscape subjects, and environmental stories. His images have been published in three books and numerous magazines such as *American Photo, Outdoor Photographer, National Wildlife, International Wildlife, Natural History, BBC Wildlife, GEO,* and *Terre Sauvage.* He travels between six and eight months each year, chiefly to Australia, the High Arctic, and Africa's Namib Desert.

Karl Ammann (p. 36)
Born in Switzerland, Karl has lived and worked in Kenya for the past 20 years, and he has traveled worldwide as a photojournalist creating images that stir others to action. He is an advisory director to the World Society for the Protection of Animals, The Africa Primate Specialist Group of the International Union for Conservation of Nature and Natural Resources (IUCN), and the Cheetah Conservation Fund. He has written about the African bush meat crises for scientific journals and popular publications. *The Hunters and the Hunted* is among seven books bearing his name as author or co-author. He lives in the foothills of Mount Kenya with his wife, a chimpanzee, a cheetah, and five dogs.

Heather Angel (p. 51)
Heather is a British award-winning wildlife photographer who constantly traverses the globe. She has authored 47 books (her latest, *Natural Visions*) and countless magazine articles, and she tutors workshops worldwide. Clients include the World Wildlife Fund, IUCN, London Zoo, and Hasselblad. The British Council in Delhi commissioned her to document in one month the biodiversity of the Himalayas. Her rare images of giant pandas in the snow are among her best-selling. Major solo exhibitions have been shown in China and at the Science and Natural History Museums in London. Heather received an honorary Doctorate of Science from Bath University in 1986, a special professorship from Nottingham University in 1994, and the 1998 Louis Schmidt laureate from the BioCommunications Association. She was president of the Royal Photographic Society from 1984 to 1986. She lives in Farnham, England.

Andris Apse (p. 11)
Born in Latvia in 1943, Andris has lived in New Zealand since 1950 and has been a full-time landscape and wilderness photographer since 1983. His images have won numerous awards and have appeared in publications throughout the world, including *Seven Seas, VSD, The Peak, The Regent International, GEO, Club Marine, The New York Times,* and *Warren Miller's Snoworld.* His major book projects include *New Zealand From the Air, This is New Zealand, Wild New Zealand, Surprising Lands Down Under, New Zealand the Beautiful Wilderness, New Zealand Landscapes, South West New Zealand World Heritage Area,* and *Spectacular New Zealand.* Andris lives in Okarito, a World Heritage area along the southwestern shore of New Zealand.

Bill Bachman (p. 22)
Born in the U.S. in 1952, Bill has lived in Australia since 1973, where he is a freelance photojournalist covering people and places throughout his adopted land. Readers of *Australian Geographic* voted Bill Photographer of the Year in 1995. He has contributed articles and photographs to books and magazines worldwide, including *Earth, Discovery,*

National Geographic Traveller, and *Outdoor Photographer*. Originally known for his ski photography, Bill has covered five winter Olympics since 1980. His books include *Off the Road Again* and *Local Colour: Travels in the Other Australia*, which appeared in the U.S. in 1998 as *Australian Colors*. His current project is a book on the Murray River, Australia's largest. Bill lives in Melbourne, Victoria.

Wayne Barrett (p. 56)

Wayne and Anne have been business partners as professional photographers since 1977. Based in St. Catherines, Prince Edward Island, their collection of award-winning landscape and wildlife images cover much of Atlantic Canada. Their more than two dozen books include *Spirit of Place, Wildlife of Atlantic Canada and New England, Atlantic Wildflowers, Wings Over Water: Water Birds of the Atlantic*, and *Atlantic Canada Nature Guide*. Their images also appear in *Canadian Geographic, Canadian Wildlife, National Wildlife,* and *Terre Sauvage*.

Tom Bean (p. 98)

Tom has been compiling an extensive library of images depicting landscape, geology, earth science, wildlife, outdoor sports, travel, and other subjects for more than 20 years. Trained as a wildlife biologist, Tom has worked in several national parks as a ranger-naturalist. His images have appeared in hundreds of magazines and books, including works published by the National Geographic Society and Smithsonian Books. Ever-striving to make dramatic use of natural light, Tom specializes in classic, iconic images of Alaska, the American West, the Great Plains, the Great Lakes, and international locations, often with a human presence. He lives in Flagstaff, Arizona.

Chris Bell (p. 21)

Chris' career as a nature photographer sprang from his conservation efforts. In 1972, he moved to Tasmania from mainland Australia to join an unsuccessful effort to save Lake Pedder from hydroelectric development. His first book, *A Time to Care: Tasmania's Endangered Wilderness*, appeared in 1980. One of the first members of Australia's Wilderness Society, a group that prevented the Franklin River from being dammed, Chris lent his images to campaign for wilderness protection throughout Australia and continues to do so. "Photographers have a special responsibility. We are the ones who derive [the] most enjoyment, and our income, out of the natural world. It is crucial we give something back." His other books include *Beyond the Reach*, featuring images of Cradle Mountain–Lake St. Clair National Park, and *The Noblest Stone*, featuring Queensland's Carnarvon National Park. Chris lives in Hobart, Tasmania.

Daryl Benson (p. 104)

With no formal photographic training on his resume, Daryl (at age 40) is nonetheless regarded among his peers as one of Canada's premier outdoor photographers. Capable of creating memorable, imaginative images with the use of both natural and artificial light, Daryl is a master of a technique called "light painting"—the practice of directing a beam of light over specific subjects or small areas in a scene during a long exposure. Must-have items in his gadget bag include a 30,000 candlepower rechargeable Mag-Lite flashlight and a 1,000,000 candlepower Brinkmann Q-beam searchlight ("for more beefy projects"). A frequent instructor to other photographers, Daryl is the co-author (with Dale Wilson) of *A Guide to Photographing the Canadian Landscape*. He lives in Edmonton, Alberta.

Thomas Blagden, Jr. (p. 76)

Born in 1951, Tom is a graduate of Harvard University, and he has been a professional photographer since 1980. He concentrates his work on South Carolina, where he has lived since 1977, and Costa Rica, where he owns a house on the Pacific coast. Tom's images frequently appear in conservation organization publications and calendars, and his writing and photography serve as a catalyst for land protection. An active lecturer on conservation issues, Tom has produced five exhibit-format books on South Carolina: *Lowcountry: The Natural Landscape, South Carolina's Wetland Wilderness: the ACE Basin, South Carolina's Mountain Wilderness: The Blue Ridge Escarpment, South Carolina Reflections*, and *The Rivers of South Carolina*. Current projects include books on Costa Rica and Mount Desert Island–Acadia National Park, Maine. He lives in Charleston, South Carolina.

Gary Braasch (p. 61)

Known for action coverage of risk-taking field science, including volcano, forest canopy, and ecological studies, Gary is a regular assignment photographer for *LIFE, Smithsonian, Audubon, Discover* and *Natural History* magazines and *The New York Times*, and his images have illustrated more than 100 publications worldwide. He has been a professional photographer and writer since 1975, and he holds a masters degree in journalism from Northwestern University. In 1999 he crossed both the Arctic and Antarctic Circles, and photographed from sea level to above 15,000 feet for "World View of Global Warming," a self-assigned project documenting climate change. No stranger to one-day assignments, he photographed Keiko the killer whale for Rick Smolan's *One Digital Day*. Gary lives in Nehelan, Oregon.

Jim Brandenburg (p. 80)

Jim began his career as a natural history photographer and filmmaker as an art student at the University of Minnesota. He became a contract photographer for *National Geographic* magazine in 1978 and was twice named Magazine Photographer of the Year by the National Press Photographer's Association. He photographed and designed 10 wildlife stamps for the U.S. Postal Service in 1981. He produced, directed, and filmed the National Geographic television documentary *White Wolf*, released on home video in 1989. In 1991, Sweden's King Gustaf awarded Jim the World Achievement Award from the United Nations Environmental Programme. His 90-day project "North Woods Journal" in National Geographic's November 1997 issue was the most photographs the magazine has published in a single article, and the

images reappeared in the best-selling book, *Chased By the Light*. Other books by Jim include *Brother Wolf: A Forgotten Promise, White Wolf: Living with an Arctic Legend,* and *Minnesota: Images of Home.* He lives in Minnesota's North Woods.

Pablo Cervantes (p. 90)

Pablo has been a nature photographer since 1978. His images have been published in books and magazines in Mexico, the U.S., and Europe, including *National Geographic, Airone,* and *GEO.* Educated in biology at the University of Mexico, Pablo is also a diving instructor. He has participated in multinational expeditions to Baffin Island, Aconcagua, the cloud forest of southeast Mexico, and islands of the Gulf of California. He has led photo safaris since 1985 and he is a frequent speaker on natural history subjects. Since 1997, he has been picture editor for the Mexican conservation organization Agrupacion Sierra Madre, and he co-authored *Celebration of the Seas,* a book commemorating the Portugal World's Fair Expo of 1998. He lives in Mexico City, Mexico.

Willard Clay (p. 79)

Formerly a botany professor at the University of Arizona, Willard left behind his Ph.D., research projects, and teaching career in 1982 to pursue photography full time. His images appeared first in *Arizona Highways* magazine, followed by a myriad of national publications and calendars. Natural composition in color and form are what Willard seeks with his 4x5 view camera. He has completed eight photographic books: *Oregon; Northern California; Illinois: Images of the Landscape; Deep in the Heart of Texas; Wild and Scenic Illinois; Yellowstone: Land of Fire and Ice; Grand Teton: Citadels of Stone;* and *A Guide to West Virginia, Kentucky, and Tennessee* (published by Smithsonian). If he is not on the road with his camera, he is home pursuing his other passion: classical music. Willard lives in Ottawa, Illinois.

Kathleen Norris Cook (p. 89)

Kathleen was born in Louisiana and earned a fine arts degree from Mississippi College. She was working as a commercial artist in Arizona when she decided to pursue photography professionally, and her first image appeared in *Arizona Highways* magazine in 1978. She took to her new career naturally, having developed a stong sense of visual design from her 13 years' experience in advertising. Her images have since appeared in Sierra Club calendars, numerous books and magazines, national and international advertising, and in her four books: *Yosemite: Valley of Thunder, Exploring Mountain Highways, The Million Dollar Highway* (a book featuring the area between Ouray and Durango, Colorado), and her most recent effort, a national award-winning book *Spirit of the San Juans.* Kathleen lives in Ouray, Colorado, in the San Juan Mountains.

Richard A. Cooke III and
Bronwyn Cooke (p. 125, 126-127)

Richard has contributed to *National Geographic* magazine for 15 years as a freelance photographer. His books include *Molokai: An Island in Time, The Blueridge Range, America's Ancient Cities,* and *Smithsonian Guide to Natural America: Hawaii.* Bronwyn is a freelance and fine art photographer. Her work has appeared in *National Geographic, GEO,* and *Pacifica* magazines, and in Smithsonian books and calendars. Richard and Bronwyn are residents of Molokai and the directors of the non-profit Hui Ho'olana retreat center for healing and the arts where they teach photography workshops. Their most recent work appeared in the book *Sundays in Hawaii.*

Enrique Couve (p. 64)

Enrique is a Chilean photographer who specializes in nature and wildlife in the southernmost region of South America, while his travels take him to other continents as well. Trained as an industrial designer, Enrique's lifelong passion for birdwatching led to his decision to dedicate his career full time to nature

photography and leading birding tours throughout southern South America. He has one of the most complete image libraries of Chilean wildlife. He is the author of an identification guide to the birds of Torres del Paine National Park. Current projects include photographic guidebooks on the natural history of Patagonia and Tierra del Fuego, and a field guide to the birds of Chile. Enrique, 45, lives in Punta Arenas.

Roger de la Harpe (p. 41)

Roger and his wife, Pat de la Harpe, are a freelance team specializing in photographing and writing about African wildlife, travel, and indigenous peoples from their base in Howick, South Africa. Their work appears regularly in South African magazines such as *Discover Africa, Getaway,* and *Out There,* and they covered the Cape Town restart of the 1998 Whitbread Round the World Yacht Race for *National Geographic.* Their eight books include *National Parks and Other Wild Places of Southern Africa* and guidebooks about the two oldest game reserves in Africa, Hluhluwe Umfolozi Park and the Greater St. Lucia Wetland Park. Their current project is a book on MalaMala Game Reserve in Mpumalanga, South Africa.

Nigel Dennis (p. 40)

Born in England in 1953, Nigel was painting nature subjects when he began photographing them more than 20 years ago. He moved to South Africa in 1985 and, in 1991, he took up freelance nature photography as a full-time profession. His images of African wildlife have since appeared in magazines such as *National Geographic, International Wildlife, Time, BBC Wildlife,* and *Geo.* Nigel's nine books include: *The Kruger National Park, Wonders of an African Eden; The Kalahari, Survival in a Thirstland Wilderness; African Wildlife: A Photographic Safari;* and *National Parks and other Wild Places of Southern Africa.* He and his wife Wendy camp in the African bush up to nine months each year. They live in Howick, South Africa.

Geoff Doré (p. 50)

An award-winning freelance photographer with a special interest in landscapes and nature, Geoff's interest in nature began in his early teens with a fascination with the insect world. This progressed into birdwatching, as many a bug was swallowed before his eyes. He studied zoology at London University and graduated with honors. He has since earned several top honors in photographic competitions and has compiled a list of publishing credits worldwide. He lives in Christchurch, along the Dorset coast of England.

Hans Dossenbach (p. 33) and
Monika Dossenbach (p. 34)

Hans was born in 1936 in Switzerland and studied animal behavior in Vienna. While attending school, he took up photography and by age 16 had begun writing nature articles for local newspapers. His photography has since taken him to remote jungles and deserts on every continent. His images of wildlife (including the earliest taken in the wild of camera-shy macaws) have appeared in magazines, calendars, postcards, and posters. He has published more than 40 books, including *The Family Life of Birds* and a dozen other titles together with his wife, Monika, who is also a wildlife photographer. Hans' work also was featured in the book *Wildlife Photography: The Art and Technique of Ten Masters*. Hans and Monika live in a 300-plus-year-old farmhouse near Schaffhausen, in northern Switzerland.

Kerry Drager (p. 111)

Kerry's work as a photographer and writer has appeared in books, magazines, greeting cards, Sierra Club calendars, and photography references. He recently published *Scenic Photography 101*, a book on the art and technique of capturing beautiful images of dynamic places. His other pictorial-essay books include the acclaimed *California Desert* and *The Golden Dream: California from Gold Rush to Statehood*. Kerry's photos also have been featured in national advertising. He is a photography seminar leader and a

writing instructor. He lives in Wilton, California.

Byron Dudley (p. 117)

Born in Illinois in 1937, Byron was educated at Michigan State University and Oregon State University. Since retiring from public school education and administration, Byron has turned his full attention to landscape photography, and the central Oregon coast in particular. His images have been featured in galleries in the Pacific Northwest, and have appeared in *Sierra, Sunset, Coastal Living, Mountain Living*, and other magazines. Byron is completing his first book, *Places of the Heart*. He lives in Eugene, Oregon.

Ken Duncan (p. 15)

Ken's interest in photography developed in his early teens when he dismantled his father's bellows camera to fashion a black-and-white enlarger. Widely known today for his panoramic landscape photography, Ken has registered "Panographs" as his trademark. His collection of more than 70,000 panorama images includes many areas of his native Australia that had not been photographed previously. A veteran of three multi-photographer projects, including *A Day in the Life of Hollywood*, Ken's 16 books include *The Last Frontier: Australia Wide, From Forest to Sea*, and *Northern Beaches: Sydney Australia*. Ken also has lent his talents to humanitarian causes. Proceeds from his book *Vision of Hope* help the organization World Vision bring fresh water to impoverished communities. Currently working on projects affiliated with the Sydney 2000 Olympic Games, Ken operates three galleries in Australia.

Jack Dykinga (p. 99)

A Pulitzer Prize–winning photographer, Jack focuses on environmental issues in the U.S. and Mexico. With writer Charles Bowden, Jack has co-produced four wilderness advocacy books: *Frog Mountain Blues, The Sonoran Desert, The Secret Forest*, and *Stone Canyons of the Colorado Plateau*. Following the appearance of *The Secret Forest*, the Mexican govern-

ment designated the Sierra Alamos, a natural area featured in the book, as a national park and a U.N. Biosphere Preserve. In 1996, President Clinton created the Grand Staircase–Escalante National Monument, preserving canyons featured in Stone Canyons. Jack's fifth book, *The Sierra Pinacate*, documents the U.N. Biosphere Preserve in Sonora, Mexico. He recently published his latest work, *Desert: The Mojave & Death Valley*. His images are also widely published in magazines, including *Natural History, Outside, Sierra Club, Audubon, Wilderness Society*, and *National Geographic*. Jack lives in Tucson, Arizona.

Jean-Paul Ferrero (p. 25)

Jean-Paul was born in France in 1960. After studying psychology in Paris, he turned to nature photography to satisfy a childhood interest in wildlife. His first trip to Australia in 1973 led to repeated journeys there until he moved to Canberra in 1982, and later to Sydney. He founded the photo agency Auscape in 1985.

Tim Fitzharris (p. 71)

Tim is the author and photographer of 27 books on wilderness and wildlife, including the award-winning *Sierra Club Guide to 35mm Landscape Photography*. His photographs of nature have been featured exclusively in more than 50 calendars, including nine solo artist titles to be released in 2000. In 1998, he published *The Sierra Club Guide to Close-up Photography in Nature* and *Virtual Wilderness: The Nature Photographer's Guide to Computer Imaging*. He designs and produces all of his books. Tim's current project, a new landscape book on the Rocky Mountains, is entitled *Wilderness Reflections*. He lives in the pinyon/juniper woodlands bordering the Santa Fe National Forest in New Mexico.

Michael Fogden and **Patricia Fogden** (p. 20)

Michael and Patricia began their careers in zoology as research scientists. Michael worked on seasonality

and population dynamics of birds in the rain forest of Borneo while Patricia was lecturing at the University of Hong Kong. They have worked as a team since 1968, tackling such projects as comparative ecology and physiology of resident and migrant warblers in Uganda's Queen Elizabeth National Park, and range management in the Chihuahuan and Sonoran Deserts in Mexico, particularly on the competition for forage between cattle and wildlife. In 1978, they became freelance writers and photographers and have compiled a collection of images of flora and fauna from rain forests and deserts worldwide. They are currently documenting climate change in collaboration with researchers studying the cloud forest around their home at Monteverde, Costa Rica.

Jeff Foott (p. 97)
Born in Berkeley, California, Jeff has been a wildlife and landscape photographer and cinematographer for more than 30 years. After completing his graduate studies on marine mammals at Moss Landing Marine Laboratories, Jeff plunged into documentary filmmaking with a work on sea otters he made in 1972. He has since filmed for BBC, ABC Kane, Nova, and Survival Anglia, and he has received two Emmy Award nominations for cinematography for documentary nature film, most recently for his film *Patagonia: Life at the End of the Earth*, which aired on PBS in 1997. As an accomplished scuba diver, marine mammals are one of Jeff's favorite subjects. His current book project, *In the Company of Manatees,* is scheduled for publication in winter 2000. He has lived in Jackson, Wyoming, since 1966.

William Fortney (p. 74-75)
Bill is regarded as one of the foremost entrepreneurs of the natural history photography field. A former editor of Nikon's "USA Club" and "NPS Nikon World" newsletters, he has more than 27 years of experience leading photography workshops, publishing, and creating images in the field. In 1993, Bill

founded the leading U.S. natural history workshop series, the Great American Photography Weekend. With photographer David Middleton, Bill co-created and co-produced the best-selling book *The Nature of America,* published in 1997. Recently, he mastered the controls of an ultralight aircraft for his current project (on which his son Wesley assists), *America From 500 Feet.* Bill lives in Corbin, Kentucky.

Michael H. Francis (p. 93)
Prior to becoming a full-time wildlife photographer, Michael worked seasonally in Yellowstone National Park for 15 years, managing the park's concession hotels and lodges. He has lived in Montana for the past 30 years. He is the sole photographer for 15 books on subjects including wild horses, elk, moose, and bison. They include *Into the Wind: Wild Horses of North America, Track of the Coyote, Moose for Kids,* and *Glacier Park Wildlife.* He lives in Billings, Montana.

Winston Fraser (p. 63)
Winston's lifelong pursuit of images of Canada has grown into a profession during the past 20 years. In 1991, he published his first book, *Historic Sites of Canada.* His images have appeared in books, calendars, and magazines worldwide, including *National Geographic, National Wildlife, Canadian Geographic, Outside, Encyclopaedia Brittanica,* and the *Kodak Encyclopaedia of Photography.* In 1999, Winston's images were selected for National Geographic's *Canada Travel Guide.* Winston also has exhibited his photographs to support children's camps, senior citizen homes and homeless charities. He lives in Rosemere, Quebec.

Jeff Gnass (p. 121)
Jeff travels extensively to photograph scenic places and wilderness, and to document the natural history and heritage of lands he visits. Since first picking up a large-format camera in 1979, his images have illustrated thousands of pages in books, calendars, and magazines worldwide, including *Arizona Highways,*

Audubon, Geo, Life, National Geographic Society, National Wildlife, Newsweek, Outside, Terre Sauvage, and *Travel & Leisure.* His *Desert Awakenings,* with writer John Murray, was published in 1998 by NorthWord Press. Jeff lives in southeastern Alaska.

Michel Gotin (p. 29)
Michel is a professional freelance photographer who travels around the world on assignment or for personal projects on lifestyle, discovery, and travel subjects. His images appear regularly in many publications based in France, and in North America by *Outside, Escape, Historic Traveller,* and others. He regularly publishes travel guides. He lives in France.

Karen Lee Gowlett-Holmes (p. 19)
Born in England in 1959, Karen moved with her family to Australia in 1965. She holds degrees in botany and zoology and she has been pursuing underwater photography professionally since 1991, specializing in macrophotography of invertebrates, marine plants, and benthic fishes. A series of postcards featuring her images of marine life is sold throughout Australia, and her images have been published in many books and magazines worldwide. As a leading Australian marine biologist, she has spent more than 20 years in the field, conducting research, publishing articles, and logging more than 2,500 hours underwater. She lives in Tasmania, Australia.

Jenny Hager (p. 87)
Prior to becoming a professional photographer, Jenny was a mountaineer and teacher of wilderness survival skills. Specializing in travel, nature, and environmental issues, Jenny has photographed throughout the U.S., the Alps, and the Himalayas. Her images have been published by Abbeville Press, Audubon, Der Spiegel, Geo, Harper's, Landscape Architecture, National Geographic World, Newsweek, Outside, Sierra Club Books, Time, and U.S. News & World Report. She was co-editor and photographer for the book *An Appalachian Tragedy: Air Pollution and Tree Death in the Eastern Forests of North America.* She lives in Boulder, Colorado.

Carlos Hahn (p. 82)

Carlos is a professional photographer based in Mexico City whose career has blossomed recently with numerous awards and publications since 1994. Born in Mexico in 1955, Carlos was exposed to photography at an early age, accompanying his mother, a journalist, to the 1972 Olympics in Munich where he found himself taking pictures alongside an international corps of sports photographers. He was hooked. Between 1972 and 1989, Carlos was active in bimonthly photography meetings and contests, and in 1980 he dedicated himself to pursue photography full time.

Mark Edward Harris (p. 24)

Mark's career as a professional photographer began in Hollywood producing still images for television and film companies, including *The Merv Griffin Show*. In 1986, he trekked across the Pacific and throughout southeast Asia, China, and Japan. Mark's assignments as an editorial and commercial photographer, have taken him to more than 60 countries, and he is a contributing editor to *Outdoor Photographer* magazine. Mark's award-winning book, *Faces of the Twentieth Century: Master Photographers and Their Work,* records in words and pictures many of the great names in photography. He lives in Los Angeles, California.

Andrew Henley (p. 16)

Born in Australia, Andrew studied zoology in Sydney and in the United Kingdom, including post-graduate work at Oxford University on the ecology and behavior of seagulls. Here, he developed his interest in nature photography and soon was under contract to create images for a multivolume animal encyclopedia. His work has been published in books around the world and in magazines including *Australian Geographic, BBC Wildlife, Geo, The Living Australia, National Geographic, Natural History, Nature Australia, Ranger Rick,* and *Terre Sauvage*. His academic background has nurtured a special interest in documenting animal behavior and life cycles. Andrew is based in Chisholm, Australia.

Fred Hirschmann (p. 122)

Fred has flown, ridden, and biked many thousands of miles, crossing and re-crossing America in search of images that showcase its grand landscape. After graduating with honors from the University of Michigan's School of Natural Resources in 1977, Fred served 11 years as a National Park Service ranger in Yellowstone, Bryce Canyon, Yosemite, Death Valley, Everglades, Petrified Forest, Voyageurs, and Lake Clark National Parks. He left the service to pursue writing and photography full time. His 11 books include *Alaska, Rock Art of the American Southwest, Yellowstone, Bush Pilots of Alaska, Alaska's National Parks,* and *Arizona*. Fred's images have appeared in magazines, books, calendars, and note cards, including publications of the Sierra Club, National Geographic, and Audubon. He lives in a log home in Alaska's Matanuska Valley, with his wife, Randi, who is also a nature photographer.

Jon O. Holloway (p. 70)

Jon is a professional photographer and photography teacher at South Carolina's Lander University. His work has appeared in dozens of exhibitions and in *National Geographic* magazine. He has received grants and national awards for his work depicting the environment. His exhibits include "Nature's Rhythm," "Ghostdance: Native America," and "India: A Journey." He lives in Greenwood, South Carolina.

Bill Ivy (p. 67)

A widely published naturalist-photographer, Bill has authored more than 24 books on natural history subjects, including the award-winning *Little Wilderness: The Natural History of Toronto* and *Close to Home: A Canadian Country Diary*. Current projects include *The Art of Nature Photography*. Bill's images have also appeared in more than 100 books throughout the world, and he has released 14 calendars featuring his photographs exclusively. He has worked as a still photographer for acclaimed nature filmmaker Sir David Attenborough. Bill is also a respected nature guide, lecturer, and expert on lepidopterons. He lives in Don Mills, Ontario.

Gavriel Jecan (p. 27)

Born in Romania in 1962, Gavriel's first photographic expeditions were during day hikes with his father at age 10. An experienced rock climber, Gavriel literally climbed out of communist Romania in 1986, escaping to Greece, then emigrating to the U.S. in 1988. In his seventh year as a professional photographer, Gavriel is employed as photographer Art Wolfe's assistant, and he has accompanied Art on all his overseas expeditions since 1994. He lives in West Seattle, Washington.

Lewis Kemper (p. 109)

Lewis has been photographing the natural beauty of North America and its parklands for more than 20 years. His work has been exhibited and published in magazines, books, and calendars throughout the U.S. and in 15 other countries. He is the author of *The Yosemite Photographer's Handbook* and *The Yellowstone Photographer's Handbook*. He recently published *Ancient Ancestors of the Southwest*. A contributing editor to *Outdoor Photographer* and *PC Photo* magazines, Lewis lives in Sacramento, California.

Robert Glenn Ketchum (p. 105)

As one of America's leading conservation photographer-advocates, Robert has for more than 30 years created images as fine art and as a frame of reference to shape conservation legislation. His photographs are in numerous public and private collections, and he sits on the boards of several ecological organizations, including the Alaska Conservation Foundation, the American Land Conservancy, and the Environmental Communications Office. His books include *The Tongass: Alaska's Vanishing Rain Forest, Overlooked in America: The Success and Failure*

of *American Land Management,* and *American Photographers and The National Parks. Audubon* magazine recognized Robert as a champion of conservation who helped shape the environmental movement, and *American PHOTO* magazine voted Robert one of the 100 most important people in photography. He lives in Los Angeles, California.

Rainer K. Lampinen (p. 42-43)
Rainer was born in Finland in 1947. His cousin taught him the basics of photography at age 5, and he spent much of his childhood photographing and camping around Finland's Lake Arajärvi nature area. While in school, he worked as a photographer's assistant and a freelancer. Today, his Panoramic Images library is an extensive collection of images collected from around the world. He also produces digital video content for television. Rainer travels extensively worldwide, creating images, delivering lectures, and leading workshops. He is the chairman of Finland's Pan Horama, an annual international photography festival dedicated to the panorama format. He lives in Tampere, Finland.

Carol Lee (p. 58)
Carol has been winning awards for her photography for more than 25 years. She has worked thoughout the U.S., Europe, Central America, and South America, and for the last 15 years she has specialized in the landscapes and culture of the Caribbean region. Her images have appeared in more than 70 publications worldwide, including *Caribbean Travel & Life, The New York Times, Audubon, National Geographic Traveler* and *Natural History,* and her work is sought by Caribbean tourism boards, public relations firms, hotels, and international corporations. Based in the U.S. Virgin Islands, Carol lives in Christiansted, St. Croix.

Jiri Lochman (p. 28)
Czech born, Jiri emigrated to Australia in 1978, and has been a professional wildlife photographer since 1986. He contributes regularly to *Australian Geographic, GEO, Nature Australia,* and *Landscape* magazines, and his images also have been published in *National Geographic, BBC Wildlife, Natural History,* and *International Wildlife* magazines. He has published four books with his wife, Marie Lochman: *Wildflowers of Western Australia; Portrait of Perth; Wild Places, Quiet Places;* and *North-west Bound.* His first solo book, *Australia's Unique Wildlife,* was published in 1998. He lives in western Australia.

Bård Løken (p. 47)
Born in Vads, Norway, in 1964, Bård has been a professional landscape photographer for eight years. He became interested in nature as a child, and he became obsessed with photography after he bought his first camera in 1985. His first subjects were birds and wildlife. He has published two books, both featuring images of the forests around Oslo. His current project is a book about Jotunheimen, one of Norway's most popular mountain areas.

Wayne Lynch (p. 38)
In 1979, Dr. Wayne Lynch left his career as an emergency physician to work full time as a science writer and photographer. He is now Canada's best known and most widely published professional wildlife photographer, with tens of thousands of publishing credits in magazines, calendars, and books worldwide. He is a popular speaker and the author and photographer of a dozen natural history books, including *Wild Birds Across the Prairies, Penguins of the World, Mountain Bears, Bears: Monarchs of the Northern Wilderness, A is for Arctic: Natural Wonders of a Polar Bear World,* and *Married to the Wind: A Study of the Prairie Grasslands.* Recognized for enlarging the scope of human knowledge through his study of wildlife in more than 50 countries, Wayne belongs to the famed Explorers Club and to the Arctic Institute of North America. He lives in Calgary, Alberta.

Mike Macri (p. 81)
Born in Windsor, Ontario, Canada, in 1950, Mike moved to Churchill, Manitoba, as a teenager, where he still lives, and where he developed a love and respect for nature and being outdoors. For 13 years, he served with the Canadian Rangers. Mike currently owns and operates Sea North Tours, a boat tour company leading visitors each summer to thousands of beluga whales that frequent the Churchill River estuary. Through guiding other photographers, Mike developed an interest in photography in 1986. The subarctic is the chief subject of his stock images, which have been published worldwide.

Alfredo Maiquez (p. 66)
After completing studies in journalism and documentary photography, at the University of Valencia, in Spain, Alfredo has been working professionally as a photographer for eight years. He has produced images throughout Latin America for advertising agencies, stock libraries, and publications such as *Natura, Rutas del Mundo, Geomundo,* and others. He has also completed special assignments for The Smithsonian Institution and the Audubon Society. He has also produced and photographed documentaries for television on national parks. He lives in Panama.

Thomas D. Mangelsen (p. 116)
Educated in wildlife biology, Tom has been making images of Earth's wild places and wildlife for more than 20 years. His first book, *Images of Nature,* was published in 1989. His award-winning book, *Polar Dance: Born of the North Wind,* captures the essence of the polar bear amid the pristine beauty of the Arctic. Tom is also an Emmy-nominated wildlife cinematographer and he was named BBC Wildlife Photographer of the Year in 1994. His work has appeared in *Audubon, Life, National Geographic, National Wildlife,* and *Wildlife Art* magazines. His photography has been exhibited at the National Museum of Wildlife Art in Wyoming, the San Diego Natural History Museum, and London's Natural History Museum. He opened the first of 12 galleries in 1978. Tom lives in Jackson, Wyoming.

Francisco Márquez (p. 55)
Born in Paris in 1963, Francisco is an award-winning professional freelance nature photographer based in Toledo, Spain. His images have appeared in *GEO, National Geographic, Terre Sauvage, Oasis, Wildlife Conservation, Canadian Wildlife,* and *Sinra* magazines and in more than 100 books worldwide. Subjects of high interest to Francisco include the Spanish brown bear, the Pyrenees lammergeier, and European cranes, depicting their lives and habits through creative composition and the use of natural light. He has authored three books: *Cabañeros, A Mediterranean Forest; The Cantabrian Brown Bear;* and *Canary Islands, Rural and Natural Parks.*

Geoff Mason (p. 11)
Geoff has been photographing New Zealand since 1969. After running a Wellington commercial photography studio for several years, he began freelancing for advertising agencies and New Zealand–based companies. His first landscape work appeared in "Wild New Zealand," a Reader's Digest epic. He often guides other photographers on photo safaris in New Zealand, Australia, the U.S., and China. He co-authored the book *Han Suyin's China.* Geoff produced his collection of New Zealand landscapes in *Huka Lodge Book of New Zealand Landscape.* He holds a fellowship with the New Zealand Institute of Professional Photographers and has won numerous awards. He contributed to the 1990 work *Salute to New Zealand* and to *A Day in the Life of New Zealand.* He lives in Auckland, New Zealand.

Michael Mauro (p. 84-85)
A Colorado native, Michael has been photographing wildlife and nature for 12 years. During the past four years, he has worked as a contract photographer for the U.S. Fish & Wildlife Service at Rocky Mountain Arsenal National Wildlife Refuge near Denver. He also produces video footage for Outdoor Life Network and MGA Communications, and he is a freelance Internet consultant. His publishing credits include *Adventure West, Backpacker, Environment,*

Outdoor Life, Outdoor Photographer, and *Ranger Rick* magazines. Michael lives in Arvada, Colorado.

Joe McDonald (p. 37) and
Mary Ann McDonald (p. 65)
Joe launched his career as a nature photographer in high school when he sold his first image to National Wildlife Federation. In the more than 25 years since, his images have been published in every major natural history magazine in the U.S., and in numerous publications around the world. One of his wolf images appeared in a set of U.S. postage stamps on Arctic animals. A teaching photographer, Joe's six books include a 1999 revised edition of *The Complete Guide to Wildlife Photography.* Joe's wife, Mary Ann, began photographing wildlife 10 years ago. Her images have been published in books, calendars, and magazines, and she is the author of 29 books for children. Each year, Joe and Mary Ann lead nature photography workshops and tours worldwide, and they recently completed their first book together, *African Wildlife.* They live outside McClure, Pennsylvania, where they can photograph flying squirrels and a dozen songbird species within 100 yards of their doorstep.

Leo Meier (p. 14-15)
Born near Lucerne, Switzerland, in 1951, Leo was trained in typographical arts before he emigrated to Australia at age 20. In his 25-year photographic career, he has authored 19 books, including *Australia the Beautiful Wilderness* and *Small Creatures of the Wild.* He has contributed to 28 other volumes and led film documentary expeditions into China and the Philippine island of Palawan. He also has served as chief photographer for the New South Wales National Parks and Wildlife Service. In 1989, the Australian government presented a collection of Leo's work to France to commemorate the bicentennial of the French Revolution. An inventor, he has designed and built unique equipment, culminating in a continuous-feed panoramic camera that uses five-inch high aerial film to create single images up

to 50 feet long with an angle of view up to 720 degrees, a world first. Another of Leo's feats: an entry in the *1976 Guiness Book of World Records* with the longest boomerang throw (88.2 meters). He lives in Kempsey, Australia.

David Middleton (p. 62)
Author and co-director (with photographer Bill Fortney) of the 1997 best-seller *The Nature of America,* David is a full-time professional nature photographer, writer, and naturalist. He has written and photographed for 16 years and has traveled extensively throughout North and South America. Books he has produced include *Ancient Forests, The New Key to Ecuador and the Galapagos* (an ecotourist's guide), and *Big Cats: A Naturalist's Guide to the Large Cats of the World.* His publishing credits also span magazines, books, and calendars. A gifted teacher, David enthusiastically shares his insights at workshops across the U.S. on photography, writing, and creativity. He lives on 200 acres in Vermont's Green Mountains.

Steven Morello (p. 69)
Steve is a wildlife photographer whose work has appeared in *National Geographic, International Wildlife, The New York Times, Outdoor Photographer,* and numerous other magazines, books, and calendars. He often works alongside scientists documenting their research of the world's animals and ecosystems, especially wetlands, in North America, Ecuador, Chile, Kenya, Tanzania, Botswana, and Antarctica. For six years he instructed at the National Audubon Ecology Camps in Maine, and for more than a decade he conducted whale research and guided whale-watch tours off Massachusetts. Steve currently leads wildlife tours for Natural Habitat Adventures. He lives in Micanopy, Florida.

David Muench (p. 102-103)
David has been a professional freelance landscape photographer for 35 years, and he is known around the world for his images of America's wild lands in

their natural state. He is the primary photographer for more than 40 books, including *Nature's America, Plateau Light, Ancient America,* and his upcoming work *Primal Forces.* He has produced 18 solo exhibitions of photographs, most notably a permanent display of more than 350 images illustrating the route of the Lewis and Clark Expedition for the Jefferson National Expansion Memorial in St. Louis, Missouri, completed in 1976. Born in 1936, David studied at New York's Rochester Institute of Technology, the University of California at Santa Barbara, and the Art Center School of Design in Los Angeles. He lives in Santa Barbara, California.

Marc Muench (p. 107)
Marc has been a professional landscape and outdoor sports photographer for 10 years. His images have appeared in *Time, National Geographic, Condé Nast Traveler, Arizona Highways, Ski, Skiing, Outside, Sierra,* and other magazines, and in numerous advertising campaigns. He has appeared on ESPN's *Canon Photo Safari* for four seasons. His book, *Ski the Rockies,* was published in 1994. The son of America's master landscape photographer David Muench, Marc has collaborated with his father on three books: *David Muench and Marc Muench: American Portfolios, The Rockies,* and *California.* He lives in Santa Barbara, California.

Francesc Muntada (p. 49)
Inspired by his father's interest in photography, Francesc has owned a camera for as long as he can remember. An award-winning wildlife photographer, Francesc now specializes chiefly in landscape photography. In addition to photographing nature, he is an outdoor enthusiast who enjoys hiking, climbing, cross-country skiing, and birdwatching. Francesc is also active with several organizations dedicated to educating others about nature protection. His images have appeared in books, calendars, magazines, and newspapers throughout Europe and in the U.S. He also shares his knowledge about photography with others through workshops. He lives in

Terrassa, near Barcelona in the Catalonia region of northeastern Spain.

William Neill (p. 108)
Bill is a professional landscape photographer whose images have been widely published in books, calendars, and magazines, including *Smithsonian, National Wildlife, Condé Nast Traveler, Gentlemen's Quarterly, Travel and Leisure, Wilderness, Sunset, Sierra,* and *Outside.* His limited-edition prints have been collected and exhibited in museums and galleries nationally, including the Boston Museum of Fine Art and The Polaroid Collection. In 1995, Bill received the Sierra Club's Ansel Adams Award for conservation photography. His work was chosen to illustrate two special-edition books published by The Nature Company: Rachel Carson's *A Sense of Wonder,* and John Fowles' *The Tree.* Bill's books include *By Nature's Design, Yosemite: The Promise of Wilderness* (for which he received an award from the National Park Service), and *Landscapes of the Spirit.* Bill has lived in Yosemite National Park, California, since 1977.

John Netherton (p. 78)
John was named by *American Photographer* magazine as a Friend of the Earth, citing his personal philosophy, respect for nature, and commitment to recording it with passion and sensitivity. He is a recipient of the prestigious Outstanding Tennesseean Award, presented by that state's governor. John is the current president of Friends of Radnor Lake and lends his images to help preserve natural areas and wildlife around the world. He has published 20 of his own books, and his images have appeared in magazines including *International Wildlife, Natural History, Nature's Best, Birder's World, WildBird, Atlantic Monthly, Geo,* and *Ranger Rick.* His photographs of wading birds have been featured in *National Wildlife* and his photo essay on frogs was featured in *Audubon.* He writes a regular column for *Outdoor Photographer* magazine. John lives in Nashville, Tennessee.

Pat O'Hara (p. 110)
For two decades, Pat has been a leading environmental photographer, focusing much of his work on wilderness conservation efforts in the U.S. and other countries. In the former Soviet Republic of Georgia, he is working in support of expansion of that state's system of protected areas. He is also developing a book in support of a U.S.–Russia proposal to dedicate Beringian Heritage International Park along the Bering Strait and Chukchi Sea near the Arctic Circle. His images have been showcased in 17 books, many dedicated to environmental issues, and in numerous magazines and national advertising. Pat has received many prestigious awards and he is a frequent speaker and photography workshop instructor. His professional philosophy centers on nurturing in others an abiding respect for nature, rather than passive viewing. He lives in Port Angeles, Washington, on the Olympic Peninsula.

Graham Osborne (p. 118)
Educated in wildlife biology at Canada's University of British Columbia, Graham is an award-winning professional photographer and journalist, specializing in large-format landscapes, wildlife, and outdoor/lifestyle photography. His images have appeared in books, calendars, and magazines, including *Audubon, Natural History, Canadian Wildlife, Snow Country,* and others, and he is a field correspondent for *Equinox.* His books include *British Columbia: A Wild and Fragile Beauty, Wildflowers: Seasonal Splendors of the North American West,* and *Rainforest: Ancient Realm of the Pacific Northwest.* He lives in White Rock, along the British Columbia coast.

Edward Parker (p. 52)
Edward has worked as an environmental photographer in more than 30 countries, including numerous commissions by World Wildlife Fund. He regularly works for television documentary production companies and was one of the chief photographers for the series "Millennium: Tribal Wisdom in the

Modern World." He is also the author of environmental books and the photographer, and co-author of the recent release, *Ancient Trees: Trees That Live for a Thousand Years*. He lives in Dorset, England.

Freeman Patterson (p. 59)
Freeman's work transcends three disciplines: photography, writing, and education. His 1962 masters thesis at Columbia University was "Still Photography as a Medium of Religious Expression." Since then, Freeman's images and writings have been widely published, and he has taught courses in photography and design in Canada, the U.S., Israel, New Zealand, and in the Republic of South Africa at the Namaqualand Photographic Workshops which he co-founded in 1984 with photographer Colla Swart. He has authored seven books, including the instructional book *Photography of Natural Things*, and he has collaborated on many others, including *The Last Wilderness: Images of the Canadian Wild*. He recently completed a CD-ROM entitled *Creating Pictures: A Visual Design Workshop*. A past trustee of several boards, Freeman lives on an ecological reserve he donated to The Nature Conservancy of Canada, at Shamper's Bluff, New Brunswick, near his childhood home.

B. Moose Peterson (p. 106)
A California native, Moose has been a wildlife photographer, photography instructor, author, and lecturer for nearly 20 years. Along with his wife, Sharon, Moose publishes the quarterly *BT Journal* for wildlife photographers in 18 countries. His images have been published in *National Geographic, Audubon, Outdoor Photographer,* and other magazines. He has authored 10 books, including *California: Vanishing Habitats and Wildlife* and *Nikon System Handbook*. Moose and Sharon live in Mammoth Lakes, California.

Andrea Pistolesi (p. 45)
Based in Florence, Italy, where he was born in 1957, Andrea is an assignment photographer for major Italian and international travel magazines, including *Islands, Travel & Leisure, Geo, Departures, Weekend Viaggi, Gente Viaggi, Bell'Italia, Bell'Europa, Airone, Viajar, Rutas del Mundo, Vacances, European Travel & Life,* and *Sophisticated Traveler*. He has published books on New Zealand, Indonesia, South Africa, Morocco, San Francisco, Prague, Washington, D.C., and Mississippi.

Rod Planck (p. 73)
Rod is a professional nature photographer, tour leader, teacher, and naturalist. For 15 years, he has shared his knowledge and experience through his popular How to Photograph Nature workshops and seminars. His images have been published in *Audubon, Geo, Sierra, National Wildlife, Natural History, Birder's World, Backpacker, Ranger Rick,* and other magazines. Books featuring Rod's photography include *The Spirit of the North, Wild Michigan, Birds of North America,* and *Capitol Reef: Canyon Country Eden*. The book *Nature's Places* is dedicated exclusively to Rod's images. Rod has also worked as a tour guide and photography instructor from Antarctica to the Pribilof Islands in the Bering Sea. He lives in Paradise, Michigan, along the shores of Lake Superior.

Darrel C. H. Plowes (p. 39)
Trained as an ecologist, Darrel officially retired in 1982 as a director of agricultural affairs for the Zimbabwe government. At 74, he is still in demand as an environmental impact consultant to national and international organizations, including the U.S. Agency for International Development. Darrel has amassed more than 50 years' experience studying the African terrain, and his photographs of local flora and fauna (seven species of which bear his name) appear in textbooks worldwide and in magazines such as *African Wildlife* and *Natural History*. He won an award for his documentary film *Black Eagle Fly Free*. He is currently producing a monograph on the more than 400 species of stapeliads. He lives in Mutare, Zimbabwe.

Fritz Pölking (p. 46)
Fritz has been photographing nature for 40 years and is one of the most widely admired wildlife photographers in the world. Born in 1936, he grew up photographing the songbirds that nested in the garden of his family home in Krefeld, Germany. Today, he has won many awards for his photography, including the BBC Wildlife Photographer of the Year competition in 1977. His images of the world's wildlife have appeared in magazines including *Geo, National Geographic, Der Stern,* and *International Wildlife*. He has published his work in more than 10 books as author or co-author, including *The Art of Wildlife Photography*, and a book on cheetahs, *Gerparde,* with fellow German photographer Norbert Rosing. Fritz lives in Greven, Germany.

Glenn Randall (p. 88)
Since 1979, Glenn has combined his love of wilderness and adventure sports with a passion for photography and writing. He has written seven books and more than 200 magazine articles. His images have appeared in calendars, books, and magazines, including *Audubon, Geo, Outdoor Photographer, Outside,* and *SKI*. He is currently at work on a book on landscape photography. Among his tips: Strong images are certain to emerge from sites visited repeatedly. If camping is restricted, Glenn often sets out from home at 1 a.m. for a one-day blitz to the backcountry. "Sleep is for photographers who don't drink enough coffee." He lives in Boulder, Colorado.

James Randklev (p. 94)
Recognized as one of America's finest landscape photographers, James creates images primarily with large- and medium-format cameras. His explorations have led him through the government parklands and public backroads of North America, pursuing his unique portrayals of nature for more than 24 years. His photographs have been published by magazines such as *Omni, Travel & Leisure, Vis-à-Vis, Natural History, Sierra, Vistas, National Geographic Traveler, Sierra,* and *Outdoor Photographer*. His images appear

often in Sierra Club calendars. His awards include grand prize in landscape at the Roger Tory Peterson Institute of Natural History. James has authored more than 105 calendars and his books include *In Nature's Heart: the Wilderness Days of John Muir, Georgia: Images of Wildness,* and *Wild and Scenic Florida.* He lives in Tucson, Arizona.

Windland Rice (p. 95)
A graduate of Duke University, Windland has been a wildlife photographer for six years. She has received several awards in just the past two years, and her list of publishing credits is growing. Her images have appeared in *Nature's Best, National Geographic World, International Wildlife, Wild Outdoor World, Natural History,* and *Disney's Animal Kingdom.* Born and raised in Memphis, Tennessee, Windland lives in Jackson Hole, Wyoming.

José Romão (p. 54)
Trained as a biologist in Portugal and the United States, José recently took up landscape photography professionally. He published his first book, *Cabo da Roca: Images of the Westernmost Point of Continental Europe,* in 1998. His images of the Portuguese and American landscape have also been published in various Portuguese magazines, and displayed in numerous exhibits. He owns an image library and publishing design studio in Almada, Portugal, where he also lives.

Norbert Rosing (p. 123)
Norbert has been a professional wildlife and nature photographer for more than 15 years, specializing in the Arctic, North American landscapes, and Germany's national parks. Norbert's images of polar bears in and around Churchill, Canada, are among the most widely published. In 1998, *National Geographic* magazine published a limited-edition poster (20,000 copies) of Norbert's image of a polar bear at rest. His work has also appeared in *Life, Stern, Geo, Terre Sauvage, Sinra, Oasis,* and *Kosmos* magazines. He has published eight books (including two on which he collaborated with fellow German photographer Fritz Pölking) on subjects including polar bears, cheetahs, the National Parks of Germany, and Yellowstone National Park. He lives in Grafrath, Germany.

Galen Rowell (p. 10)
As America's foremost adventure-nature photographer, for nearly 28 years Galen has relayed in words and pictures his experiences exploring the great outdoors in the U.S. and on more than 40 expeditions into the mountains of Africa, Antarctica, Canada, Chile, Greenland, Europe, India, Nepal, New Zealand, Pakistan, Peru, and Tibet, including the first one-day climbs of Mount McKinley and Mount Kilimanjaro. His articles and images have appeared in *Life, National Geographic, Outdoor Photographer, Outside, Sports Illustrated,* and countless other publications around the world. His 15 books include the best-seller *Mountain Light and Bay Area Wild,* a tribute to nature within a 40-mile radius of San Francisco. In 1984, he received the Ansel Adams Award for his contributions to the art of wilderness photography. Still an avid mountaineer, Galen lives a few blocks from where he was born, in 1940, in Berkeley, California.

Becca Saunders (p. 12)
Becca is a Sydney-based freelance photographer and writer specializing in marine science and ocean-related subjects. She is the author of *Ambon: Marine Wonderland,* a coffee-table book on the underwater splendors of Ambon, Indonesia. Her articles and images have appeared in *BBC Wildlife, Australian Geographic, Australian Natural History, Australian GEO, UVM* (Sweden), *Skin Diver, Rodale's Scuba Diving, Mergulho & Nautica* (Brazil), *Sport Divers Journal* (Hong Kong), *Sportdiving* (Australia), *Scuba Diver* (Australia), and *DIVE Log* (both Australia and New Zealand). Becca is the only woman to receive the prestigious Australian Underwater Photographer of the Year award, which she received in 1997. She is currently working on her second book, *Top Dive Sites of Australia.*

Wendy Shattil and **Bob Rozinski** (p. 86)
Wendy and Bob, both wildlife photographers, approach their field work as a team, capturing private moments of wildlife from separate points of view. Wendy was the first woman awarded Grand Prize honors in the BBC Wildlife Photographer of the Year competition. They have earned other prestigious awards and have been named Conservationists of the Year and Outstanding Business Partners of the Year by the Colorado Wildlife Federation. They are honorary research associates for the Denver Museum of Natural History and have published 10 books together, including new releases for children: *Wildlife Detectives* and *On the Trail of Colorado Wildlife.* They live in Denver, Colorado.

John Shaw (p. 83)
John is an internationally acclaimed nature photographer and a respected authority on the profession, which he has pursued as a freelancer since 1971. His images have appeared in all the major magazines that publish natural history photographs, including *Airone, Audubon, Country Journal, Defenders of Wildlife, Equinox, International Wildlife, National Wildlife, National Geographic Traveler, Natural History, Outside, Ranger Rick, Relax, Sierra, The Living Bird Quarterly, Vista,* and many others. John's photographs have also appeared in numerous calendars, books, and advertising. He has released a workshop on home video, and he is the author and photographer of five best-selling books: *The Nature Photographer's Complete Guide to Professional Field Techniques, John Shaw's Closeups in Nature, John Shaw's Focus on Nature, John Shaw's Landscape Photography,* and *John Shaw's Business of Nature Photography.* He leads workshops and tours throughout the U.S. and Canada. John lives in Colorado Springs, Colorado.

Wendy Shymanski (p. 120)
Wendy is a professional freelance photographer who has been photographing nature and outdoor sports subjects throughout Canada and Alaska since 1985. Her images have appeared in *Equinox, Canadian*

Geographic, Beautiful British Columbia, Ski Canada, Canadian Wildlife, Up Here, Sea Frontiers and other magazines, as wells as numerous calendars, advertising, and other publications. Wendy is also a ski instructor/coach, a triathlete, and a qualified avalanche technician assistant. She lives in Terrace, British Columbia.

Bill Silliker, Jr. (p. 60)
Bill is a professional photographer specializing in wildlife of the northern forests of North America. His images have been published by Audubon, Backpacker, National Parks, National Geographic Books, National Wildlife, The Nature Conservancy, NorthWord Press, Sinra, the Wilderness Society, and other publishers. His books include *Moose: Giant of the Northern Forest, Just Loons,* and *Maine Moose Watcher's Guide.* He has taught wildlife and nature photography for L.L. Bean's Outdoor Discovery School since 1992. He has also been an assignment photographer for The Trust For Public Land, and he has hosted a weekly public television show devoted to nature. A leader in his field, Bill is on the North American Nature Photographer's Association's board of directors and he serves other wildlife organizations. He lives in Saco, Maine.

Scott T. Smith (p. 5, 100)
In 1988 Scott quit his job as a research meteorologist to pursue freelance photography full time. He and his wife, Mary, lived in their truck and the backcountry of North America for a year making photographs. Scott's images of landscapes, natural history subjects and muscle-powered sports have appeared in text and trade books, calendars, advertising and magazines, including *Alaska, Audubon, National Parks, Outside,* and *Sierra.* Scott's books include *Nevada: Magnificent Wilderness,* and *Along Wyoming's Continental Divide.* He and Mary live in Utah's Cache Valley with six pack llamas and three cats.

Eric Soder (p. 48)
Eric was born in Zurich in 1969, and grew up in the rural Swiss village of Moenchaltorf. He has been a professional freelance writer and photographer for 11 years, with a strong emphasis on the subjects of wildlife and nature. Eric's stock images have appeared in *BBC Wildlife, International Wildlife, Nature Photographer,* and *Terre Sauvage,* and he has contributed articles and images to German language photo magazines. In 1992, Eric published his first book, *Natur Fotoschule,* a how-to guide on nature photography, featuring his own images and those of leading nature photographers from around the world. He lives outside Uster, Switzerland.

Mark Spencer (p. 13)
Mark is an adventure diver who specializes in photographing unusual and remote underwater subjects. An international fellow of the Explorers Club, Mark's work has appeared in *National Geographic, BBC Wildlife, Australian Geographic, Australian Geo, Mergulho,* and *Sportdiving* magazines. Major projects for Australian Geographic include photo-documentation and in-depth articles of a deep-water shipwreck off the coast of New South Wales and a flooded limestone cave in Wellington, New South Wales. In October 1998, Mark led a team of divers and archaeologists to verify and photo-document a World War I–era Australian submarine sunk off Turkey, a project that enabled the Australian government to formulate an official position regarding the relic at rest in foreign waters. He is based in Sydney, Australia.

Tom Stack and **Therisa Stack** (p. 68)
From their home base in Key Largo, Florida, Tom and Therisa constantly explore the Florida Keys and Caribbean Sea on assignment both under and above water. Their images have appeared in countless books, calendars, and magazines including *National Geographic, Skin Diver, Aqua, Audubon* and *International Wildlife.* Tom has been a professional underwater photographer for 40 years. "Still, every

dive reveals something I've never seen before." They are currently documenting the ecological significance of the world's mangroves.

Hans Strand (p. 44)
Born in Sweden in 1955, Hans was a mechanical engineer for nine years before changing careers in 1990 to become a professional landscape photographer ("a change I never regret"). Based in Sweden, Hans travels worldwide photographing nature and has published *And the Sea Never Rests,* a book on the life cycle of water, and *While the Forest Grows,* depicting the forests of the world. In 1999, Strand received the Swedish Nature Protection Agency's environmental prize for his efforts to promote conservation of old growth forests in Sweden. He lives in Hägersten, Sweden.

Mark Strickland (p. 32)
Mark's passion for underwater photography is based in his lifelong relationship with the sea. Growing up in Florida, he worked many years as an ocean lifeguard, boat captain, and diving instructor. He has since dived and photographed many of the world's choice spots, and for much of the past 13 years he has served as the on-board photographer and cruise director on a live-aboard dive boat in Thailand. Mark's images have appeared in dozens of books and magazines around the world, including *Discover Diving, Dive International, Ocean Realm, Sport Diver, Sport Diving,* and many others. He co-authored *ScubaGuide Thailand,* and he is currently at work on Lonely Planet's *Diving & Snorkeling Guide to Thailand.* He is based in Patong Beach, Thailand.

Toshinobu Takeuchi (p. 23)
Born in 1943 in Aichi prefecture, Japan, Takeuchi graduated from the department of science and engineering at Meijo University and worked in the civil engineering section of the Aichi prefectural government before turning to freelance photography at age 27. Drawn to Japan's natural landscape, Takeuchi has devoted much of his work to nature. His books

include *Japan's Wild Horses, Portraits of Nature* and *Voice of the Wind-Ten Chi Fu In.* One of his current projects is a collaboration with Dutch photographer Martin Kers to commemorate the 400-year relationship between Holland and Japan with a special exhibition in those two countries in September 2000. Takeuchi's studio is in Tokyo.

Mills Tandy (p. 92)
Mills has been photographing natural history subjects and working as a research biologist since 1960. He holds degrees from the University of Texas at Austin including a PhD completed in 1972 in environmental and systematic zoology and botany. The evolutionary biology of animals and plants is the main subject of his studies. He has photographed throughout Africa, Central America, and the midwestern and southwestern U.S. His images have been published in *National Geographic, BBC Wildlife, Natural History, Ranger Rick,* and other magazines, and in more than 10 books, including *Encyclopaedia Brittanica.* He lives in Sierra Vista, Arizona.

Steve Terrill (p. 113)
A native of Portland, Oregon, Steve has been trekking throughout the U.S. for 20 years photographing nature, chiefly in the Pacific Northwest. As a self-taught photographer, Steve was hired as a staff photographer for Beautiful America Publishing in April 1980. In May, his career literally exploded when he captured the eruption of Mount St. Helens on May 18, 1980. One of Steve's images was presented to President Carter who visited the site to survey the destruction. In 1982, Steve launched his freelance career. His six books include *Oregon: Images of the Landscape, Oregon: Magnificent Wilderness, Oregon Coast, Oregon Wildflowers, Oregon's New Forests,* and *Oregon Reflections.* Steve still resides in his old neighborhood in northeast Portland.

Tom Till (p. 91)
For more than 20 years, Tom has photographed landscape, nature, history, and travel subjects with his 4x5 view camera in all 50 states of the U.S. and on six continents. His images have appeared in books, calendars, magazines, and advertising worldwide, and he has been the sole photographer for 26 books. One of the first photographers to explore Arizona's mystifying slot canyons, Tom and others kept the locations of the choice spots secret for years, often inventing location names to keep throngs (and competitors) off the scent. He has received the North American Nature Photography Association/ Guilfoyle award for landscape photography and was named Photographer of the Year by *Arizona Highways* magazine in 1996. He lives in Moab, Utah.

Larry Ulrich (p. 119)
Larry began making a living with his camera in 1972, selling prints of his images at street fairs along the U.S. west coast. When he discovered a demand for his images in books and calendars, he abandoned the craft show circuit and began making photographs full time. He self-published a redwoods calendar for nine years before devoting his attention to selling stock images. A self-taught photographer, Larry is assisted in the field by his wife, Donna. Their books include several titles devoted to wildflowers: *Wildflowers of California, Wildflowers of the Plateau and Canyon Country,* and *Wildflowers of the Pacific Northwest.* Their current project is *Wildflowers of the Rocky Mountains.* Both native Californians, Larry and Donna live in Trinidad, a coastal village not far from the Redwood forest they affectionately refer to as "the office."

Kennan Ward and **Karen Ward** (p. 114, 115)
An adventurer-naturalist, Kennan photographs and writes about wilderness and wildlife. Born in Illinois in 1954, Kennan moved to Santa Cruz, California, in 1973. He earned degrees in wildlife biology and natural history/environmental studies at the University of California Santa Cruz, and he was a ranger for the National Parks Service for 10 years. His images have appeared worldwide in calendars and magazines, including *Audubon, BBC Wildlife,* *National Geographic, GEO, Sierra, Sinra, Natural History, National Wildlife,* and *Equinox.* His books include *Grizzlies in the Wild, Journeys With the Ice Bear,* and *Denali: Reflections of a Naturalist.* Since 1986, Kennan's wife, Karen, assisted in the field and contributed to their stock image library as a photographer in her own right. Kennan and Karen live in Santa Cruz, California.

Alan Watson (p. 53)
Since 1974, Alan's work as a photographer has been devoted to environmental causes. Born in Scotland in 1954, Alan graduated with honors at England's Essex University. In 1978, he joined the Findhorn Foundation, an organization working toward a cooperative relationship between humanity and nature. In 1987, Alan founded Trees for Life, a charity he currently heads and whose goal is the restoration of Scotland's Caledonian Forest. He has lectured worldwide on the subject of trees, forests, and ecological restoration, and he publishes calendars featuring images and information about threatened forests worldwide. Alan's photographs also have been published in *Encyclopaedia Britannica* and books and magazines in Europe, the U.S., Australia, and New Zealand. He lives in an ecologically retrofitted house at Findhorn on the Moray Firth coast in Northeast Scotland.

James D. Watt (p. 124)
At age 48, James has been diving the oceans of the world for more than 30 years. His experiences include working as a professional diver, a medical technician, and a dive charter captain. In 1980, he turned his efforts to professional photography, specializing in marine wildlife and, in particular, open ocean subjects such as sharks and marine mammals. His images have been published in more than 300 magazines and books worldwide, by National Geographic, the Audubon Society, and other prestigious houses. He is also an underwater filmmaker whose footage has been televised by ABC, Discovery Channel, and other broadcasters, and he has worked

as a location scout for movie studios, including George Lucas' firm, Industrial Light & Magic. He lives in Kona, Hawaii.

John Weller (p. 96)
Born in 1974 in Albany, New York, John was raised in Boulder, Colorado. He was first published at age 11, taking an honorary mention award in the *Colorado Outdoors* photo contest. Since then, he graduated from Stanford University with a degree in environmental economics. John is currently staff photographer at the Ansel Adams Gallery in Yosemite National Park and he is an assistant to photographer William Neill.

Darwin Wigget (p. 101)
Darwin is an award-winning stock, travel, and assignment photographer specializing in landscape, travel, nature, lifestyle, and outdoor recreation photography. A decade of teaching at the college level prepared Darwin to instruct others on photography technique, and he regularly leads workshops and writes for photography magazines. His images have appeared worldwide in calendars, books, advertising, and magazines, including *Outside, Sierra, National Geographic Traveler, Geo, Canadian Geographic, Equinox,* and *Outdoor Canada.* He completed his first book, *Darwin Wiggett Photographs Canada,* in 1997, and he is at work on two more books on the Canadian Rockies. He lives in a log home nestled in the foothills near Water Valley, Alberta.

Dale Wilson (p. 57)
Born in 1958, Dale has been a freelance photographer since 1990 when he resigned from the Canadian military after 15 years of service. A self-taught photographer, his stock images are published in trade books, advertising, and magazines, including *Canadian Geographic, Equinox, National Geographic Traveler, Natural History, Sierra,* and *World Explorer.* He is the co-author (with photographer Daryl Benson) of *A Guide to Photographing the Canadian Landscape.* He lives in Eastern Passage, Nova Scotia.

Art Wolfe (p. 26)
Art's 25-year photography career has taken him to the farthest reaches of every continent, and he spends nine months each year on the move, creating new images of wilderness and wildlife. Since 1978, he has published 41 books, including *Migrations, Light on the Land,* and *Rythms from the Wild.* He has 10 new titles in preparation, including his landmark work, *The Living Wild.* The son of commercial artists in Seattle, Washington, Art graduated from the University of Washington with degrees in fine arts and art education. He is an influential force in the emerging medium of digital photo illustration. In 1998, the National Audubon Society recognized Art's work in support of the national wildlife refuge system with its first-ever Rachel Carson Award. That same year, he was named Outstanding Photographer of the Year by the North American Nature Photography Association. Art's home and studio in West Seattle overlooks Puget Sound.

King Wu (p. 30-31)
Born in the People's Republic of China, King at age 20 fled communism by swimming to Hong Kong during the Cultural Revolution in 1971. Six years later, he emigrated to the U.S. An avid photographer since 1980, King photographs regularly around Washington and other western U.S. states. His homeland remains of high interest to him and he has visited China with his cameras 15 times since 1981. His photographs are in private and corporate collections throughout the U.S. He lives in Bothell, Washington.

Norbert Wu (p. 112)
In the course of his worldwide travels, Norbert has been bitten by sharks, run over by an iceberg, stung nearly to death by sea wasps, and trapped in an underwater cave. The author and photographer of eight books on wildlife and photography, his library of marine and topside wildlife is comprehensive. His books include *Life in the Oceans, Beneath the Waves, Splendors of the Seas,* and *A City Under the Sea.* Recent projects include filming the revolutionary Deep Flight

submersible for National Geographic Television, tiger sharks for Survival Anglia, and great white sharks for the PBS series *Secrets of the Ocean Realm.* In 1997 and 1999, Norbert received National Science Foundation grants to research and document wildlife in Antarctica. He lives in Pacific Grove, California.

Cliff Zenor (p. 77)
Cliff is a full-time nature photographer, tour leader, and workshop teacher. He leads up to 20 workshops and tours each year (many together with photographer Bill Fortney) in national parks and nature preserves across the U.S., in Kenya, and on Ecuador's Galapagos Islands. His images have been featured in *Outdoor Photographer, Horticulture, Fine Gardening* and *Chicagoland Gardening* magazines, and in books including *Indoor Gardening* for which he was principle photographer. Cliff grew up in Wisconsin and Illinois, and he lives in northern Indiana.

Acknowledgments

The book in your hands is more than an album of photographs taken on one day. It represents more than two years of planning, thousands of telephone calls, faxes and e-mails, and the generous contribution of insight and time by hundreds touched by this project. Too numerous to name here, all who simply embraced the idea provided the energy to buoy it from concept to completion. The individuals and companies listed below represent many who shared generously their resources (and occasionally, a shoulder to cry on), including family, friends, advisors, consultants, and others who showed the way. To all of you: Thank you.

A & I Color
Omar Abdla
Bryan Alexander
David Alexander
John Allmann
Sabine Allofs
Jim Ankeny
Tawni Archer
Peter Arnold
Wendy Baker
Daryl Balfour
André Bärtschi
Claire Beck
Mary Bedingfieldsmith
Stephen Benavides
Daryl Benson
Tom Blagden
Cynthia Black
Blue Earth Alliance
Lynette Bond
Jerry Bowman
Jim Brandenburg
Lori Breeden
William D. Buckner, Esq.
Buckner, Alani & Young
Jennifer Burnett
Janet Bush

Jamie Butcher
Mike Campbell
Richard & Sharon Carpenter
Pablo Cervantes
Tony Cherbok
Gilles Chevaleau Jean
Ron Cichocki
Terry Clark
Willard Clay
David Cline
David Colin
Myrna Colwill
Jessica Cook
Kathleen Norris Cook
Gerald Cubitt
Thomas A. Curley
daybreak2000.com
Deborah Daly
Pat de la Harpe
Ned DeLoach
Michel & Christine Denis-Huot
Wendy Dennis
Dimitri Dimitriaris
Patrick Donehue
Chyril Dorcas
Byron & Nancy Dudley
Ken & Pamela Duncan

Terry Durr
Jack Dykinga
Christine Eckhoff
Larry M. Edwards
Federal Express Corp.
Michael Fatali
Yuri Filimonov
Natalie Fobes
Susan Fogden
Jeff Foott
Eric Forstrom
Bill & Sherelene Fortney
Mark Fox
Michael Fragnito
Michael Francis
Fuji Photo Film U.S.A., Inc.
Jorge Garcia
Manuel A. Gil
Mike Glenn
Doris Gotin
Maureen Graney
Bob Grant
Marcel W. Gut
Mika Haneishi
Marci Hansen
Norman Hanson
Richard Hanson

Barbara Harold
Angela Hartwell
Brett Hayes
Angelle Hebert
Dr. Haywood & Elizabeth Hill
Fred Hirschmann
Amy E. Holm
Patty Housman
Paul Humann
Imacon U.S.A., Inc.
Pat Ivy
Kevin C. Jackson
Gavriel Jecan
Ricardo Jóia
Dewitt Jones
Tracy Jones-Sullivan
Christine Kapiioho
Vere Kenny
Robert Glenn Ketchum
Tom Kitchin
Masashi Kudou
Russ Kuepper
Rainer & Marja Lampinen
James Lee
Carol Leslie
Marie Lochman
Wayne Lynch
Wolfgang & Kathy Mack
Anne MacKay
Deanna Mah
Camilla Mateo
Michael Mauro
mauromedia.net
Joe & Mary Ann McDonald
Duncan & Teresa McIntosh
Erin McNiff
Patricia McQueeney
David Middleton

Michael J. Mirkovich
Joseph Montebello
Pat & Baiba Morrow
David & Bonnie Muench
Karen Mullarkey
Steve Mulligan
Nicole Mummenhoff
Gary Myors
William Neill
Reneé Oakes
Océ U.S.A., Inc.
Rei Ohara
Pat O'Hara
Tina Smith O'Hara
Don Oster
Yukio Oyama
Maria Parham
Burt Park
Freeman Patterson
Timothy V. Peatling
Rebecca Pelletier
Moose & Sharon Peterson
John Pezzenti, Jr.
Ray Pfortner
Heinz Plenge
Tammy Radcliff
Rick Reiff
Roger Ressmeyer
Windland Rice
Patricio Robles Gil
Lori Robinson
Sally Rodd
Jesús Rodriguez
Galen Rowell
Secretari de Medio Ambiente,
Recursos Naturales y Pesca
Peter Sharp
John Shaw

Rob Sheppard
Noburu Shimizu
Bill Silliker
Nick Simmonette
Fredrick W. Smith
Scott T. Smith
Rick Smolan
Mark Stack
Tom & Therisa Stack
Hans & Carina Strand
Kate Stanuch
Ted Sullivan
Atsushi Suzuki
Jeff Swanson
Colla Swart
Magdi Szaktilla
Bob & Bernece Tefft
Margaret Tefft
Ross & Nola Tefft
Larry & Donna Ulrich
Pablo Valenzuela
Cecilia Vargas Jeria
Eulàlia Vicens
Ken Walz
Kennan & Karen Ward
Walter Weintz
Art Wolfe
Barbara Wons
Micha Wotton
Lesley D. Young
Cliff Zenor
Rae Zimmerman